SPLENDORS
OF THE
UNIVERSE

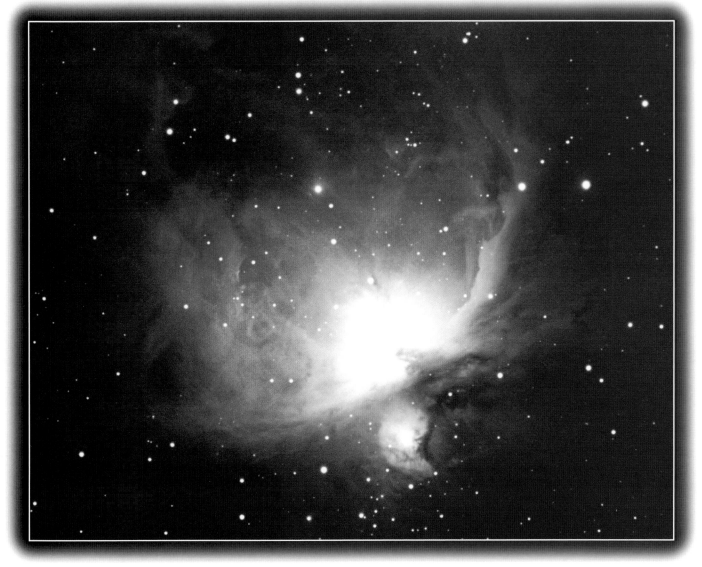

TERENCE DICKINSON AND JACK NEWTON

A FIREFLY BOOK

Copyright © 1997 Terence Dickinson

Cataloguing-in-Publication Data

Dickinson, Terence
 Splendors of the universe

ISBN 1-55209-141-4

1. Astronomy — Pictorial works.
2. Astronomical photography.
I. Newton, Jack, 1942 - .
II. Title.

QB68.D52 1997 520'.22'2 C97-930860-7

Published by
Firefly Books Ltd.
3680 Victoria Park Avenue
Willowdale, Ontario
Canada M2H 3K1

Published in the U.S. by
Firefly Books (U.S.) Inc.
P.O. Box 1338, Ellicott Station
Buffalo, New York 14205

Produced by
Bookmakers Press Inc.
12 Pine Street
Kingston, Ontario K7K 1W1

Design by
Roberta Cooke

Printed and bound in Canada by
Friesens
Altona, Manitoba

Printed on acid-free paper

Cover photo: The Horsehead Nebula in Orion; 25-inch telescope CCD image by Jack Newton.

Back cover: The Veil Nebula in Cygnus, a supernova remnant; 16-inch telescope CCD image by Jack Newton.

Title-page photo: The Orion Nebula; 6-inch telescope photo on Fujicolor SG+ 400 by Terence Dickinson.

Information on availability of images in this book for any form of reproduction should be directed to the authors at the publisher's Canadian address (above).

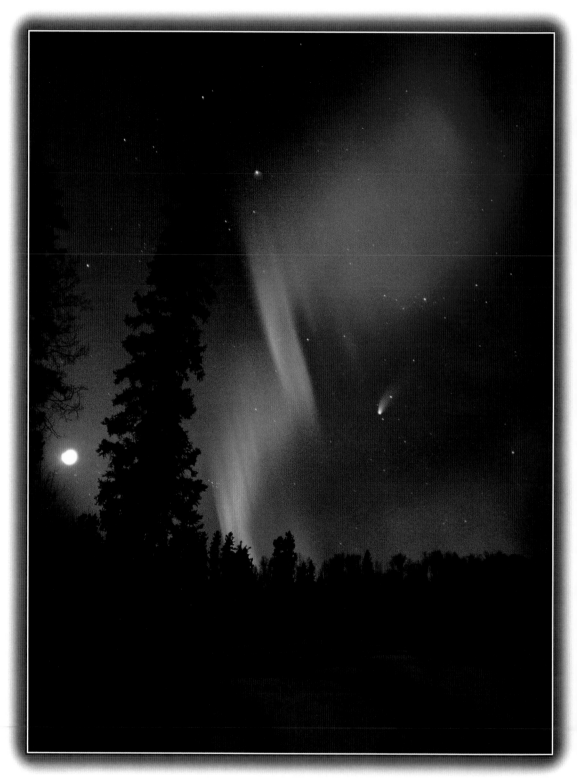

This pastoral evening scene in central British Columbia on April 10, 1997, shows a stunning celestial portrait: Comet Hale-Bopp, an aurora and the Moon, far left. Photo by Jim Fink.

ABOUT THIS BOOK

Splendors of the Universe is a celebration of the beauty of the universe as captured by cameras and telescopes in the hands of amateur astronomers. From the radiance of an aurora to the majesty of a total eclipse of the Sun or the subtle wisps of a galactic nebula, the universe has a deep visual appeal. Every picture you see on these pages was taken by an astronomy enthusiast, someone—perhaps like you—who decided to frame a celestial scene, opened the camera shutter for a few seconds or minutes and was pleasantly surprised by the results.

And there lies the second objective of this book: practical information to guide you in your own astrophotography endeavors. We have tried to cover it all, from the simplest camera-on-tripod constellation shooting to the use of state-of-the-art telescopes and CCD cameras. A surprising number of the universe's visual treasures can be captured with relatively modest equipment. Of course, other targets require expensive and/or highly specialized gear. But no matter where you are in your personal trek into astrophotography, you will find useful tips and guidance on these pages.

One particular emphasis in this book, which we haven't seen covered to any extent in other astrophotography books, is the how-to aspect of creative photography—attempting to realize the maximum possible *splendor* in the astronomical shot. To that end, we wanted to supply plenty of examples, making these pages delightful to look at as well as information-packed. Each of us has spent thousands of hours at our telescopes over several decades, many of them devoted to adding that next elusive photo to our collection. But we wouldn't do it if we didn't thoroughly enjoy the challenge.

To pass on our personal experiences and comments to you, much of the text has been written in the first person. The speaker in Part 1 through Part 3 is Terence Dickinson. In Part 4, it's Jack Newton. Of course, we revert to "we" when appropriate. Enjoy.

Terence Dickinson
Yarker, Ontario

Jack Newton
Sooke, British Columbia

Featuring More Than 200 Color Photographs by Amateur Astronomers

Principal Photography by
Terence Dickinson and Jack Newton

Contributing Photographers
Peter Ceravolo
Roland and Marj Christen
Doug Clapp
Alan Dyer
Jim Failes
Jim Fink
Andreas Gada
George Greaney
Cathy Hall
Tony & Daphne Hallas
Randy Klassen
Glenn LeDrew
George Liv
Jerry Lodriguss
Donald MacKinnon
Robert May
John Nemy
Don Parker
Jim Raffan
Russell Sampson
Bob Sandness
Brian Schneider
Janice Strong & Jamie Levine
Brian Tkachyk
Michael Watson

Illustrations by
Adolf Schaller

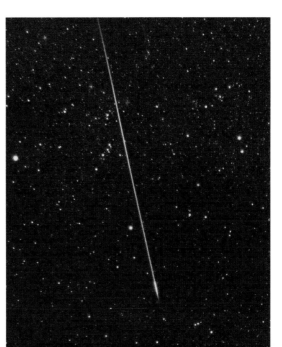

Leonid meteor, photographed November 17, 1996, by Terence Dickinson.

From the Australian out-
back, the Milky Way is a
silky ribbon reaching
across the entire sky. The
Milky Way is our disk-
shaped home galaxy as seen
from our solar system's
location two-thirds of the
way from the center to the
galaxy's edge. The obvious
bulge is the central star-
rich hub of the galaxy. The
horizon is at the edge of
this circular all-sky view,
which was shot on
Konica 3200 medium-
format color film by
Glenn LeDrew using a
16mm f2.8 fish-eye lens.

CONTENTS

There is something soothing about a sky full of stars. At one time or another, almost everyone has felt the tranquillity that seems to accompany a few moments spent under the stellar tapestry from a dark rural site. But there is more. As if summoned up from some subconscious memory bank passed on by our forebears, questions emerge when the starry vista is on display: How far away are those shimmering points of light? Are they the same stars seen last night or last year or in the last millennium? What would a star look like close up? Might there be thinking beings like us in that starry abyss?

These questions, as old as human existence, gain a new and powerful personal force when *you* capture that same stellar scene in pictures. When the cosmos is imaged by your camera and your effort, it becomes not only personal discovery but a permanent record available for sharing and repeated viewing. But before we delve into the how-to of astrophotography, here's a brief overview to establish the scale of the universe as well as our place in it.

Imagine that each star in the known universe is represented by a grain of sand. A large construction wheelbarrow would carry enough sand to make up the Milky Way, the galaxy in which the Sun is located. The wheelbarrow holds about 100 billion grains—100 billion stars. A thimble dipped into the wheelbarrow's cargo would scoop out at least 10,000 grains, more than enough to account for all the stars visible from Earth on a clear, dark summer night. Many of the remaining grains—the rest of our galaxy—meld into the pale glow we see as the Milky Way, but most of the stars in our galaxy are either too far away or too dim to be visible, even with the aid of binoculars or a backyard telescope.

To demonstrate all the stars in the universe using the sand-grain model, we need a freight train with hopper cars filled with sand. Each car holds enough sand to represent hundreds of galaxies like the Milky Way. The train begins to pass us at a level crossing. We count the cars as we wait patiently to cross. The cars roar past, one per second. We have to keep count 24 hours a day for *three years* before the universe train has completed its pass!

For a different perspective, go outside on a clear night and hold your hand up against the sky at arm's length, with your little finger extended. The area of sky blocked by your little fingernail covers roughly two million galaxies. No matter what direction you

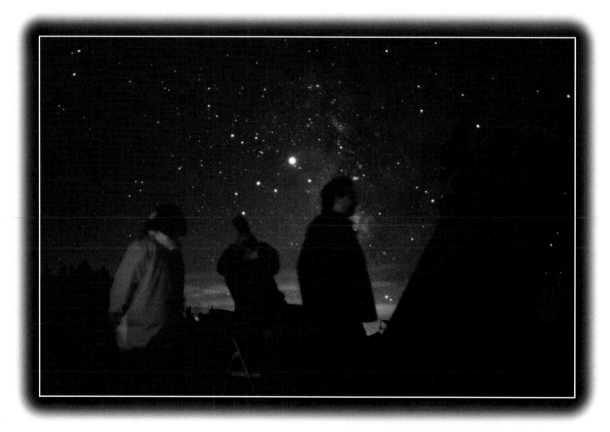

For this night portrait of a family of backyard astronomers enjoying the celestial sights, Terence Dickinson used a 24mm lens at f2 for a 30-second exposure on Scotchchrome 400 slide film push-processed to 1600. Facing page, an aurora dances above the Château Whistler Hotel in British Columbia. Twenty-second exposure by John Nemy with a 28mm f2.8 lens on Kodak Ektachrome 200.

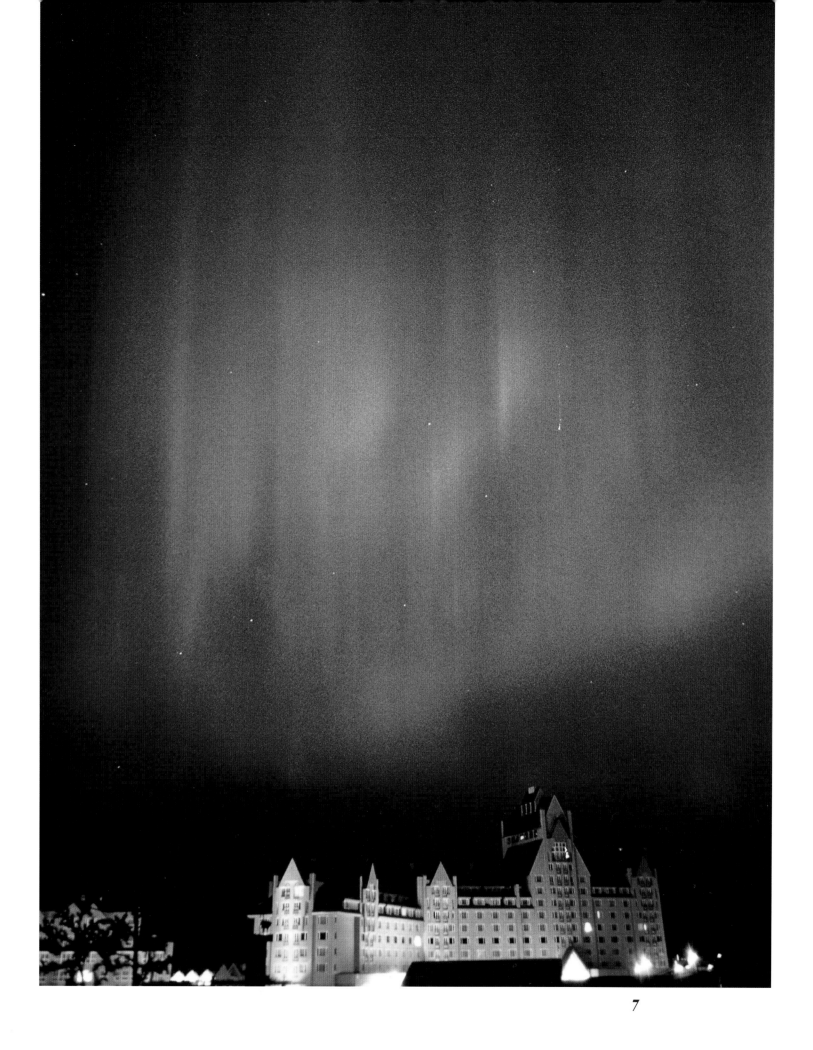

face, the same statistics apply. Between you and the edge of the known universe, a fingernail's worth of the cosmos carries a payload of several million galaxies, give or take a million or so. And each galaxy is a stellar metropolis of tens or even hundreds of billions of stars.

It's a humbling demonstration. The universe is enormous almost beyond comprehension. But there's another component yet to add—*distance*. If the Sun were represented by a golf ball, Earth would be the size of the ball in a ballpoint pen, four meters away. Pluto, the outermost planet, would be an even smaller

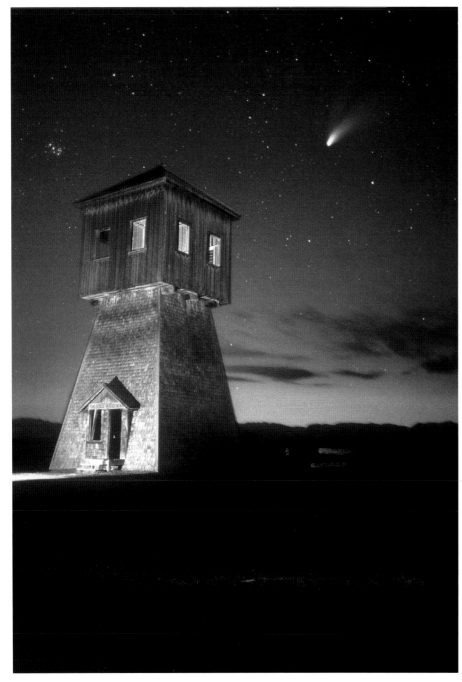

ball 125 meters away, less than the distance from tee to green on a par-3 hole. At the far end of its orbit, Comet Hale-Bopp (seen in the photo on this page and at lower right, above Jack Newton's house) would be 1.6 kilometers from the golf-ball Sun.

Some comets range farther out than Hale-Bopp, but the next nearest object of interest is Alpha Centauri, a star that happens to be an almost exact duplicate of the Sun. If the Sun were a golf ball lying on a fairway in a golf course in suburban Chicago, Alpha Centauri would be another golf ball somewhere in New Jersey. On that same scale, a star in the Andromeda Galaxy, the nearest major galaxy to the Milky Way, would be a golf ball on one of Jupiter's moons. And, of course, there are billions of galaxies far beyond Andromeda.

IMAGING THE COSMOS

If everything mentioned in these analogies were restricted to observation by the world's largest telescopes, the universe would still be interesting, however remote it might be from personal experience. Instead, though, the universe is displayed to us every night. You can step outside, even deep within a major city and its lights, and identify the bright planets—Venus, Jupiter and Mars—and watch the Moon cruise through its phases from night to night.

Away from city lights, the stars shine forth along with the star-powdered Milky Way. Binoculars turned to the starry panorama will reveal nebulas—gas clouds inside our galaxy where new stars are aborning—and galaxies like Andromeda, pale ovals that harbor hundreds of billions of other suns. Now, take a standard 35mm camera loaded with high-speed film. Place it on a tripod, aim it at the stars, and open the shutter for 30 seconds. More stars will be recorded on that picture than you can possibly see with the naked eye. Do that once, and you'll be back for more.

Astrophotography can be addictive, especially since you can so easily display and share what you do as a hobby. And, of course, you can also invest a pile of money in equipment, some of which you may rarely use. (Both authors can attest to that!) On the other hand, after perusing this book, you might be able to grab a camera and tripod you already own and start a rewarding pastime—tonight.

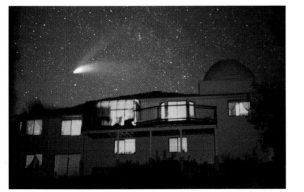

Creative compositions using interesting or familiar foregrounds make these photos "keepers." Janice Strong and Jamie Levine used a 28mm lens at f2.8 and Fujichrome 1600 film in combination with flash guns to illuminate a historic mill, facing page, while Comet Hale-Bopp was at its best. Jack Newton's house served to frame a memorable shot, left, of the same comet. Above, the chilly but tranquil essence of a winter camp was captured by naturalist Jim Raffan in this moonlit 15-second exposure at f2 on Kodachrome 64.

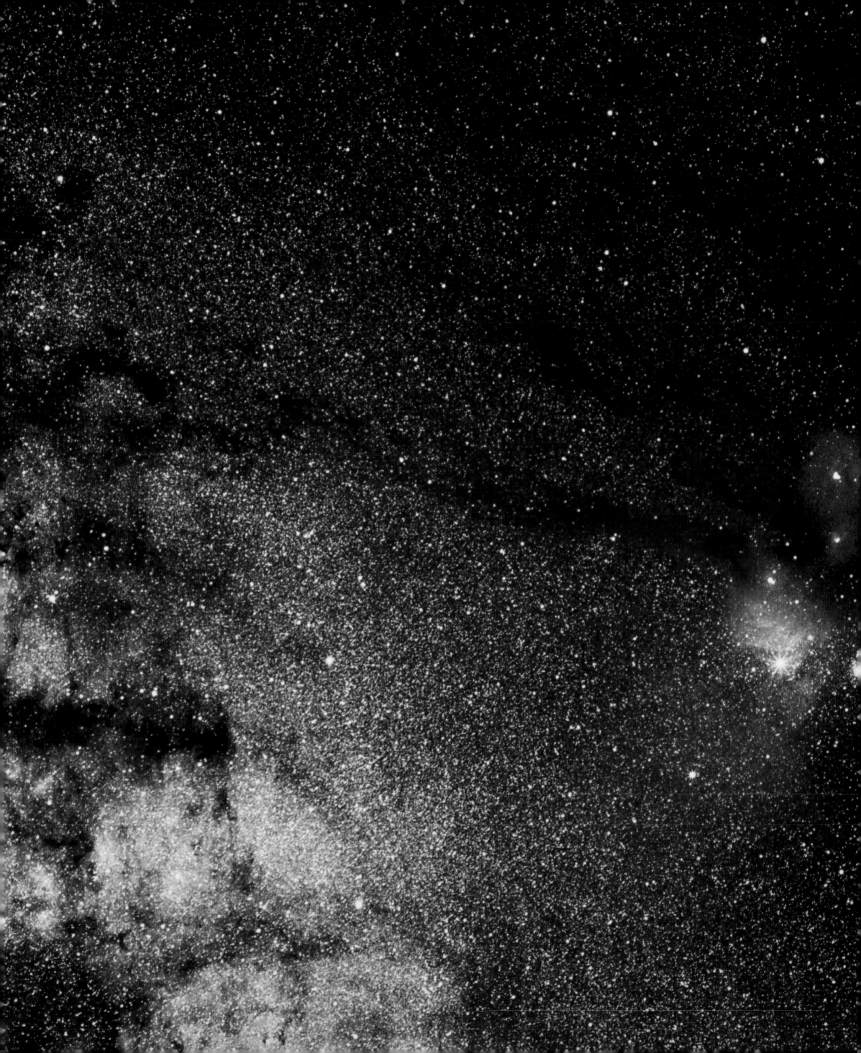

The region around the star Antares in the constellation Scorpius is a favorite target for astrophotographers. The center of the Milky Way Galaxy is just beyond the lower left corner of the frame. The prominent dark lanes are ribbons of cosmic gas and dust thousands of light-years long that can be seen to the upper left of the Sun in the illustration on pages 14-15. This composite of two 25-minute shots, made with a medium-format camera fitted with a 165mm f5.6 lens, demonstrates the superb characteristics of modern 400-speed color-film emulsions. Photo by Tony and Daphne Hallas.

11

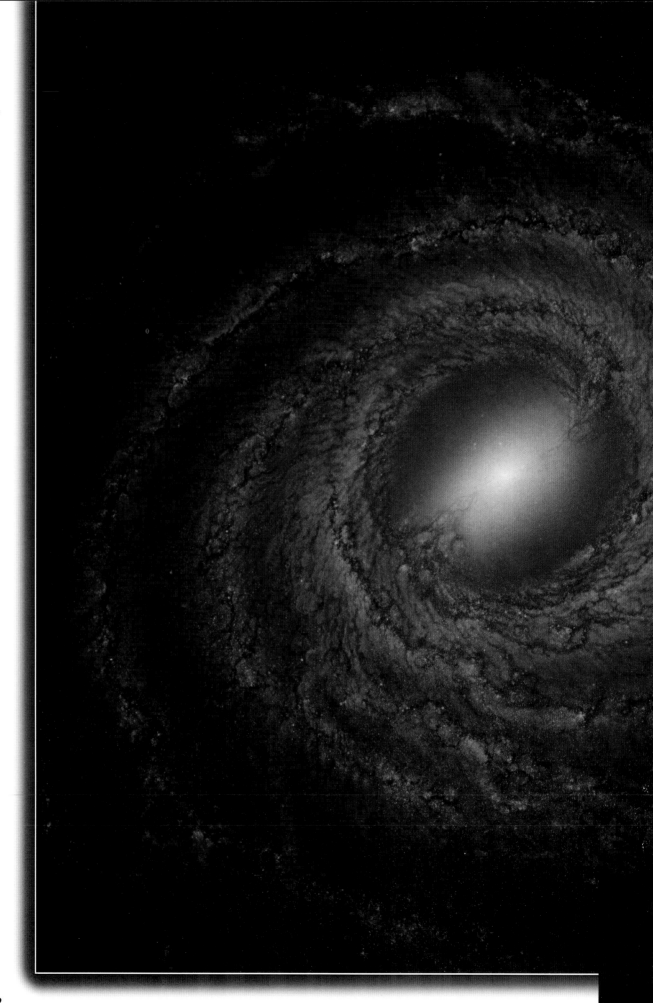

Our star city, the Milky Way Galaxy, is a vast wheel-shaped system of several hundred billion stars. More than 80,000 light-years across, this colossal structure is 10,000 light-years thick at its core (lower illustration) and less than 3,000 light-years thick in the Sun's vicinity, two-thirds of the way out from the hub. Illustrations by Adolf Schaller.

ANATOMY OF OUR GALAXY

On clear, moonless evenings in late summer and early autumn, a ghostly ribbon arches across the canopy of darkness. This delicate powdering on black velvet, known since antiquity as the Milky Way, is the visible portion of the gigantic pinwheel-shaped galaxy we inhabit. What the eye perceives as a sky full of stars is our cosmic neighborhood, merely our corner of the galaxy, a system so vast that the unaided eye peering into the starry night sees only a tiny fraction of its bulk.

The Sun resides on the inside edge of one of the curving spiral arms, about two-thirds of the way from the galactic center, in what the late astronomer Carl Sagan called the galactic boondocks. The Sun's exact position is shown on page 15, at the center of the detailed illustration of our sector of the Milky Way Galaxy. Stars in our vicinity are, on average, seven light-years apart. (One light-year, the distance light travels in a year, is 10 trillion kilometers, about six trillion miles.) The most distant individual stars visible to the naked eye are roughly 3,000 light-years away. Most stars we see are a few dozen light-years distant. The galaxy's total population of stars is at least 100 billion, probably much more. Billions of other galaxies of comparable dimensions exist.

Galaxies are the molecules of the great cosmic body we perceive as the universe. Stars, planets, comets, gas, dust and nebulas in profusion are the galactic ingredients. The Milky Way seems to be a typical example of a spiral galaxy: an enormous disk 80,000 light-years from edge to edge with a bulge 10,000 light-years thick at the hub. In our vicinity, 25,000 light-years out in one of the spiral arms, the galaxy is 3,000 light-years thick. Two compact disks glued together provide a correctly proportioned analogy, with the glue representing the 200-light-year-thick zone where nebulas and newborn stars are concentrated. The Sun spends most of its nearly circular 200-million-

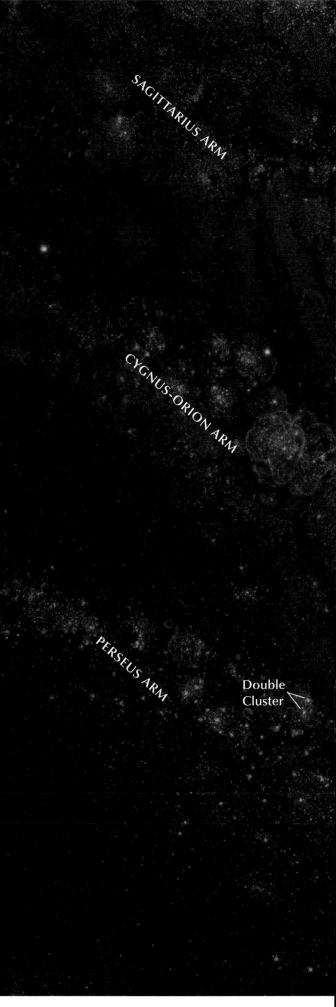

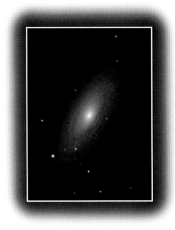

Our sector of the Milky Way Galaxy (small box in illustration at far right) is shown in detail in the large illustration that fills most of these two pages. Note the Sun's position on the inside edge of the Cygnus-Orion Arm. Some of the nebulas and other features of the local region of the galaxy that are pictured in this book are identified. For example, the Orion Nebula, shown on the title page, is 1,500 light-years from the Sun, below and to the right as seen here. Virtually all the stars and constellations visible to the unaided eye are within a thumb's width of the Sun on this scale. The galaxy known as NGC2841, above, is probably quite similar to our Milky Way Galaxy. Galaxy M101, bottom right, seen nearly face-on, has more open spiral arms than our galaxy. Both of these galaxies are about 35 million light-years from Earth. Photos by Jack Newton; illustrations by Adolf Schaller.

year orbit around the galactic nucleus within this zone.

Galaxies come in three basic types: *spiral galaxies*, like the Milky Way; spherical swarms of stars called *elliptical galaxies*; and *irregular galaxies*, loose collections of stars with no distinct structural form. The Large and Small Magellanic clouds, the Milky Way's satellite galaxies, are irregulars. Two nearby ellipticals are companions of the Andromeda Galaxy, easily seen in photos of that galaxy (pages 114-115). Although spiral galaxies are outnumbered by ellipticals and irregulars, spirals *appear* to be most common because a typical spiral is larger and brighter than the average elliptical and irregular galaxies.

The elegant pinwheeling form of a spiral galaxy makes it look as if it is in the process of winding up, or perhaps unwinding. In fact, the spiral arms are regions of recent star formation. They look bright because they are alight with hot newborn stars. Astronomers think that "density waves" gradually sweep across the galactic disk. These natural features compress the galaxy's clouds of gas and dust, which in turn causes the star formation that defines the spiral arms.

The illustration at right is a useful frame of reference for the pictures displayed throughout this book. The Milky Way is the most rewarding hunting ground for astrophotographers. For example, the view toward the Sagittarius Arm and beyond into the center of our galaxy is seen on page 77 (large image). Close-ups of the Lagoon and Trifid nebulas in the same direction can be found on pages 92-93.

In general, observers in the northern hemisphere have the zone at upper right, including the section containing the spectacular Eta Carinae Nebula, blocked from view because Earth is in the way. Conversely, and for the same reason, southern-hemisphere observers never have a good view of the lower left sector. In this trade-off, the Australians win, with access to the full sweep of the rich Sagittarius Arm, shown looming across the center of Glenn LeDrew's spectacular all-sky shot on page 4.

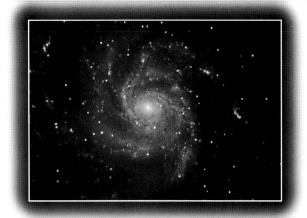

M22

Eagle Nebula (M16)

Omega Nebula (M17)

Trifid Nebula (M20)

Lagoon Nebula (M8)

Eta Carinae
Nebula

NGC3572

Veil Nebula

Sun

North
America
Nebula

Gum Nebula

Orion Nebula (M42)

Cone Nebula

Rosette Nebula

Crab Nebula (M1)

5,000 light-years

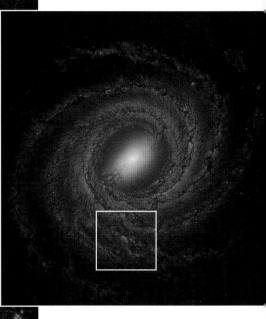

Portions of IC2177, a wispy cloud of celestial gas and dust at least 30 light-years long, are illuminated by stars either embedded in the nebula or a few light-years away. IC2177 is located inside our galaxy's Cygnus-Orion Arm, about 5,000 light-years distant. We see it eight degrees northwest of Sirius, the brightest star in the night sky. Despite its brightness here, it is very faint visually, and most telescope owners have never seen it. Photo is a composite of two 90-minute exposures on Fujicolor 400 taken through a 6-inch f/7 refractor telescope by George Greaney.

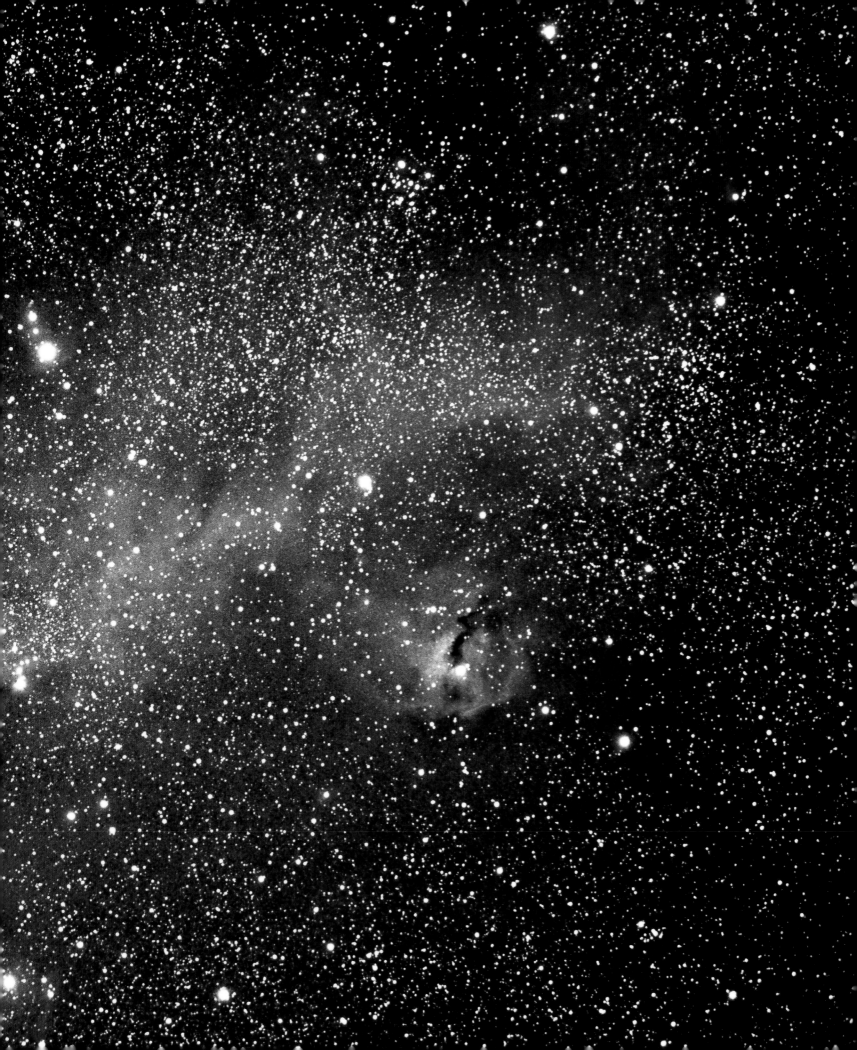

Getting Started:
Camera and Tripod

Some of the most impressive astronomy pictures ever taken were captured by standard 35mm cameras atop camera tripods. Glance back at pages 2 and 7, for instance, to see two splendid examples. But like almost everything else, camera-on-tripod photography has undergone considerable evolutionary change in recent years. In several respects, this type of photography has become easier, while in other ways, it has become more challenging. The factors working to make it easier, however, significantly outweigh the negative aspects. The primary change has come from what might seem to be an unlikely quarter: major-league sports. We can thank those multi-million-dollar athletes and the magazines and newspapers that publish their pictures for being a prime driving force behind the development during the 1990s of superb new high-speed films with rich color saturation and much tighter grain and sharpness than anything available before. Thanks, guys, for letting us astronomy buffs have so much fun.

Modern high-speed color films produce camera-on-tripod shots like this in less than 30 seconds.

PART 1

There are two basic techniques for camera-on-tripod astronomy shots: keep it under a minute (three photos inset), or go for the star trails by leaving the shutter open for half an hour or more, as was done to record this meeting of astrophotographers in the Mojave Desert in southern California (15mm f2.8, Fujicolor 800). Right center photo of Comet West by Cathy Hall; all others by Terence Dickinson.

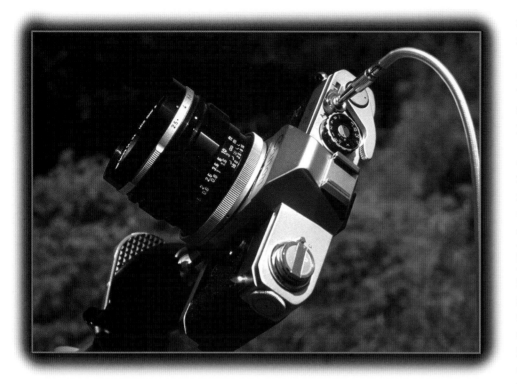

CAMERAS AND LENSES

Great buys in used manual cameras are common if you know what to look for. This decades-old fully manual 35mm SLR Canon, above, along with two lenses was purchased at a flea market for $75. It is a perfectly serviceable astrocamera for tripod and star-trail shots. The Nikon F, bottom, one of the premier cameras for astronomy, is available only on the used market. Interchangeable viewscreens and magnifying viewfinders are among its attributes. The Olympus OM-1, facing page, bottom left, is the all-time favorite astronomy camera. Interchangeable lenses, facing page, bottom right, are one of the features of 35mm SLR cameras.

You may already own a camera suitable for astrophotography. Any camera that can take a time exposure 30 seconds or longer will do the job, but by far, the camera of preference is the versatile 35mm single-lens-reflex camera. The single-lens-reflex designation, or SLR, refers to the fact that the same lens which directs light onto the film is also used to view and focus the composition in the viewfinder. The dual use comes courtesy of a mirror that flips out of the way the instant before the shutter fires and exposes the film. What you see is what you get on film.

There are many advantages to this type of camera;

foremost among them being that the main lens is interchangeable. In a few seconds, the photographer can switch from a wide-angle lens to a telephoto or can remove the lens entirely and attach the camera at the focus of a telescope. It is this versatility that allows a 35mm SLR camera to become a powerful and indispensable tool in the hands of an astrophotographer.

The now ubiquitous 35mm SLR has evolved from a strictly manual mechanical camera, where the settings for each photo must be set by the photographer, to the modern incarnation that is laden with such electronic doodads as auto-focus, auto-film-advance, auto-rewind, auto-light-metering, auto-exposure-compensation—just about auto-everything. Although these features have made today's 35mm SLR easier to use and more foolproof than ever before for daytime shooting, they are far from advantageous for most types of astrophotography. For instance, since all celestial objects are essentially at infinity, auto-focus is superfluous. In fact, many auto-focus lenses focus past infinity, which can make it difficult to focus manually on the stars at night using the viewfinder. To get down to specifics, here's what you need.

First, the camera must allow you to take a time exposure of any duration manually. Most 35mm SLR cameras let you dial in the shutter speed by hand, fixing it at, say, 1/500 of a second for a daytime exposure, regardless of the other settings. Using that same feature, your camera should also allow you to dial in the "B" setting—an almost century-old designation for "bulb." (In the old days, a photographer had to squeeze an air-pressure bulb to trip the shutter for a time exposure and then release it at the end of the exposure.) Most 35mm SLR cameras have this setting, which gives the photographer, not the camera, control over the duration of an exposure. Most other types of cameras, such as the popular 35mm and APS (Advanced Photo System) point-and-shoot models, do not.

To get the "B" setting to function for time exposures, you'll need a cable release, such as the one

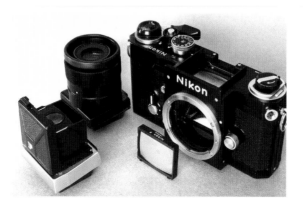

shown on the Olympus camera below. Virtually every 35mm SLR camera can be fitted with a cable release. You control the exposure by pressing in the plunger to begin and flicking a release lever or turning a thumb screw on the cable release to end it. Although in theory, the "B" setting and cable release will allow an indefinite exposure, there is another auto-everything gremlin hiding in your modern Nikon or Minolta's brain: the camera's batteries are required to keep the shutter open. Many kinds of astrophotography call for exposures of several minutes to an hour or more. A one-hour exposure will kill almost any camera's batteries, because the electronically controlled shutter is drawing power the whole time the shutter is open.

If you already own a 35mm SLR camera, determine whether the batteries are required to take a lengthy time exposure. This is easy to do. Just set the exposure to "B," take the batteries out and use the cable release to trip the shutter, then see what happens.

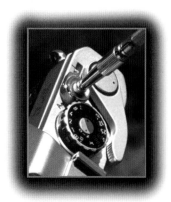

An essential feature of any camera used for astronomy is the "B" setting, right, which allows the photographer to keep the shutter open for as long as desired for a time exposure. Below, photo of Halley's Comet from Arizona by Alan Dyer was a 30-second exposure with a 50mm lens at f2. Red light was from a nearby streetlight.

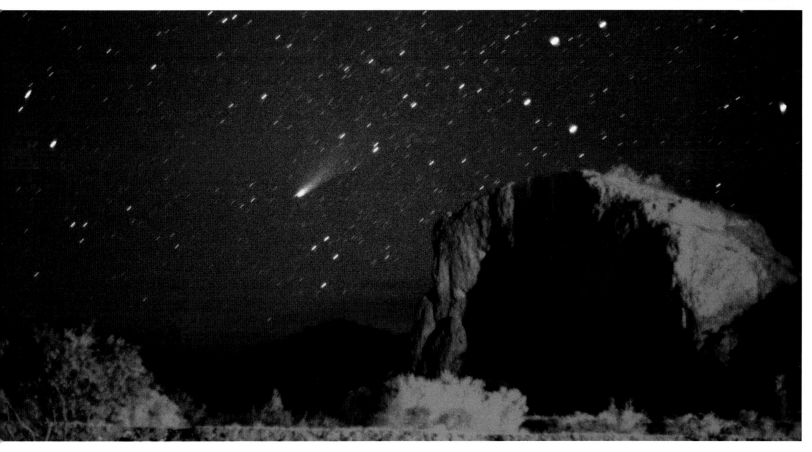

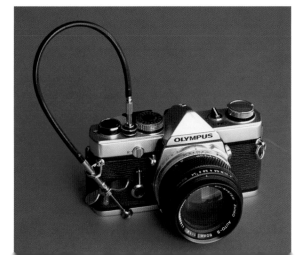

Regrettably, most modern 35mm SLRs fail this test. So if you own a camera like this, you won't want to use it to take star-trail pictures of many minutes' or hours' duration, unless you are willing to replace the batteries with every roll of film. However, such cameras do work fine with exposures up to one minute, and there are many terrific examples on these pages of pictures taken with such a camera. I use one myself, a Canon T-90 that becomes a doorstop with

the batteries removed. However, I have used it for many of the aurora photos and other 40-second (or less) shots on these pages.

Now that the downside of the 35mm SLR world is out of the way, let's explore the advantages of these cameras. Many models have excellent focusing screens that allow you to frame the starry scene. Some models have interchangeable screens for selection of an optimized screen for a particular application. If your camera has this feature, you might want to invest in an extreme fine-grain laser matte screen without

Just about any 35mm SLR camera can capture scenes similar to those on these two pages. Astonishing results are possible, such as the 20-second f2.8 aurora shot, top, by Robert May, taken under a streetlamp in suburban Toronto. Both the aurora, below, and the observer silhouetted against the Milky Way, facing page, top left, were 25-second 24mm shots by Terence Dickinson at f2 on 1000-speed film.

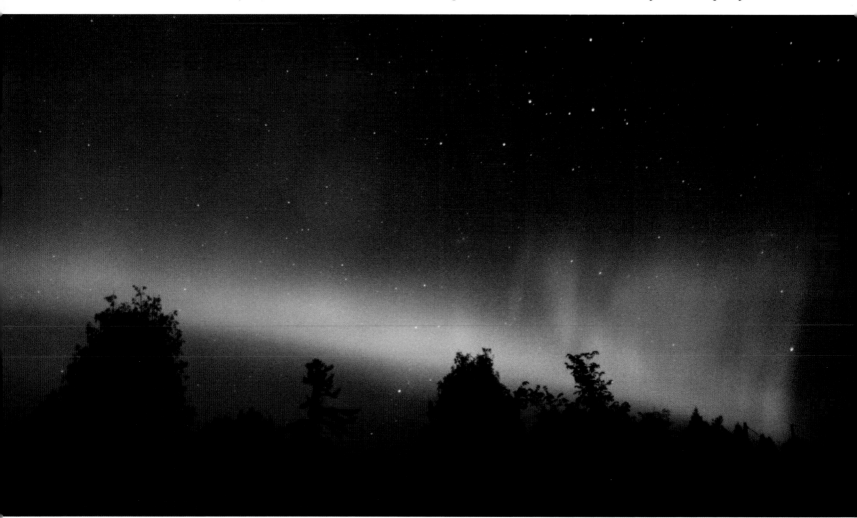

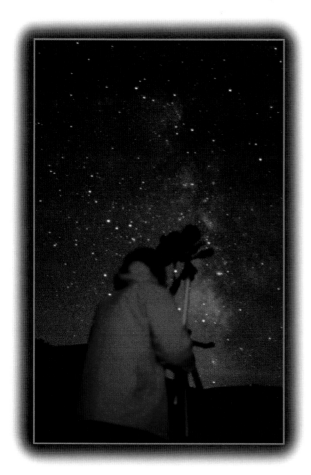

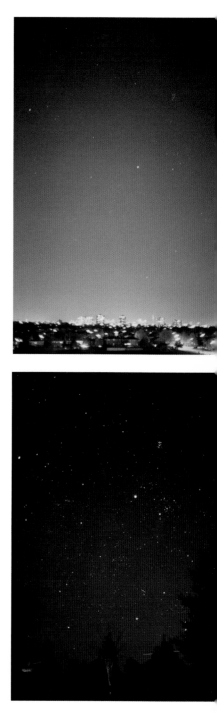

someone with a lifetime of experience with cameras and their accessories. These dealers generally have the best film selection as well, often stocking the sometimes more obscure films that astrophotographers favor. A particularly good sign when you go into one of these stores is a sizable display of used cameras and lenses. This is a strong tip-off that you're more likely to find what you're looking for and get experienced advice.

The used-camera department is also a good place to find an older all-manual model more suitable for astrophotography than the auto-everything cameras currently in vogue. The all-time favorite, and one of the most popular cameras a generation ago, is the Olympus OM-1. There are many of them still around in good condition that can be picked up for about $200 with the standard 50mm f1.8 lens. Used-camera stores often have other lenses to fit this camera, such as the 135mm f2.5 or the 28mm f2.8. The Olympus OM-2 and OM-3 are also good choices, but they will be a bit more expensive and have features that you won't need for astrophotography.

The top choices among secondhand models are the Canon F-1, Nikon F, Nikon F2 and Pentax LX, although they may be considerably more costly than the Olympus. If you can get any of this group with the custom 6x viewfinder, you have the best the camera industry ever made for astronomy. Also on the used market—and the least expensive—is the Pentax K-1000, which sells in the $150 range. None of these cameras is being manufactured today, but all of them can be repaired, if necessary, at independent repair shops.

As the 20th century draws to a close, only four partially or fully manual cameras are still being manufactured. The Nikon FM10 ($250), the Nikon FM2 ($600), the Nikon F3 ($1,600) and the Yashica FX3 Super 2000 (a good buy at about $200). The Nikons take the highly regarded Nikon lenses, and the Yashica accepts the Yashica/Contax bayonet-mount lenses made by Zeiss. Lenses will be additional to the prices

the central split prism common in many cameras. A nice screen of this type is the Intenscreen made by Beattie, an independent manufacturer (see Appendix for address). Your photo dealer should be able to assist you in finding this specialty product.

And while we're on the subject of photo dealers, any city with a population of more than about 50,000 likely has at least one dealer catering to experienced amateur and professional photographers. These stores are usually owner-operated and rarely come under the banner of recognizable chain-store names. This is the type of operation you're going to want to seek out. Astrophotography is a very specialized activity, and sooner or later, you'll need the assistance of

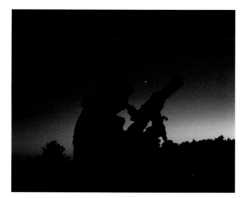

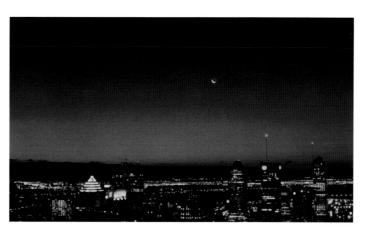

Where you shoot is just as important as what you shoot. Views such as the early-morning cityscape at left by George Liv have a magical quality if the air is exceptionally clear. Typically, though, the difference between city and country conditions is shown above.

The classic bull's-eye pattern of star trails, bottom left and facing page, results from aiming your tripod-mounted camera toward Polaris, the North Star, and opening the shutter for an hour or two. As Earth turns during the time exposure, the stars produce concentric trails on the film. Polaris, the short curved streak, is located very close to the rotational hub exactly above the Earth's North Pole. Facing south, bottom center, and southeast, bottom right, well away from the rotational hub, the star trails are gently curved. Top and bottom right photos were taken in moonlight, which illuminates the land-scape but limits the duration of the exposure. Photos by Alan Dyer (bottom center and bottom right) and Terence Dickinson (top and bottom left).

mentioned. Lenses for all these cameras are available on the used market.

The zoom lens, once considered a luxury, is now standard equipment on almost every new 35mm camera. But once again, new is not necessarily better when it comes to astronomy. The preferred astro-lenses are fixed focal length, such as 50mm f1.4 and 28mm f2.8. Why use these old-style lenses instead of the new when it would seem as though a versatile zoom lens, such as a 28mm to 80mm, would super-sede the use of individual fixed-focal-length lenses? The difference between zooms and fixed-focal-length lenses that goes unnoticed in most daytime photogra-phy is the lens focal ratio. Zoom lenses are typically f3.5 to f4.5 at their fastest setting, whereas most fixed-focal-length lenses range from f1.4 to f2.8. Focal ratio is also known as the "speed" of the lens: f1.4 is twice as "fast" as f2, and f2 is twice as fast as f2.8, which in turn is twice as fast as f4. In practice, this means that it takes an f4 lens four times longer than an f2 lens to take the same picture. In daytime photography, this is no big deal. But in astronomy, where dim scenes are routine, fast lenses are pre-ferred. Most zoom lenses are slowpokes.

In contrast to recent trends in the evolution of 35mm cameras, the development of films for those cameras has worked spectacularly in favor of astron-omy. A new crop of color films introduced during the 1990s has better color fidelity, finer grain, greater sharpness and more sensitivity to the low light levels

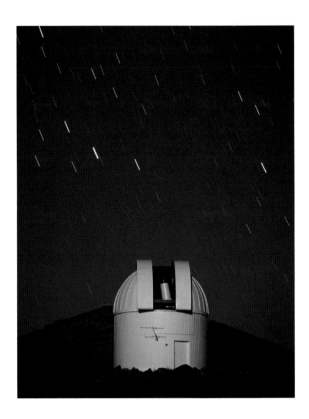

encountered in astronomy than anything available before. The new films yield astrophotos that simply blow away what films from the 1980s could produce. (More on this in Part 2.)

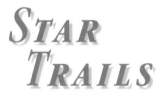

Observatories and astronomy conventions are ideal for star-trail photography because they offer foreground interest to comple-ment the stellar streaks. Tony Hallas used a 20mm lens at f8 and Fujichrome Velvia 50 film for this 6-hour exposure, facing page, during which hundreds of amateur astronomers, using dim, red lights for charts, enjoyed the wonders of the universe.

STAR TRAILS

The world turns, and we turn with it. The daily twirling of Earth on its rotation axis—astronomers call it diurnal motion—causes the Sun to rise in the east and set in the west. At night, the stars move for the same reason, also rising in the east and setting in the west. The hub of the spin axis (in the northern

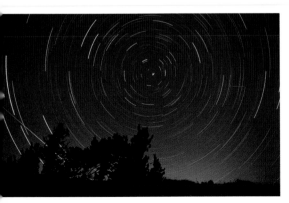

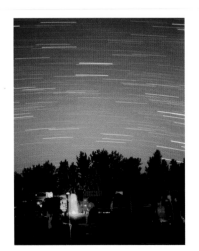

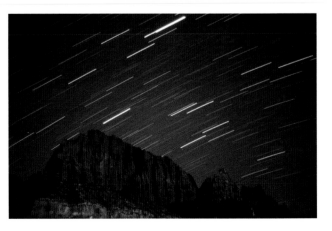

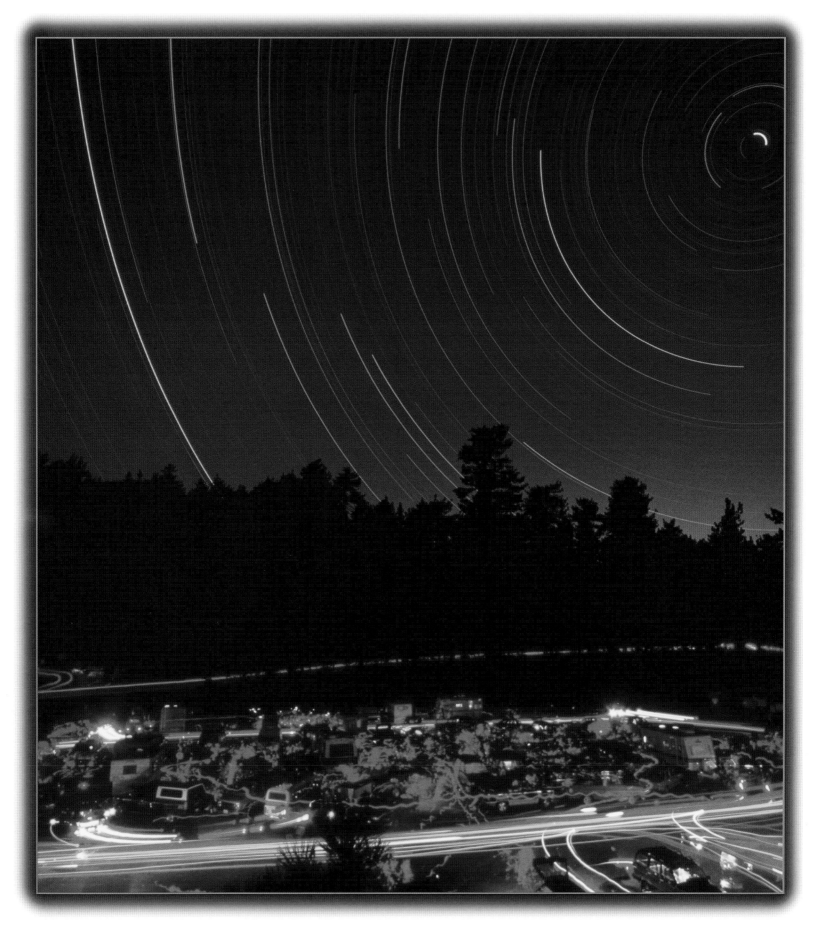

This neat twist on the
classic star-trail photo
shows the stars that made
the trails—in this case,
the stars of Orion.
Here's how it was done:
Alan Dyer used a Nikon
manual 35mm camera
with a 50mm lens and
attached it to a motor-
driven equatorial
telescope mount designed
to track the stars by
compensating for the
Earth's rotation. For the
first hour of the time
exposure, with the camera
set at f5.6, he left the
mount's tracking motor
off. This produced the star
trails. For the next two
minutes, the camera
shutter remained closed,
creating the break
between the trail and the
star images. Finally, with
the camera reset at f2.8
and the tracking motor
on, the stars of Orion
were burned in for
5 minutes. Film was
Fujicolor 400. A similar
result, though with less
emphatic stars at the end
of the trails, can be
achieved with a standard
camera-on-tripod setup
and no equatorial mount.
Use a lens cap for the
2-minute break, and care-
fully adjust the lens f-stop
to its wide-open setting
without moving the
camera, then remove the
lens cap for about
20 seconds before ending
the exposure to record the
stars as tiny points.

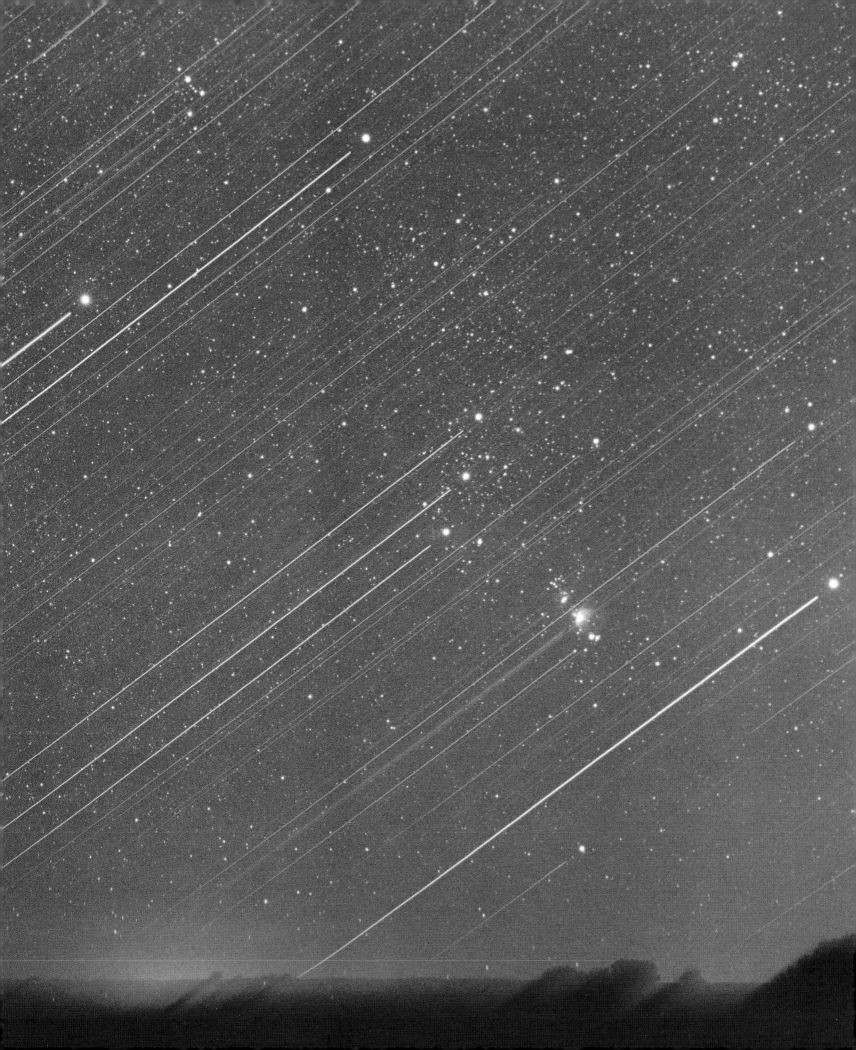

hemisphere) is the point in the sky directly above the Earth's North Pole. As the rotating Earth turns, an observer on that spinning globe sees the sky spin in exactly the opposite direction. Picture a rider on a merry-go-round, and you'll get the idea. Fortunately, Polaris, the North Star, lies within one degree of the north celestial pole, making it easy to frame a classic bull's-eye star-trail photo like the images on these pages.

Even to those who know nothing about astronomy, star-trail photos represent the timelessness of the cosmos. A well-composed star-trail exposure is a prize worthy of being blown up to a 16-by-20 print and framed for your den wall. Yet among all the categories of astrophotography, star trails are the easiest type of photo to take.

Unlike photos where exposures are kept under a minute to prevent the stars from trailing, here you *want* the stars to trail—the more, the better. This means long exposures. Even better, because of the long exposures, you should back off one or two f-stops to keep from saturating the film. That means you'll be operating between f2.8 and f8, which in turn means that any lens, including a zoom lens, can be brought into use. Indeed, this is probably the only category of astrophotography where zoom lenses work just as well as fixed-focal-length lenses.

Star-trail photos can be taken almost anywhere, although they are quickly ruined by lights—either a bright light within the frame or overall bright skies from city lights—and by dew. Since exposures can

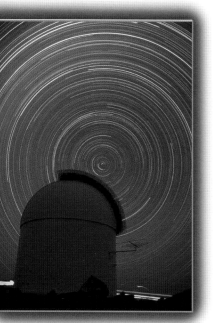

Star trails from the southern hemisphere, above, swing around the south celestial pole. There is no prominent star near the south celestial pole comparable to Polaris in the northern hemisphere, as seen in the photo at right.

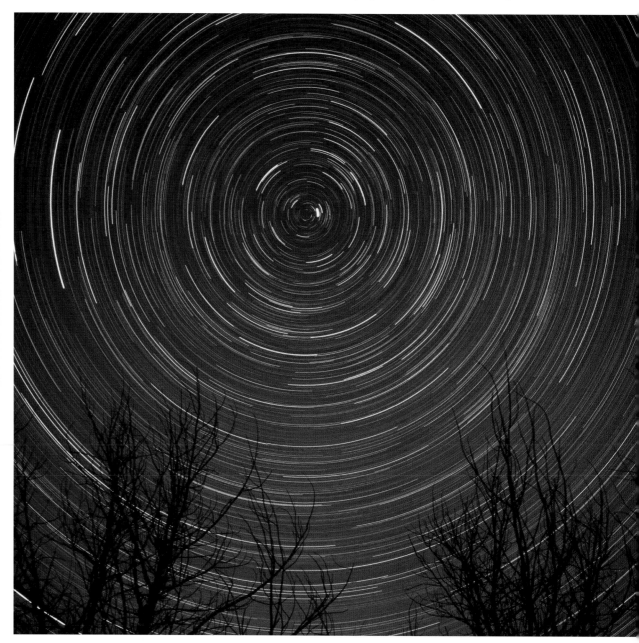

Star-trail photos on these two pages vary from a 6-hour exposure, facing page, left, to 20 minutes for the Canada-France-Hawaii Telescope shot at bottom right, and they produce noticeably different effects.

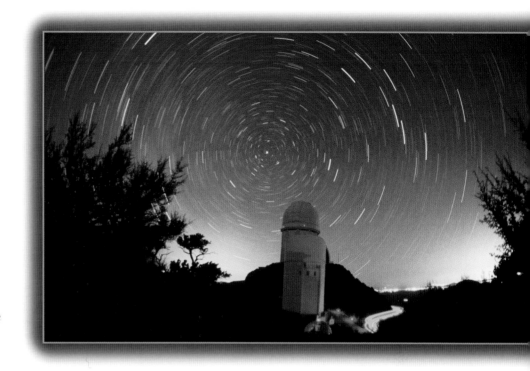

run for several hours, dew accumulating on the lens has spoiled more than one of my star-trail shots. My best results have come from shooting sessions at clear, dry locations at high-altitude observatories in Arizona and California. At Las Campanas in Chile, I got my one and only perfect 6-hour star-trail shot, unblemished by dew, lights, haze, clouds or my own blundering. It's the picture at far left on page 28. The same observatory is shown on page 24 in a much shorter moonlit exposure.

You can see the effects of city lights in the Kitt Peak Observatory star-trail shot at right. The tall dome houses a 158-inch telescope. To its left is the glow of Phoenix, 100 miles away, and to the right shine the lights of Tucson, a city about one-third as large 40 miles away. Actually, this is a very dark site, so you can appreciate how a more severe glow from urban lights can flood a star-trail exposure—or any astronomy shot, for that matter.

All-Night Star Trails

Film used for the star-trail pictures on these pages ranges from 50 to 800 speed—both slides and prints. I recommend 400-speed film for most situations, with a lens setting of f3.5 or f4 for exposures up to an hour, f4.5 or f5.6 for longer portraits. For marathon 3-to-6-hour shots, try f8 or use 200- or 100-speed film. After a test roll or two, you will establish your own preferences. These general guidelines bring me back to zoom lenses, which I singled out earlier as less versatile than fixed-focal-length lenses. Since most zooms have focal ratios of f3.5 to f4.5 "wide open," they are fine for star trails. Star-trail photography is

almost exclusively wide-angle territory. Zoom lenses that come as standard equipment on today's 35mm cameras have their widest setting at 35mm or 28mm, which is fine, although 24mm is even better, because its wider field allows more variety in composition.

My favorite lenses for star-trail work are 20mm and 24mm, both of which offer expansive panoramic compositions in horizontal format. My preferred films are Kodak Ektachrome P1600 (processed at 400) for slides and Fujicolor SG+ 400 for prints. But I've achieved excellent results with many other films. For this type of work, the differences between films, especially print films, are minimal.

So here are the priorities: Seek dark skies, avoid dewy nights (or employ lens heaters to eliminate dew), and include an interesting foreground. Set your tripod-mounted camera at infinity, with the shutter setting on "B," set the f-stop, open the shutter, and let the Earth's rotation do the rest.

Photo data: Images on these two pages are by Alan Dyer (facing page, right; this page, bottom left) and Terence Dickinson (all others). Dyer's photos were shot on Kodak Ektachrome 400 at f4; Dickinson used a 15mm lens at f2.8 on Fujicolor 800, above, and Kodak Ektapress Multispeed PJM 640 with a 20mm lens at f3.5, bottom right. The 6-hour shot, facing page, left, was taken with a 28mm lens at f2.8 on Fujichrome 50.

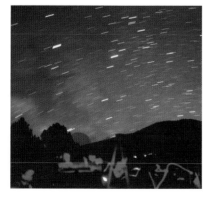

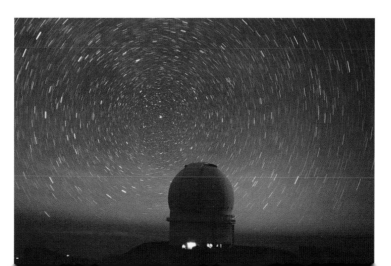

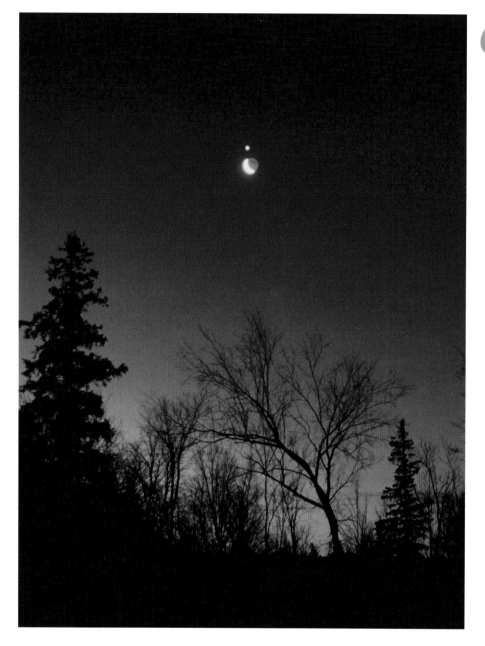

CONJUNCTIONS

Picture people strolling down an urban street on a perfect summer evening. The sky is clear, the temperature accommodating, encouraging people to take a leisurely walk. Now picture them stopped in their tracks, looking through the trees at two brilliant objects, side by side. It's a head-turner, in the same category as a brilliant aurora, a fireball meteor or the ghostly tail of a bright comet. But this phenomenon is a conjunction, the apparent close approach of either two bright planets or the Moon and a bright planet such as Venus or Jupiter. It may not sound like something that would attract attention, but when it happens (generally once or twice a year), heads do, indeed, turn. One example occurred on a public pier in Vancouver, British Columbia, in mid-June 1991. More than 50 evening strollers were seen pointing at and discussing the impressive conjunction of three planets —Venus, Jupiter and Mars. Seldom are such bright objects seen so close together, and this group of observers sensed the unusual nature of the scene.

Most people take these chance alignments at face value—they are drawn to nature's visual display. But there is an undercurrent here too. For millennia, astrologers and other prognosticators have viewed such planetary groupings as signs of some significance to human affairs. There was a time when this approach made some sense. Thousands of years ago, nobody had any idea why the planets move among the stars. When two or more of these magic "stars" came together, it was not unreasonable to conclude that it was an omen. Today, we know that planetary motion is operating under the clockwork of gravity. Just as the hands of a clock come together, so do the planets.

For astronomy aficionados, conjunctions draw attention purely for the beauty of the celestial scenery—

An astronomical attention-grabber. The night sky's two brightest objects had a close encounter on the morning of January 27, 1995. The camera's exposure meter was manually overridden to underexpose the reading by one stop on Ektachrome Lumiere 100X.

and because such groupings offer prime photographic opportunities. Of special interest are close conjunctions of the crescent Moon and Venus, the two brightest objects in the night sky.

Because most conjunction pictures are taken in

Kodak Ektachrome Elite II 100 slide film, produce stunning results. In the print-film category, just pick any of your favorite daytime films. Basically, what you have in the camera to photograph kids and pets is perfectly suitable for twilight conjunction portraits.

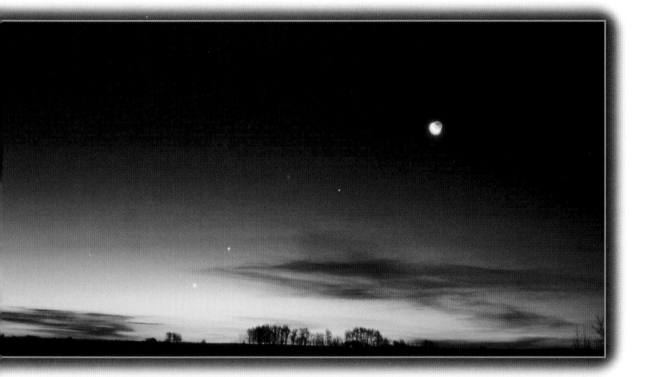

Twilight panoramas gain a magical boost when several prominent celestial objects vie for attention. Photo at left by Alan Dyer; all others on these two pages by Terence Dickinson.

twilight and rarely exceed a 30-second exposure, they are perfect candidates for fully automated cameras. The metering system on modern cameras can read twilight and set the exposure, a luxury that is not available in most celestial-photography situations. Indeed, the guidelines for conjunction photography apply to any photography in deep twilight, whether it's planets, the Moon or silhouettes of observers and telescopes, all of which are worthy subjects.

The high-speed films—400 speed or higher—used for most astrophotography are not necessary here. Slower films with rich color and fine grain, such as

All the pictures on this and the facing page were taken with lenses between 50mm and 24mm focal length. Fixed-focal-length lenses were recommended earlier, but general-purpose zoom lenses will also do an acceptable job. Set fixed-focal-length lenses at f2.8. For zoom lenses, use the wide-open setting obtained by dialing in the lowest f-number. When you have framed the scene, simply let your meter do the shooting. But here's an important tip: Because the lighting at twilight is tricky, the "weighting" that your meter gives to the scene is often a bit overexposed, producing a scene brighter than you remember. This is no

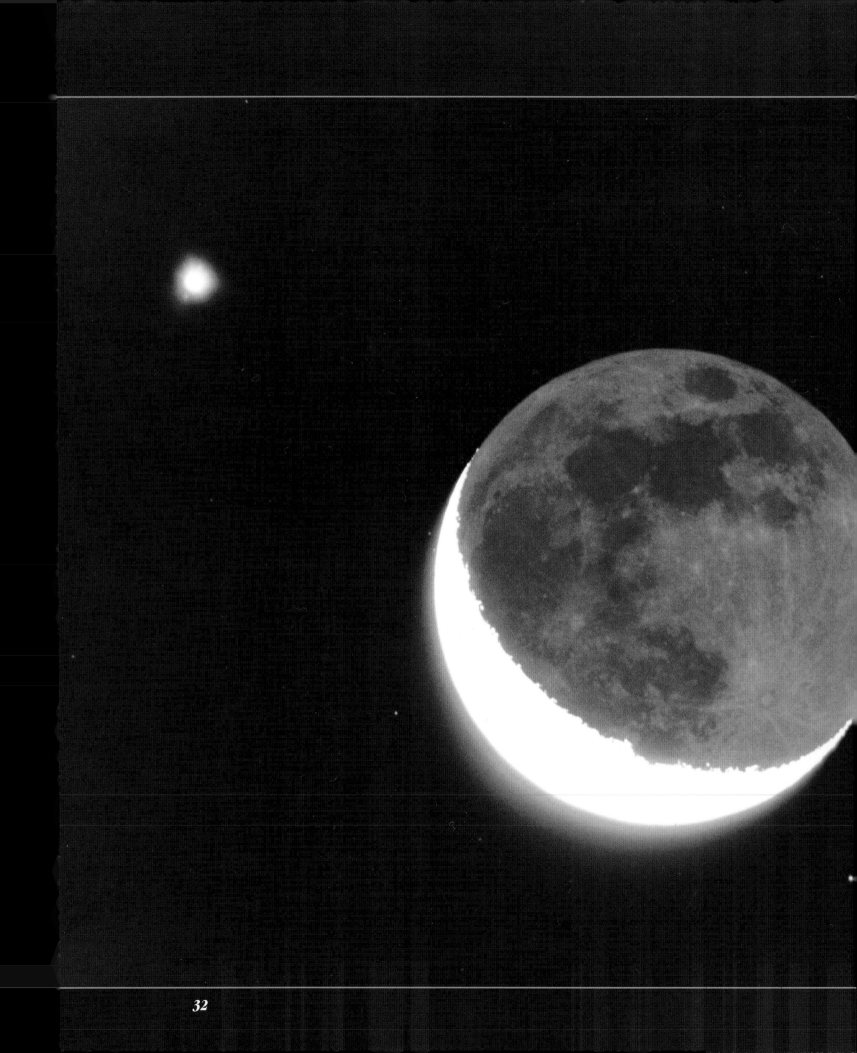

problem for print film, which can be adjusted at the printing stage. But if you are shooting slides, you'll want to bracket the exposure. My recommendation is to bracket only in underexposure.

Here's an example: Let's suppose your meter is telling you that for an f3.5 setting, it wants to expose for 2 seconds. Go ahead and take that shot, then manually override the setting to underexpose frames at 1.5 seconds and 1 second (75 percent and 50 percent of the metered exposure). As twilight deepens and the metered exposure time increases, keep repeating the same procedure by dropping back manually to take 75 percent and 50 percent of the metered exposure. If your camera has one-third stop overrides to underexpose, use those for more bracketing possibilities.

Some high-end modern cameras have a bracketing feature that allows three pictures to be automatically taken in succession with varying predetermined overexposures or underexposures. If this setting can be preset on your camera to expose at meter settings of, say, one-third and two-thirds stops under, go ahead and use it. What you'll find when your film is returned is that the underexposed shots will give a somewhat darker and richer color balance than the meter-exposed picture. In twilight, most meters tend to make the scene too bright, because it's a lighting situation that the meters weren't intended to measure.

For each of the shots on pages 30 and 31, which were all taken on slide film, I typically used half of a 36-exposure roll to get the "perfect" image. Twilight conditions are optimum for just 10 minutes or so, and it's impossible to know which 10 minutes that is until after it happens, hence the use of one to two dozen frames on a scene. Also, especially when it comes to close Moon-Venus and bright planetary conjunctions, you're probably only going to get one opportunity a year, on average, with good weather conditions. Half a roll of film is a small investment to make to capture a memorable image of the event.

Note also the foreground compositions. For the largest image on page 31, Alan Dyer, photographing from rural Alberta, could have chosen a perfectly flat, unobstructed vista, but the central clumping of a few trees and the fortuitous appearance of a couple of clouds give this shot just the right expansive treatment. The key is to have something of interest in the foreground but not too much. The larger shot on page 30 has a lot of trees in it, but the curving, leafless deciduous tree dominates.

It's a useful exercise to check out possible horizons, particularly toward the sunset point, and have

The night sky's two brightest objects, the Moon and Venus, were in close proximity on January 27, 1995. For this image, Terence Dickinson used Kodak Gold 400 and a 25-second exposure with the 6-inch f/7 refractor telescope pictured on page 143. A wide-angle view of this scene is at upper left on page 30.

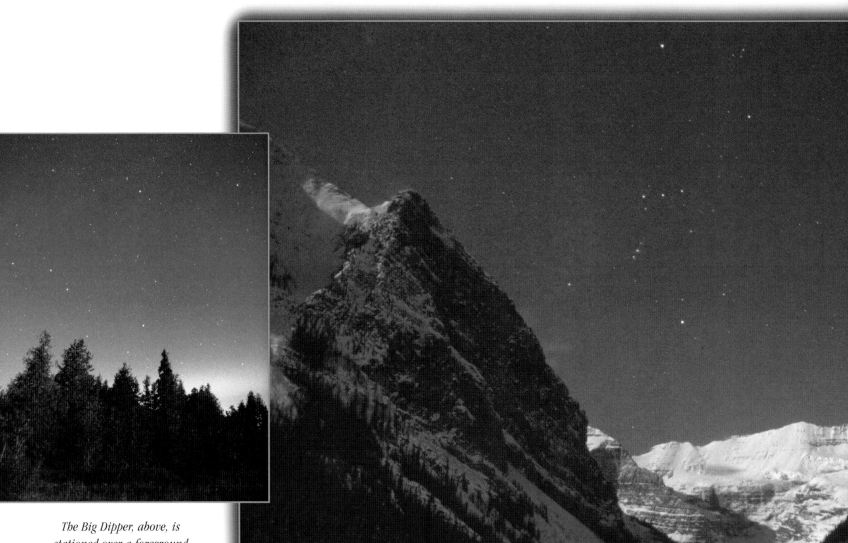

The Big Dipper, above, is stationed over a foreground illuminated by a gibbous Moon. The 25-second exposure on Ektachrome 400 was taken with a 24mm f2 lens. All photos on these two pages by Terence Dickinson, except Rocky Mountain scene by Alan Dyer.

them in mind well in advance of a conjunction. The same goes for morning scenes. Because of the symmetrical clockwork of the heavens, half of the good conjunctions will occur in the morning sky.

See page 142 for future conjunctions of interest to observers and photographers in North America.

CONSTELLATIONS

Once people get to know that you are interested in astronomy, you may be invited to present a talk on stargazing to your local school or church group, service club or scout troop. Preparing for such a talk is a way to improve your own knowledge of astronomy —you suddenly feel obliged to bone up on the topic.

Then you begin hunting for audiovisual props so that you're not just *talking* about such a visually compelling subject.

One of the best ways to augment any astronomy talk is to have your own slides of the night sky show-

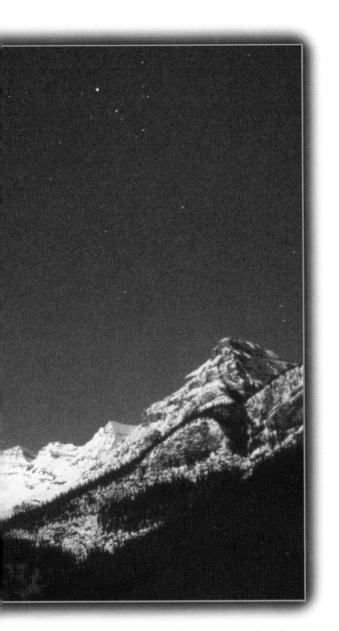

A tripod-mounted camera with a 24mm or 28mm lens and fast film has almost unlimited possibilities for recording 30-second exposures of constellation "skyscapes." At left is Orion, the celestial hunter; below, telescopes silhouette the summer Milky Way.

sation piece. Constellation shots are the perfect solution because they provide opportunities to talk about recognizing star patterns and about the rich mythology connected with them. Constellation shots can also be taken on print film, but the utility of having the images on slides so that they have instructional and conversational value really makes slides a heavy favorite.

The preferred lenses for constellation shots are 28mm and 24mm. Their wider fields allow framing of more than one constellation at a time. It's also easier to fit a tree, horizon or house in the shot. Zoom lenses, with their short-focal-length end at either 28mm or 24mm, can be tried, although my results with them have been mediocre in this application.

High-speed film in the 800-to-1600 range is a must. For prints, use Fujicolor 800, Kodak Royal Gold 1000 or, probably the best choice, Kodak Pro 1000 PMZ. My favorite in the slide-film category is Kodak Ektachrome P1600, which is a 400-speed film designed for push-processing. Push-processing means that the developer leaves the film in the developing tank for a longer period to increase the speed of the film by one or two f-stops. When you take the film in for developing, you can request push-processing by stating what you want the end result to be. That is, in the case of 400-speed film, request a one-stop push or a two-stop push, so the film will be processed as if it were rated at 800 or 1600 speed, respectively. Any slide film can be push-processed in this fashion, but P1600 is preferred because it is manufactured expressly to be

ing the constellations. The pictures can be taken to reproduce the naked-eye appearance of the night sky as closely as possible—and you can include some familiar landmarks in the scenes. Furthermore, the fact that *you* have taken the pictures makes them a conver-

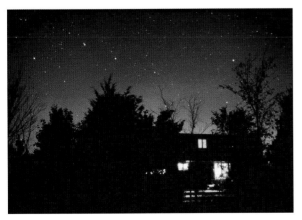

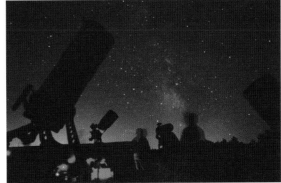

35

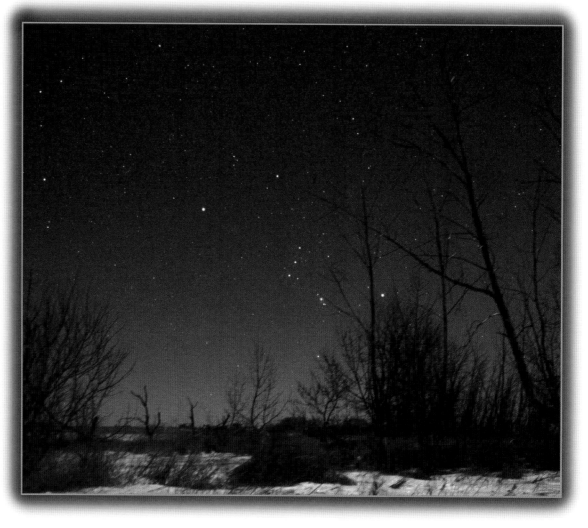

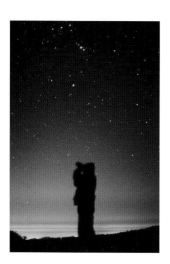

Light pollution from San Diego, California, 40 miles distant, frames a lone binocular observer, above, in this 50mm 15-second shot at f2. Under darker-sky conditions, bottom, another stargazer examines the Milky Way where Jupiter and the constellation Sagittarius are seen. The observer in this case was "painted" with a dim, red flashlight. Both photos by Terence Dickinson.

pushed, and it tends to have excellent color balance.

The trick in constellation photography is to make the exposure long enough so that stars are recorded roughly to the naked-eye limit. Yet if the exposure is too long, the stars will be trailed by the Earth's rotation. The optimum balance between these two competing factors is around 25 seconds for a 24mm lens and 20 seconds for a 28mm lens. But as in most astrophotography endeavors, bracketing your exposures is the preferred technique, allowing

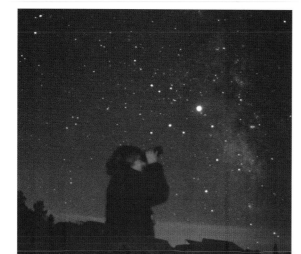

you to select the picture you find most appealing.

There is also a bit of leeway in the time limitation to prevent trailing. In the area of the Big Dipper or closer to the north celestial pole, the stars move at a slower apparent speed than those in the equatorial region of the sky, so when shooting in this region, increase the exposure to 30 seconds for a 24mm lens and 25 seconds for a 28mm lens. But in all cases, a plus or minus 5-second bracketing will ensure that you get the best possible shot.

Once again, any 35mm SLR camera is suited to constellation photography. You may not even need a cable release if the shutter-speed setting has increments extending up to 30 seconds. The camera can then be set to shoot an exposure of a predetermined length, perhaps 20 or 30 seconds, and you can make use of the exposure timed-delay setting (the setting used to allow you to take self-portraits by tripping the shutter, then standing in front of the camera). This setting permits you to keep your hands off the camera during the actual exposure, eliminating accidental vibrations that might blur the stars.

The favorite constellation subjects for photography in the northern hemisphere are Orion and the Big Dipper, the two most distinctive stellar configurations in the sky. (Not a true constellation, the Big Dipper is part of Ursa Major.) All other constellations are a distant second to these two. Other groups of interest are Bootes, Virgo, Leo, Lyra, Cygnus, Sagittarius, Pegasus, Andromeda, Cassiopeia, Taurus, Gemini and Canis Major. Filling out your constellation gallery will mean a shooting session every couple of months over an entire year. As Earth cruises in its orbit around the Sun, the nighttime side of our planet swings through the starry vault, with each season having its flagship constellations. A few constellations are visible through two or three seasons, and a select group—the circumpolar constellations—are on display year-round.

Moonlit Star Show

Both constellation portraits and star trails take on a new dimension in moonlight. You'll capture fewer stars but more landscape. Indeed, a moonlit starry scene can be a striking nightscape, a unique and seemingly contradictory combination of a "daylit" night. That's because the landscape is, in fact, being illuminated by sunlight—sunlight reflected off the Moon. The sky is deep blue and dotted with stars or streaked with the trails of slowly moving stars.

As a glance through binoculars or a telescope will show, the Moon is gray rock. It shines only by reflected sunlight, so moonlight is simply sunlight bouncing off the Moon. Moonlight has the same color balance as light coming directly from the Sun. It's just much fainter (by a factor of about half a million).

Because the viewer's attention is drawn to the foreground as well as the stars, composition is even more important in moonlit scenes than it is in regular constellation shots. Wide-angle lenses, such as 28mm or 24mm, are the favorites. Include a lot of sky, with the foreground scene in the bottom third or so. Set the camera lens to f2 or f2.8, use 400-speed or faster film, and open the shutter for 15 to 30 seconds, the same as for normal constellation shots. (The readily available Kodak Royal Gold 1000 works very well for this type of shot.) Don't rely on the camera's light meter. It likely won't register or will expose incorrectly in the dim light.

The Moon varies significantly in brightness as it advances through its phases. The quarter Moon is roughly one-fifth as bright as the full Moon, a difference of about 2½ f-stops. This offers lots of opportunity for experimentation. Framing tip: Always have

The prominent winter constellations Orion and Canis Major stand above a tranquil country scene in this shot illuminated by the gibbous Moon. Terence Dickinson used a 28mm lens at f2.8 for the 25-second exposure on 1000-speed film. A similar 28mm moonlit portrait of Orion by Alan Dyer, facing page, top, makes good compositional use of stark, leafless trees.

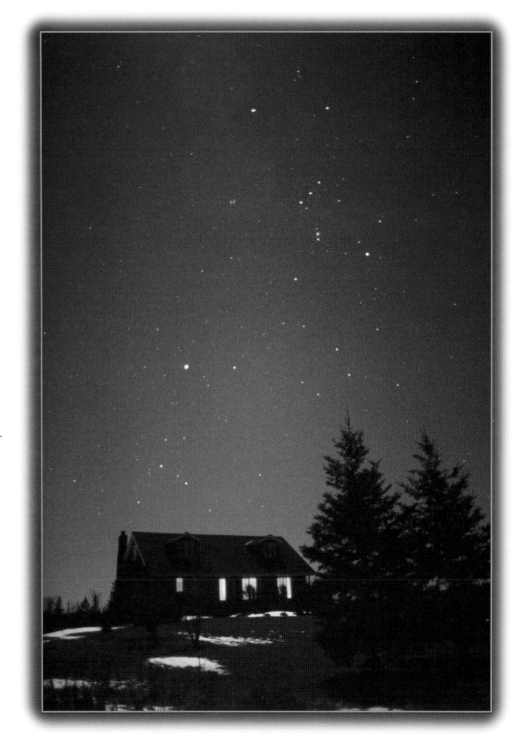

Astrophotographer Alan Dyer planned to be at the right place at the right time to frame the Big Dipper and an eruption of Old Faithful, in Yellowstone National Park in Wyoming. He used a 28mm lens at f2.8 for this 30-second camera-on-tripod shot on Kodak Ektachrome 400.

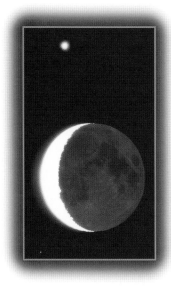

Telescopic views of Earthshine on the waning crescent Moon, above, and the waxing crescent Moon, right, give close-ups of the phenomenon. A 400mm telephoto shot reveals Earthshine and Venus, bottom left. The same two objects were captured on 1600-speed film, bottom right, with an 80mm-to-210mm zoom lens at 210mm. All photos on these two pages by Terence Dickinson.

the Moon behind you or well out of the frame when composing the picture.

For star-trail moonlit photos, use any of the standard fine-grained 100-speed films. They produce very sharp results and can withstand tremendous enlargement for framing. For an exposure time of about one hour, set your lens at f4 for the first-quarter Moon, f5.6 for the gibbous phase and f8 for the full Moon. Bracketing exposure settings and times is a good idea. Even exposures of exactly the same duration will differ in appearance because the Moon changes position in the sky, affecting shadows and lighting.

Astrophotography is more an art than a science, with the photographer taking the creative lead. It's not easy, which is why a great shot *should* be a prized trophy. The photographer soon learns what works and what doesn't—what type of night is worth pursuing for that elusive shot and when it is better to quit and go to bed. With a few successes comes the planning for future shooting sessions, perhaps involving travel to photogenic locations. "Will the weather cooperate when I get there?" you wonder. Welcome to the challenge—and allure—of astrophotography.

CRESCENT MOON AND EARTHSHINE

The faint, ghostly illumination of the night side of the Moon, clearly seen in these photos, is a phenomenon known as Earthshine, sometimes called "the old Moon in the new Moon's arms." Earthshine is visible to the naked eye for a couple of days a month during the Moon's crescent phase, and it represents one of nature's most serene and beautiful celestial sights.

Earthshine is the illumination of the nighttime side

of the Moon by sunlight reflected off Earth, hence the appropriately descriptive name. Earth shining on the Moon is 50 times brighter than the Moon shining on Earth—plenty bright enough to light up the Moon's night side to the point where we can see it with the unaided eye from 385,000 kilometers away. Leonardo

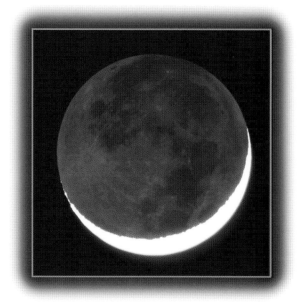

da Vinci was the first person (in print, anyway) to deduce that it is light from Earth that makes visible the part of the Moon not in sunlight. Binoculars are the best aid for spotting Earthshine, often giving better contrast than a telescope.

Earthshine is best seen at dusk three or four days after the new Moon in February, March, April and May when, because of seasonal changes in celestial geometry, the crescent stands highest and therefore in the clearest air. The favorable morning-sky visibility window is about one hour before sunrise, three or four days before the new Moon in August, September, October and November.

The twilight techniques for shooting Earthshine are the same as those for photographing conjunctions (see page 30). As with conjunction pictures, the most

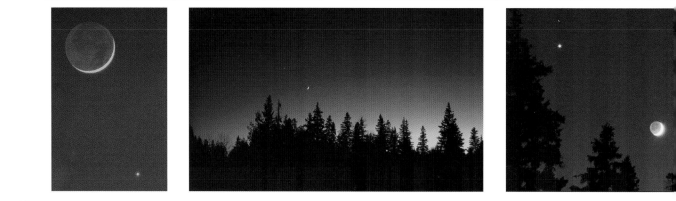

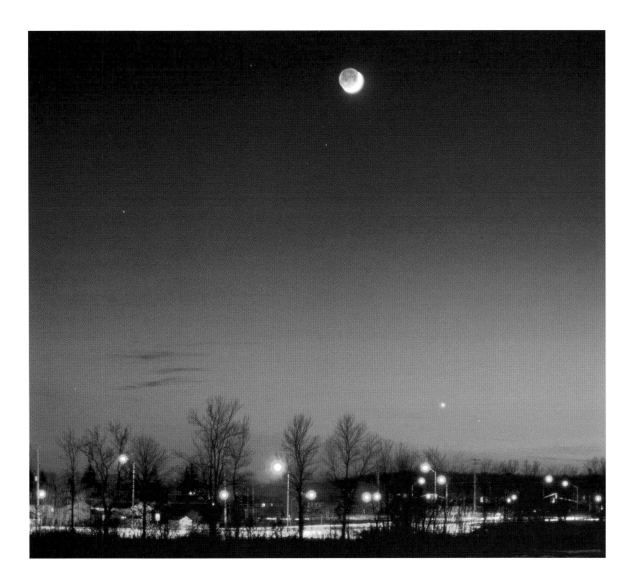

If captured at just the right twilight brightness, an urban foreground can enhance a celestial portrait. In addition to the Moon, this scene includes Jupiter and Mercury.

impressive results come from careful selection of foreground objects and generous bracketing of exposures. But Earthshine is much more common than a photogenic conjunction, so you may be tempted to experiment with different films, lenses and locations.

One possibility is the urban foreground, as shown in the 85mm shot on this page. "The Moon hanging over the city" effect can be even more dramatic with the inclusion of tall buildings, illuminated civic monuments, churches, and so on. But the trick is not to overwhelm the Moon and demote it from being the prime interest in the picture.

Another tempting option is to try some telephoto shots of the Earthlit crescent Moon. Three pitfalls await. One is the puny size of the Moon in a typical

telephoto shot unless the lens is *really* long (500mm or longer) or unless some scenic balance—trees, distant buildings—is retained. But if you try that, the second rude surprise emerges—the defocusing of the foreground scenic matter because of the telephoto lens's narrow depth of field. The longer the telephoto, the worse this effect becomes.

The third pitfall of telephoto shots of the Moon is smear from trailing, the same process that causes stars to trail. The smearing begins after only one second with a 500mm telephoto, three seconds with a 200mm and eight seconds with an 85mm. But to capture the optimum amount of Earthshine on film always requires an exposure of at least one or two seconds, usually more, so camera-on-tripod telephoto shots of Earthshine are tough. My recommendation is to stay with lenses 85mm or shorter and to frame the scene for maximum visual interest. The only practical way to graduate to telephoto Earthshine portraiture is with a tracking mount, as will be described in Part 2.

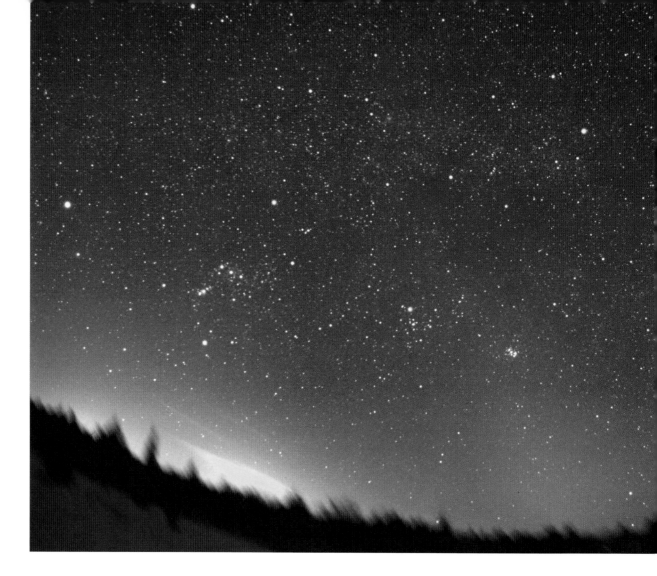

ZODIACAL LIGHT

The planets of our solar system orbit around the Sun on a flat plane, like balls rolling on the surface of a billiard table. When we look out from our observing platform—Earth—and gaze toward the other planets, we see them strung out along this horizontal plane, which astronomers call the ecliptic. The constellations of the zodiac are the background to that plane. As the planets move around the Sun, they pass in front of the zodiac constellations. Because the planets look like bright stars, they appear to be *in* the particular zodiac constellations.

Observations of the planets' repetitive motions through the zodiac constellations date back thousands of years. Records of the positions of Venus found on Sumerian clay tablets are more than 5,000 years old. What the Sumerians didn't know is that a lot of other rubble much smaller than the planets is distributed in this same plane, some of it in the form of dust-sized particles that become visible from reflected sunlight. Known as interplanetary dust, the particles form a delicate misty band, much fainter

The winter constellations, including (from left to right) Orion, Taurus, Auriga and Perseus, are augmented by Comet Hale-Bopp just below Cassiopeia in this 15mm f2.8 super-wide-angle view. The zodiacal light can be seen at bottom center of the picture, a vague wedge extending up and to the left. Photo by Terence Dickinson.

than the Milky Way, exactly in the ecliptic. The band is barely visible in the picture on page 4, running from lower right to upper left at about a 60-degree angle to the Milky Way.

Interplanetary dust is more concentrated closer to the Sun. Under dark-sky conditions, this more concentrated zone is seen by the unaided eye as a pale wedge in the west after sunset or in the east before sunrise. Easily masked by twilight glow, the zodiacal light, as this wedge is known, is best seen in the 15 minutes immediately after twilight has dimmed enough to allow its visibility.

The zodiacal light is a seasonal phenomenon best seen in the evening sky in late winter and early spring and, six months later, in the morning sky in late sum-

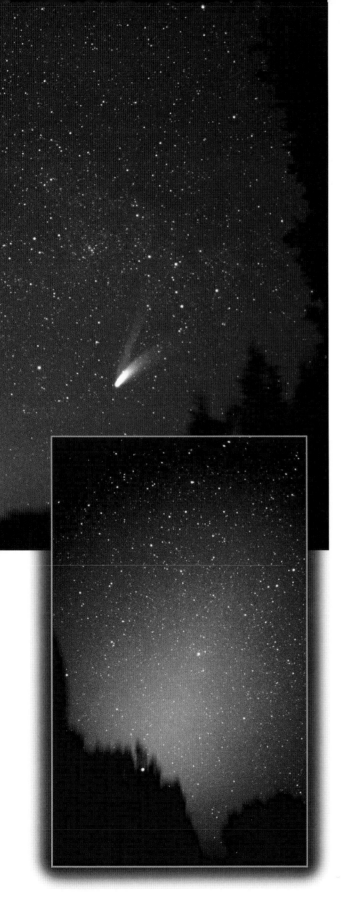

latitude-dependent, being more prominent within 40 degrees of the equator than it is farther north or south. However, the big factor is atmospheric clarity. Crisp, clear air is necessary for a good view.

Photographing zodiacal light usually requires a tracking mount, but if it is exceptionally bright, it can be caught with a simple camera-on-tripod setup using fast film in combination with a fast wide-angle lens, as was the case with the shot at right.

Slides Versus Prints

There was a time when the choice between slide film and print film was no contest (it was slides, hands down), but today, with outstanding films available in both formats, the choice depends on you. What do you ultimately want to do with the pictures? First, some fundamentals.

Slide film is positive-transparency emulsion. The picture in the slide mount is the actual film used in the camera, whereas with print film, the original film is negatives, which are used to make the prints. There are advantages and disadvantages to both methods. With slides, what you photograph is what you get. If the slide itself is underexposed or overexposed or color-shifted from the natural hues of the scene, the only way to manipulate the image is through slide duplications or to have the slide scanned, usually to Photo-CD, where it can then be manipulated on a computer using software such as Adobe Photoshop.

On the other hand, the process of printing a photo from a negative has color correction inherently built into it. When you take your snapshots to the local one-hour photo store, appropriate filtration in the machine used to make the prints ensures that faces in the photos are pretty close to natural coloration. Using this same technique, astrophotos can usually be brought close to desirable color balance as well as density (not too bright, not too dark) in the process of making the print. This is a more direct method of ending up with what you want compared with what has to happen to a slide. But the problem is that the negatives are in the hands of an operator at an automated print machine, someone who has probably never paid any attention to astronomical photographs.

Your local one-hour photo dealer should be quite receptive to helping you get what you want. As a general rule, I've found that most print films tend toward a slight yellowish green tint when printed without any correction. At the outset, you might suggest that the

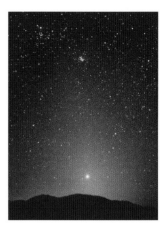

An exceptionally bright display of zodiacal light stands almost vertical in this March 1991 scene from California's Mojave Desert. The bright object seemingly in the center of the zodiacal wedge is the planet Venus. Terence Dickinson used a 28mm f2 lens for the 30-second shot on Scotchchrome 400 pushed to 1600. Left, zodiacal light by Jack Newton.

mer and early autumn. This is also true for the corresponding seasons in the southern hemisphere. The seasonal favorability is caused by the tilt of the Earth's axis, which angles the ecliptic to its highest elevation relative to the horizon. The phenomenon is also

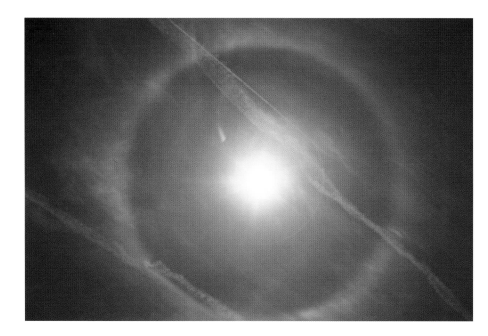

HALOS AND SUNDOGS

"Ring around the Moon, rain will come soon."

Snippets of weather lore such as this are usually only partly right, and this one is no exception. Lunar halos often precede rain or snow by a day or two, but I'd put my money on the official weather forecast.

One thing those old rhymes do tell us, though, is that several generations ago, people were very aware of changes in the sky. When is the last time *you* saw a halo ringing the Sun or the Moon? Have you ever seen one? These halos are actually quite common. Probably a dozen lunar halos and several dozen solar

operator set "yellow minus two" for many films, including the ones repeatedly recommended in this book. Such a correction will give the night sky a much more natural deep blue-gray hue. Or you can leave the corrections up to the operator by showing examples of what you want. Establishing a good rapport with your local one-hour photo dealer often returns dividends —the operator will work to get the most out of your prints. For slides, be sure to shoot a couple of daylight frames at the beginning of the roll so that the operator can frame them for mounting.

A thin veil of high-altitude cirrus or cirrostratus clouds can provide the perfect conditions for solar halos and sundogs. Sometimes brilliant enough to rival the Sun's brightness, sundogs are seen only near the horizon, right and far right. Lingering jet contrails are the streaks through the solar halo above. Photos by Jack Newton, right, and Terence Dickinson, above and far right.

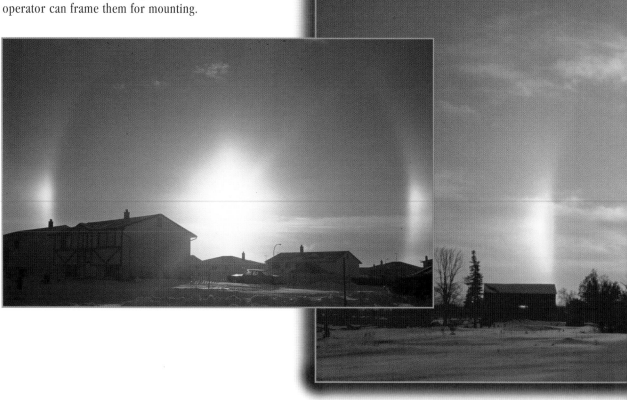

halos are visible each year from any one location.

One reason halos around the Sun frequently go unnoticed is that the sky is often extra bright when a halo is present. The brightness is due to white cirrostratus clouds, which give rise to the halo phenomenon. Cirrostratus clouds are thin, milky sheets that veil the sky but allow the Sun to shine through. They are made of tiny prismatic ice crystals that tend to refract, or bend, sunlight at one specific angle, 22 degrees, which creates a halo 44 degrees in diameter. That's about half the angular distance from the horizon to overhead, and it means that only a wide-angle lens will capture the whole thing. A 28mm

The solar-halo photo at right shows heightened intensity at the sundog position, indicating conditions suitable for both phenomena. Photo by Alan Dyer.

lens will just do it, but a 24mm or 20mm is ideal.

Solar-halo photography is not difficult, but it is tricky for several reasons, not the least of which is having to point your camera directly at the Sun. Fortunately, wide-angle lenses, like the 24mm and the

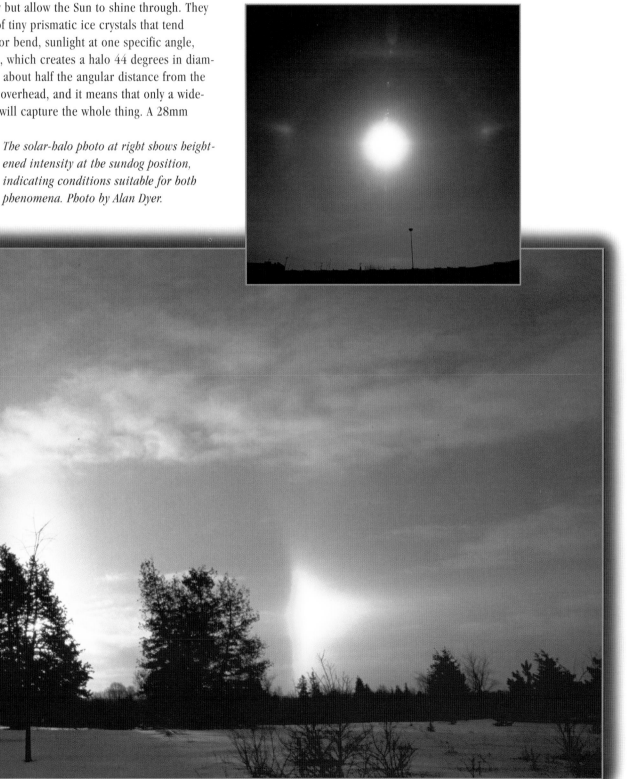

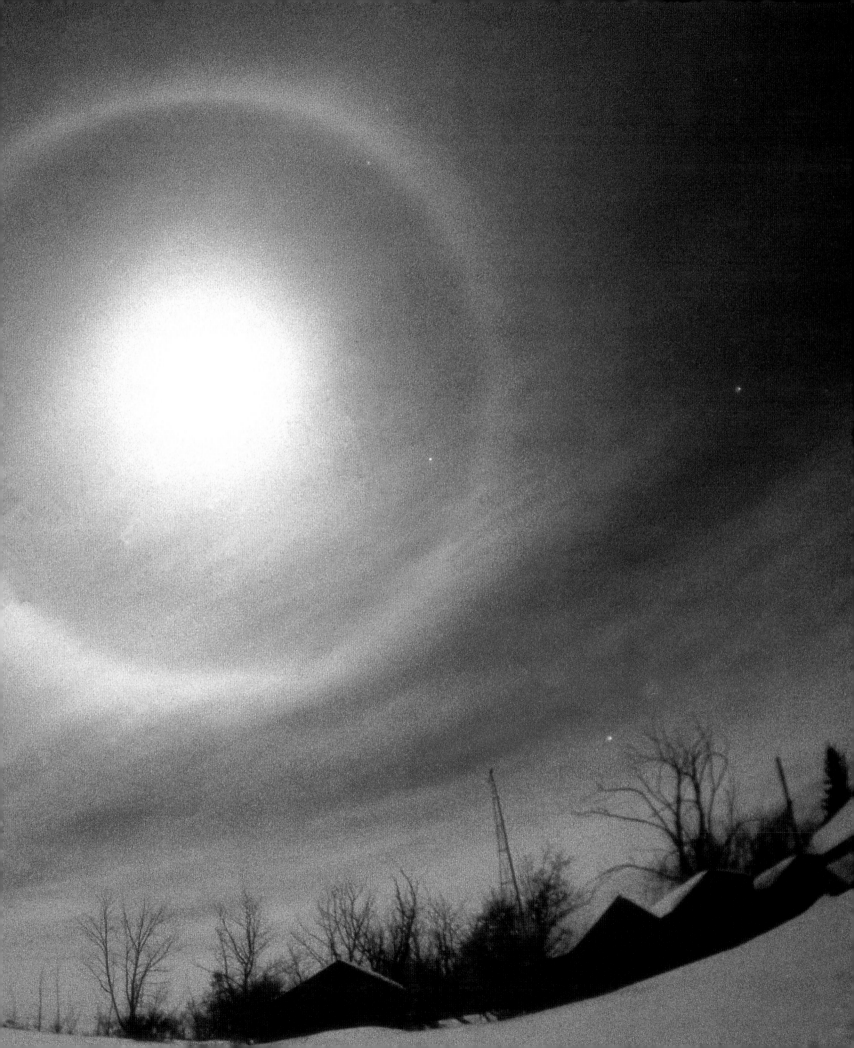

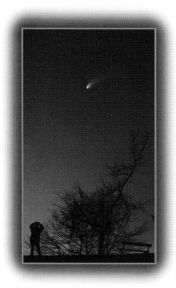

20mm, shrink the Sun to a tiny enough dot that it can be tolerated for the few seconds it takes to frame the picture in the viewfinder and press the shutter button. An alternative that is easier on the eyes is to position yourself to place the top of a pole or similar obstruction in front of the Sun.

Camera meters usually underexpose this type of shot. It is wise to bracket heavily, especially to overexpose the meter reading by one or two f-stops. And most important: Remove the UV filter that most camera owners use to protect the lens. Otherwise, a reflected image of a false sun will ruin the shot. (You should try to remember to do this for Earthshine shots, too, to prevent a distracting "ghost" Moon.)

Solar halos are most often seen in cooler weather, when conditions are ideal for the formation of cirrostratus clouds. Since halos are big, the best way to observe them is to stand just within the shadow of a tree or building to block direct sunlight and reveal half or more of the halo.

The same-sized halo caused by the same cirrostratus cloud formations can be seen around the Moon. Lunar halos are more conspicuous than solar halos because, with no danger of zapping the eyes, the Moon halo tends to be noticed.

A related sky phenomenon, the sundog, is a brilliant glow seen 22 degrees to the right or left of the Sun and only when the Sun is fairly low in the sky. Cirrus or cirrostratus clouds must be present too, because those clouds are made of the right kind of ice crystals—six-sided ones shaped like short pencils. The little ice pencils can float straight up and down in the air. When they do, they refract sunlight just the right way to create a sundog.

If the sundog is especially bright, it will be obviously colored, red on the side closest to the Sun, blue on the far edge and yellow in the middle. Although usually brighter in winter, sundogs are visible all year if you look for them. That's the secret—deliberately watching for nature's displays.

Framing people in the scene can turn a good astronomical shot into a great one. There's the silhouette technique, above and facing page, and the painting technique, used for the shot at right. Painting is done during the exposure by waving a dim, diffuse red flashlight over the desired area. Keep the flashlight itself out of the frame, and don't overdo it. It's easy to blast the foreground and wreck the shot. This 30-second exposure by Terence Dickinson was taken at f2 on Kodak Pro 1000 PMZ. Photo above by Randy Klassen. Silhouette photo on facing page by Terence Dickinson using Kodak Ektapress Multispeed PJM 640. All photos on these two pages are camera-on-tripod shots.

For the clever "multiple comet" shot at right, Andreas Gada removed the lens cover for five 30-second exposures, each spaced by five minutes with the lens cover on. For a picture like this to be a success, extra care is needed to ensure that the tripod is not jarred (a black cloth makes a good lens cover). Moonlit abandoned house with Comet Hale-Bopp, facing page, top, by Glenn LeDrew.

COMETS

In March and April 1997, Comet Hale-Bopp became the brightest and the most easily observed comet visible in the evening sky from the northern hemisphere since the historic visit of Halley's Comet in 1910. Billions of people likely saw Comet Hale-Bopp, and millions of them took pictures of it (or tried to). By any measure, early spring 1997 was the most intense period of astrophotography in history.

And Hale-Bopp did not disappoint. Far more detail

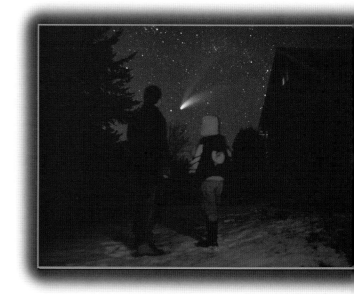

was recorded in the average 20-second camera-on-tripod exposure with a 50mm f2 lens than was seen visually by the photographer. And people were right to want a souvenir. Nothing like Hale-Bopp had been seen before from the United States and Canada, at least by anyone alive today.

Comet Hyakutake of 1996 had a longer tail but was more delicate overall and was easily washed out by interference from streetlights or the Moon. Twenty

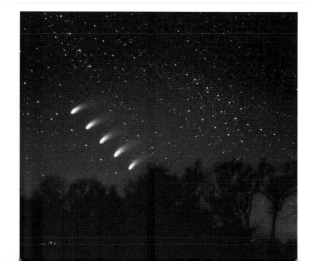

years earlier, Comet West was brighter than either Hyakutake or Hale-Bopp, but only for a couple of days and then only at 5 a.m. According to some comet observers, Comet Bennett of 1970 had the most beautiful tail, but in terms of easy visibility, Hale-Bopp was the people's comet—one that everybody could see, night after night, by simply stepping outside and looking in the right direction. Comet Hale-Bopp could well prove to be the best comet most people alive today will ever see.

Comets are essentially flying mountains of ice left over from the formation of Jupiter and the other giant planets in the outer solar system. Billions of comets swarm in a celestial deep-freeze beyond the orbit of Pluto, the most distant planet. Occasionally, a comet is gravitationally perturbed from its frigid lair and hurtles into the inner solar system where Earth orbits the Sun.

When it nears the Sun, the cometary ice begins to be vaporized by sunlight, creating a huge cloud of gas and dust. The pressure of sunlight and the solar wind (electrically charged particles emerging from the Sun) then push the cloud into the classic comet tail. The tail can be 50 million kilometers long—more than 100 times the distance from Earth to the Moon.

The swept-back tails of comets make them look as if they are moving coma first, tail last. But the comet's motion has little to do with the tail's stream-lined looks. Comets point at the Sun. They come in headfirst and go out tailfirst.

Comet Hale-Bopp displayed both a gas tail (blue) and a dust tail (white) emerging from its nucleus, a 35-kilometer-wide chunk of primordial ices. Those ices included frozen water, carbon dioxide, carbon monoxide and a host of other simple compounds that accumulated during the formation of the outer solar system 4.5 billion years ago. Embedded within the ice are dust particles about the size of typical windowsill dust. As sunlight vaporized the outer surface of Hale-Bopp's nucleus, the dust was released along with the

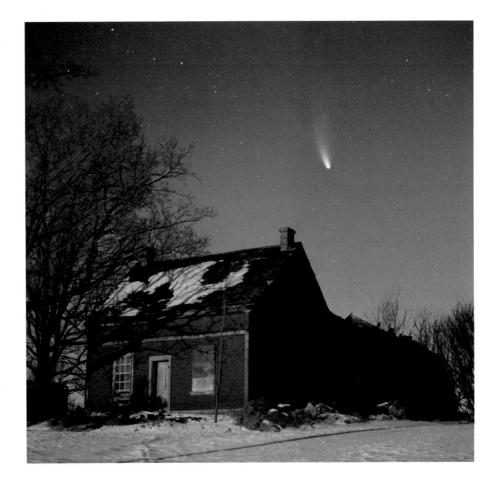

gas. Just as dust floating in a darkened room is easy to see in a shaft of sunlight, the dust in Hale-Bopp's tail was an equally effective reflector of sunlight.

Yet for something so big, the comet's tail contained surprisingly little material—about the equivalent amount of gas and dust as would be released by the vaporization of less than half an inch of snow covering the state of Delaware. In total, less than one-hundredth of 1 percent of the mass of Hale-Bopp's nucleus was vaporized on its recent trip through the inner solar system, and the comet is potentially good for many more loops around the Sun.

Comets are celestial vagabonds, so the appearance

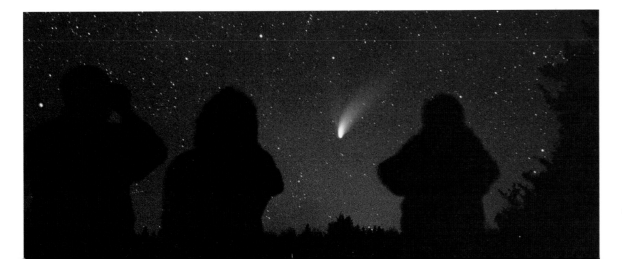

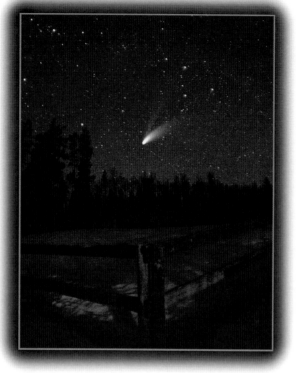

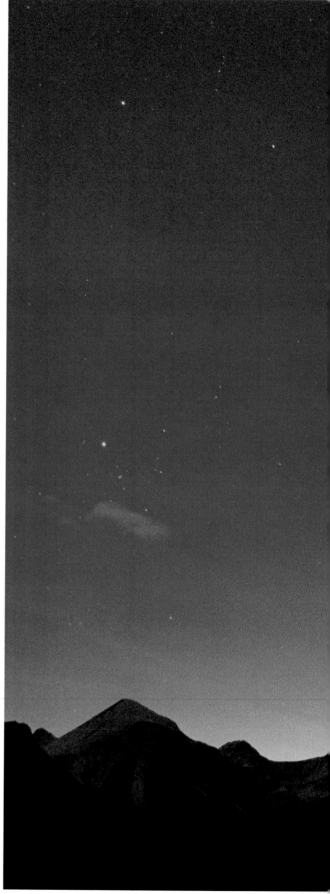

of a new comet is completely unpredictable. Most comets never become bright enough to reach naked-eye visibility. We know about their existence only when they come close enough to the Sun to begin to be vaporized. But there must be billions of comets out there too remote to see—there have to be in order to account for the number we *do* see each year. Comet Hale-Bopp won't be back for 2,380 years, but a comet just like it could come booming in from deep in the outer solar system at any time.

Comets and Meteors

For many people, the word comet conjures up a flaming object streaking across the sky. But comets don't streak. They hang around for days, weeks or even months, only gradually changing position in the sky from night to night—a fact that is not obvious from a single comet photo.

The objects that are often confused with comets are bright meteors, known as fireballs, or bolides, which light up the night sky as they zip across the heavens in a few seconds. They really do flame and streak—they're chunks of rock from deep space burning up as they plunge into the Earth's atmosphere.

The photo on page 3 shows the trail of a meteor as bright as Jupiter. Bagging a meteor photographically is the astronomical counterpart of fishing. You open the shutter of a tripod-mounted camera with a 50mm-to-24mm lens at f2.8 with 400-to-1,000-

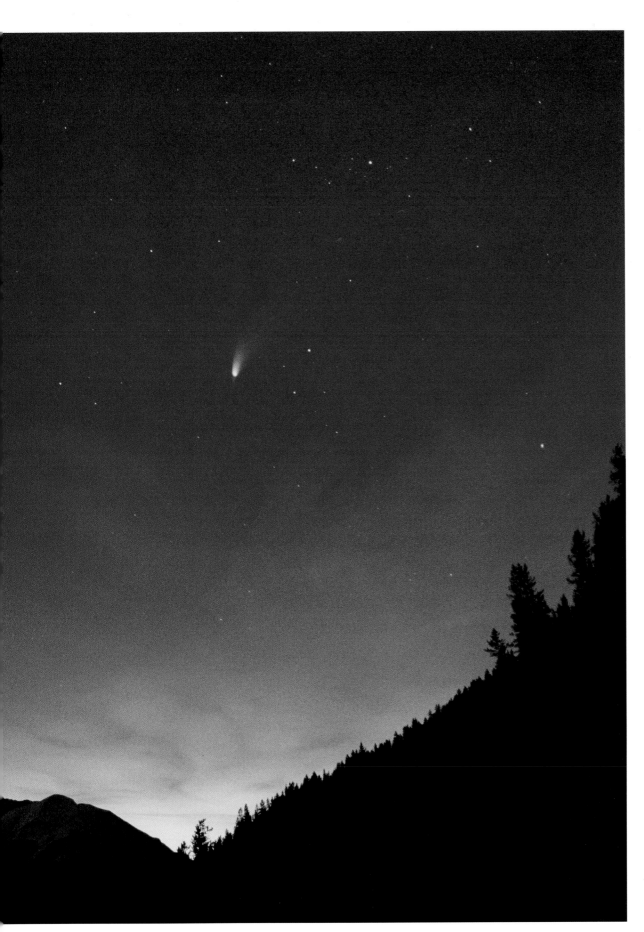

Three completely different compositions centered on the same object—Comet Hale-Bopp—demonstrate the creative possibilities of the camera-on-tripod technique. Below, Brian Schneider used a 17mm f3.5 super-wide-angle lens and lights from surrounding buildings to illuminate the foreground in this 60-second shot with 200-speed film. At left, Alan Dyer used Kodak Ektachrome 400 and a 28mm f2.8 lens for a 30-second celestial portrait deep in the Canadian Rocky Mountains. For the photo at far left, Jim Fink selected a rural setting in British Columbia and got some help from the crescent Moon to illuminate the foreground of the Fujicolor 800 shot.

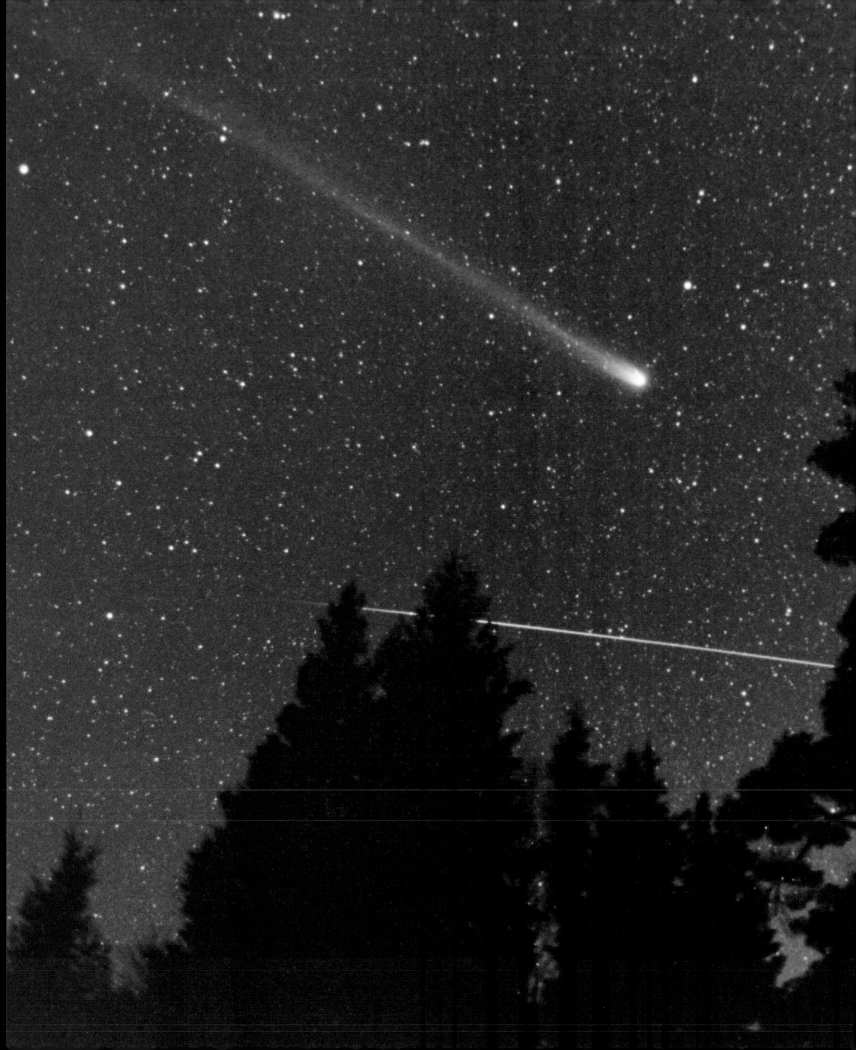

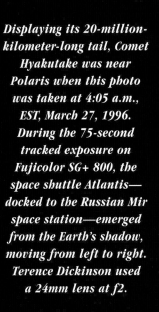

Displaying its 20-million-kilometer-long tail, Comet Hyakutake was near Polaris when this photo was taken at 4:05 a.m., EST, March 27, 1996. During the 75-second tracked exposure on Fujicolor SG+ 800, the space shuttle Atlantis—docked to the Russian Mir space station—emerged from the Earth's shadow, moving from left to right. Terence Dickinson used a 24mm lens at f2.

speed film, expose for 5 to 10 minutes of star trails and hope for the best. The best nights of the year to do this are August 11 and December 13, the nights of the Perseid and Geminid meteor showers, respectively. Only meteors as bright as the brightest stars will register on film.

Meteor showers like the Perseids are intimately related to comets. As comets loop around their orbits, their cast-off dust forms a diffuse stream along the orbital path. When Earth passes through one of these streams, a meteor shower is seen as the bits of comet debris collide with the Earth's atmosphere.

ECLIPSES

There are two very different types of eclipses, lunar and solar, and two types of each, partial and total. By far, the most spectacular is a total eclipse of the Sun, which occurs when the Sun is completely covered by the Moon. Think of it this way: To see a total solar eclipse, you must stand in the Moon's shadow. Although the Moon is one-quarter the diameter of Earth, its shadow is much smaller, only about 60 miles wide where it strikes our planet. As the Moon moves in its orbit during a total solar eclipse,

its shadow sweeps across the daytime side of Earth at about 1,000 miles per hour. Astronomers call this track the path of totality.

Amateur astronomers, naturalists and eclipse buffs will travel to the far reaches of the globe to stand in the path of totality to see a total solar eclipse, even though the phenomenon typically lasts less than four minutes. They say that one exposure to the splendor of totality is addictive. We agree. The quick plunge into darkness at midday as the Moon's shadow sweeps over, the sudden appearance of bright stars and planets, plus the Sun's delicate pearly corona and brilliant red prominences visible without eye protection all add up to an unforgettable experience.

For your first total solar eclipse, veteran eclipse watchers recommend that you simply stand and gape. The power of the event is overwhelming. Any serious photography should probably wait until after you have absorbed the full impact of the phenomenon at least once. However, wide-angle photos of the eclipse and the site can be conducted without much

Eclipse expedition to Bolivia in 1995. While the astronomers set up photographic gear, two bus drivers use borrowed aluminized Mylar eclipse glasses to watch the Moon creep over the Sun toward totality.

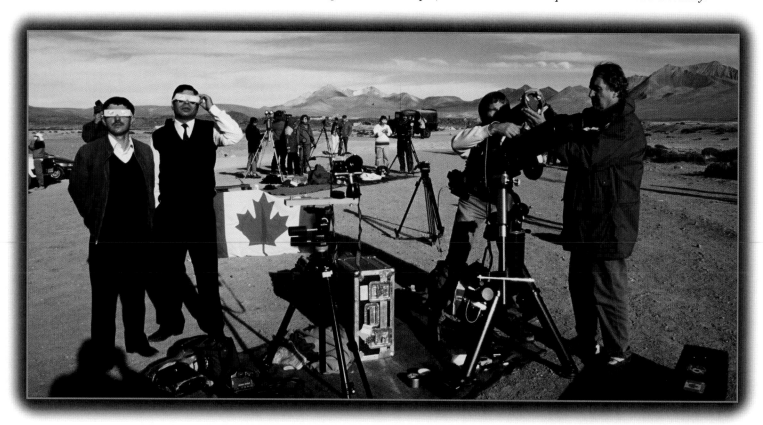

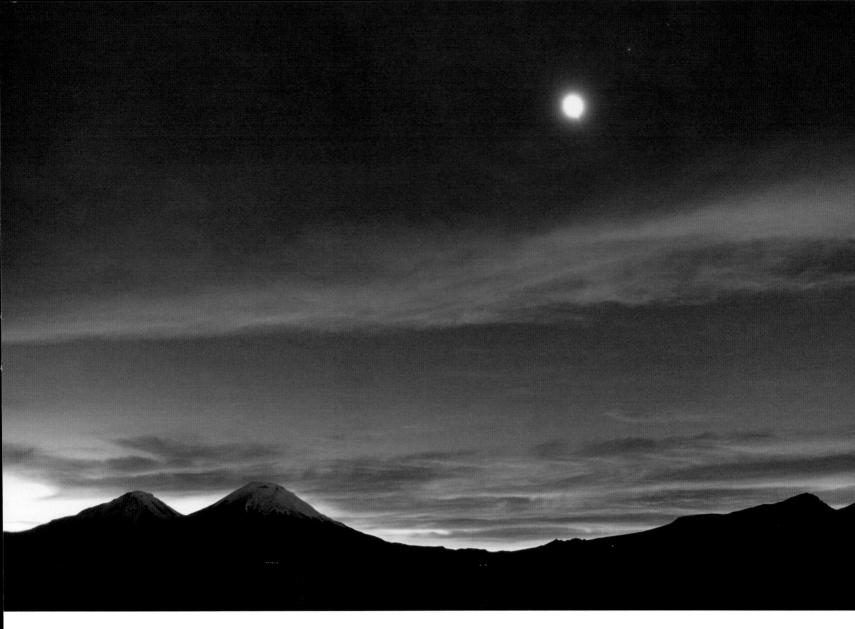

concentration on technique. Set up your tripod-mounted camera with its widest-angle lens framed to include the Sun and some horizon, as in Alan Dyer's shot above. Take one shot at least half an hour before totality begins, to set the scene, then fire off progressively more shots as the lighting dramatically changes throughout totality and the minutes immediately before and after. Rely on your camera's auto-exposure. You won't want to fiddle with settings during the

spectacle. (More on eclipse photography in Part 3.)

While the total eclipse is going on, a partial eclipse is being seen over a larger sector of Earth than the path of totality. But the difference between a total and a partial solar eclipse is literally the difference between night and day. Even if 99 percent of the Sun is covered, the Sun still shines with a brightness equivalent to a heavily overcast day and requires proper filtration for direct viewing. A total solar eclipse rates a

For several minutes during totality, above, the Moon's shadow plunges areas in the eclipse path into an eerie darkness, like deep twilight. Photo by Alan Dyer. Much less impressive than totality is an annular eclipse, bottom left, which occurs when the Moon is near its maximum distance from Earth. Photo by Alan Dyer. The solar corona, bottom right, as photographed by Michael Watson. Photo of astronomers on facing page by Alan Dyer. Lunar-eclipse scene at upper left, facing page, by Terence Dickinson.

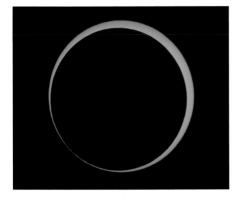

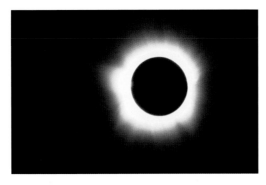

55

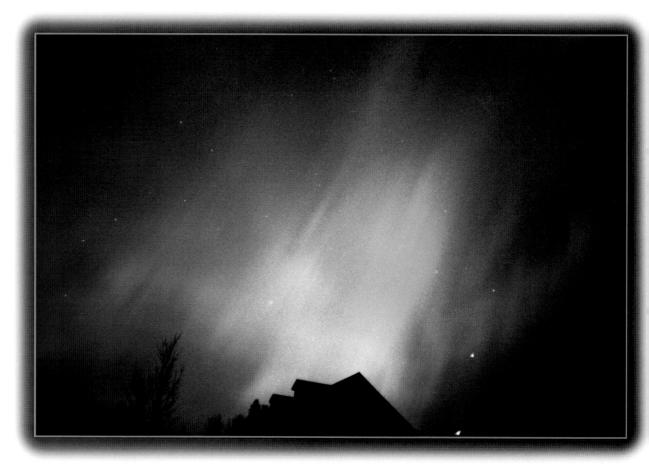

10 on a 1-to-10 scale; a partial solar eclipse gets a 3.

There are two ways to view a partial eclipse of the Sun in complete safety: (1) punch a small hole in a piece of cardboard with a pencil point, and use it as a pinhole projector to throw a small image of the Sun on a white card held a foot or so behind; or (2) buy commercial "eclipse glasses" or a No. 14 welders' filter plate, available at many welding-supply outlets for a few dollars. Don't use substitutes. Traditional methods such as smoked glass, dark bottles or layers of exposed film do not block the infrared radiation from the Sun that can injure your eyesight. (It is dangerous to look at the Sun at any time; no special radiation is emitted during an eclipse.)

Photographing the partial eclipse requires the same type of protection in front of the camera lens *before* you look through the viewfinder. Don't take any chances with your vision. Purchase an approved solar filter for your camera from a telescope dealer. Standard or zoom telephotos of 200mm or longer focal length will easily record the Moon's passage in front of the Sun during the partial eclipse. Tripod mounting is essential. And well beforehand, you will want to shoot a few practice frames of filtered shots of the Sun to satisfy yourself that you will get reasonably exposed shots on eclipse day.

A total eclipse of the Moon occurs when Earth casts its shadow on the Moon. In this case, the shadow is

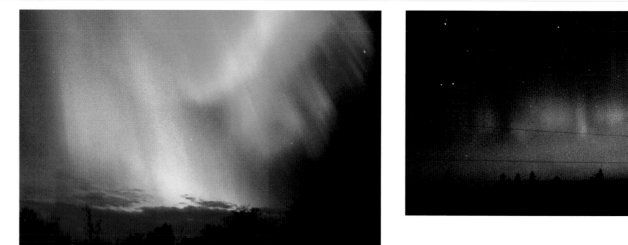

big enough to engulf the Moon completely, with room to spare. The portion of the eclipse with the Moon entirely inside the shadow (totality) can last for 1½ hours and is visible anywhere on the side of Earth facing the Moon. The Moon is not blacked out by the shadow; rather, it is dimmed to a dull copper hue, imparted by red light from the Sun filtering through the Earth's atmosphere and refracting into the shadow.

Total lunar eclipses are readily visible with no optical aid. The photo at top left on page 54, taken with a standard 50mm lens on 400-speed film, is of a particularly dark total lunar eclipse. The Moon's unpredictable brightness during totality makes exposure advice difficult, so wide bracketing of exposures is essential. Telephoto shots of an eclipsed Moon require exposures of at least a couple of seconds, during which the image will drift enough from the Earth's rotation to blur the Moon's disk. Stick with 85mm lenses or shorter for totality, although longer lenses will work for a partial eclipse.

Partial eclipses of the Moon occur when the Moon swings through the edge of the Earth's shadow. They are slightly more common than total lunar eclipses but are less impressive because the subtle shading of the eclipsed portion is often overwhelmed by the brilliance of the sector of the Moon still in full sunlight. It is the varying shape of this brighter part that can be recorded by a tripod-mounted telephoto lens. Normal exposure for the full Moon is 1/250 at f8 with 100-speed film. Use this as a starting point. From there, bracket to overexpose one to three stops during

The arctic regions may experience the most auroras, but more populous parts of the globe are treated to some impressive displays as well. The photo taken September 25, 1987, by Russell Sampson, bottom center, records a tremendous aurora with classic green curtains that overpowered the lights of Edmonton, Alberta.

the partial phases (for example, 1/125, 1/60 and 1/30 at f8). More on this in Part 3.

AURORAS

The elusive nature of the aurora borealis makes a great aurora shot a prized catch. A fine auroral display is largely unpredictable and can emerge and subside within a few minutes. Moreover, unless you live in Alaska or northern Canada, the brilliant celestial cascades are relatively rare. Residents of Florida and Arizona, for example, see only one or two bright displays a decade. More favored are northern states like Minnesota and North Dakota and most of the populated regions of Canada, where skywatchers can enjoy a hundred or more in the same period.

Auroras are caused by eruptions on the Sun that spew clouds of electrically charged particles toward Earth. The particles become trapped in our planet's magnetic field, then funnel along magnetic field lines and descend into the atmosphere in a wide ring around the magnetic poles. Particle interaction with the nitrogen and oxygen in the atmosphere produces colored light—an aurora.

Thus activity on the Sun often signals an auroral display a day or two later. But there is still a lot to learn about this phenomenon. There is no guarantee that an auroral display will follow when particles hurled by a solar flare reach Earth. Overall, though, there is no doubt about the general connection between solar storms and celestial light shows.

Auroras are most frequent and intense around the peak of the 11-year sunspot cycle. The last sunspot maximum extended over three years, 1989-91, and spectacular all-sky auroras were visible in March 1989, March 1990 and November 1991, with many other fine displays at other times during the three-year span. In contrast, auroral activity was very low during

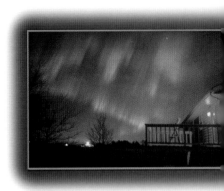

The intense red in the aurora photos on facing page and at bottom right is a common feature of the most brilliant auroras. All four photos were taken by Terence Dickinson from southern Ontario using a 24mm f2.8 lens and Fujichrome 400 push-processed to 800. Above, Alan Dyer captured this aurora over southern Alberta.

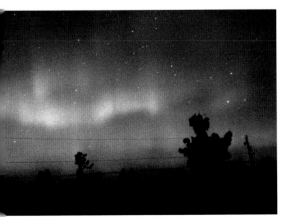

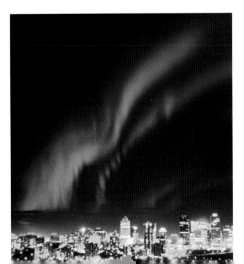

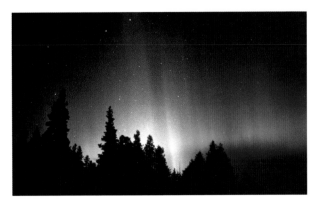

One of the most widely observed displays of aurora borealis (northern lights) was this fanfare on April 10, 1997, during the peak visibility of Comet Hale-Bopp. The comet is just touching the treetops, left of center, and is dwarfed by the colorful auroral curtains. A Canon 24mm f1.4 lens was used at f2 for this 25-second exposure on Fuji-color SG+ 400. Photo by Terence Dickinson.

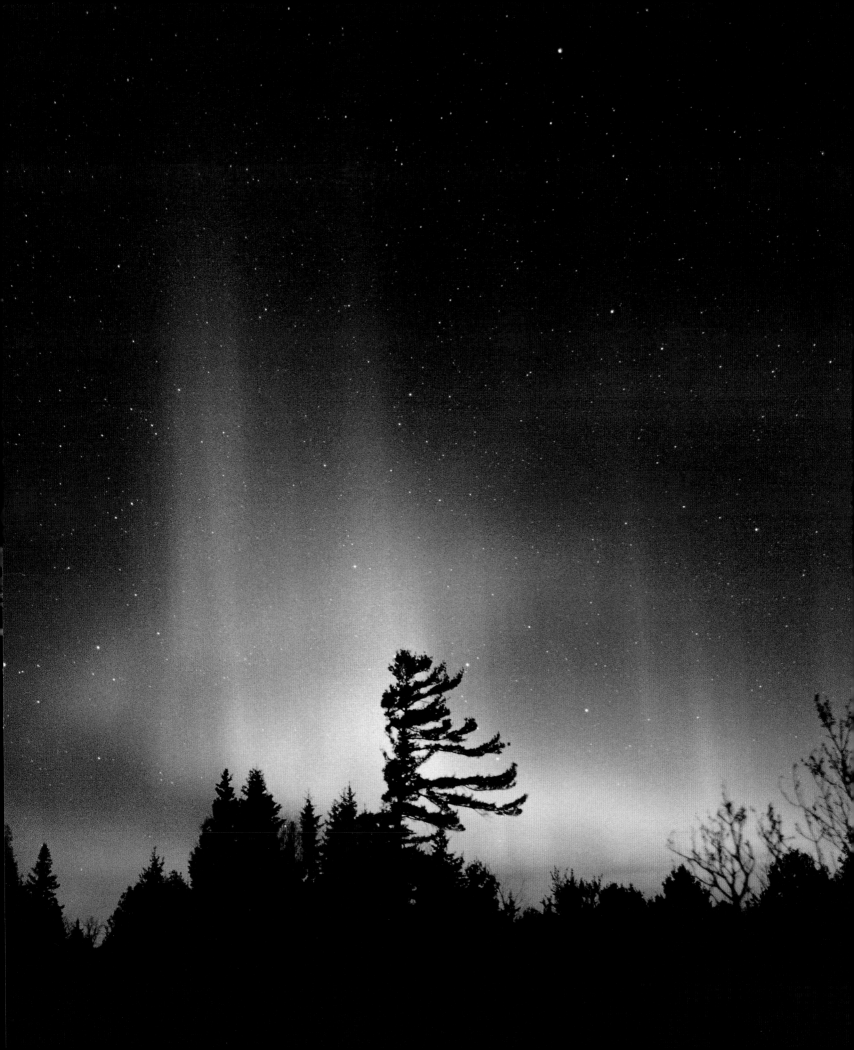

sunspot minimum, 1994-96. The next maximum is expected from 2000 to 2002.

Specific aurora predictions more than a day or two in advance are impossible. Nor is there a favored time of night or season, although March, April, September

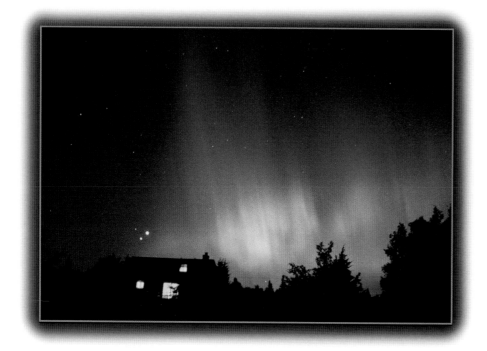

The rare three-planet conjunction of Venus, Jupiter and Mars on June 17, 1991 (above the house), was framed by an aurora and captured on Scotchchrome 400 with a 28mm f2 lens. Photo by Terence Dickinson. Some of the finest auroral displays of the 20th century occurred during the sunspot maximum of 1989-91. The overhead corona, a feature of strong auroral displays, is shown in photo at top on facing page, taken by George Liv on November 9, 1991, using 400-speed Fujichrome push-processed to 1600. All photos on these two pages were taken from southern Ontario.

and October seem to have the strongest displays. The best way to see an aurora is simply to go outside every clear night and look for an unusual brightening over the northern sky—or, less common, a shimmering luminescence pulsating across the entire sky.

Auroras range from a pale greenish white glow near the horizon to intense red, green and purple spears and curtains that fill the sky, magically wafting among the stars. To capture an auroral display on film is not difficult. The key is vigilance: Always have your camera and film at the ready, particularly on trips to dark-sky sites.

Capture the Dancing Lights

A well-exposed shot of a brilliant aurora is one of the most prized astrophotographic trophies. Yet just about any 35mm SLR camera can be used to acquire it. The trick is not equipment but being prepared. Have at least one roll of deep-sky astronomy film on hand at all times. My personal favorites are Fujicolor SG+ 800 for prints and Kodak Ektachrome P1600 and Fujichrome Provia 400 for slides. These films are even better than the now obsolete films that were used for most of the aurora pictures in this book.

Another bonus is that aurora photography is per-

fect fodder for the "auto-everything" 35mm SLR camera. Exposures are typically 20 to 30 seconds at f2.8, and f2 is even better. As with camera-on-tripod constellation shots, wide-angle lenses are required. The standard 50mm lens is too narrow, although a few good aurora shots have been bagged with one. A 28mm is much better, and a 24mm or wider is preferred to capture the full sweep of the phenomenon.

The finest aurora lens ever made was the Canon FD 24mm f1.4, an awesome performer (with an awesome price too, even used). More reasonably priced f2 and f2.8 lenses will do a fine job, as evidenced by the shots reproduced here. With 400-to-1000-speed film, exposures can be kept to 30 seconds or less, which captures the stars as points rather than trails. Some aurora specialists, primarily those in northern Europe, prefer slower-speed films that provide better color saturation and finer grain. But 1-to-3-minute exposures are necessary to get sufficient auroral light on the film. The results can be impressive, but the technique is not favored by most photographers because of two drawbacks: distracting star trails and blurred auroral streamers. Rarely does an aurora stay in position long enough to accommodate exposures of several minutes.

Where is the very best place to see and photograph auroras? Canada is the most favored nation on Earth when it comes to both frequency and brightness of displays. The so-called auroral oval—a ring of maximum auroral activity about 2,000 miles in diameter that encircles the magnetic north pole just north of Hudson Bay—is roughly located over northern Quebec, southern Hudson Bay, northern Manitoba, northern Saskatchewan, northern Alberta and much of Alaska and the Northwest Territories and Yukon. Three renowned aurora-watching sites are Churchill, Manitoba; Yellowknife, Northwest Territories; and Fairbanks, Alaska. Among larger cities, Edmonton, Alberta, probably has more auroras than any other place of comparable size.

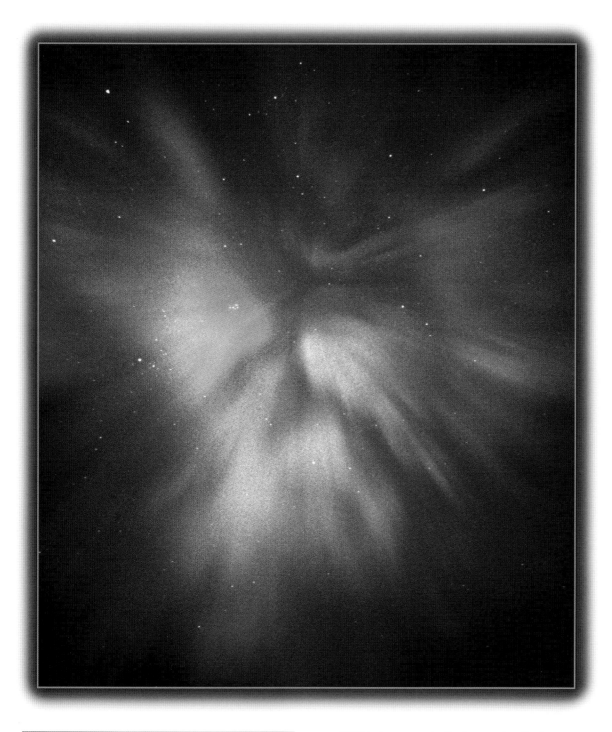

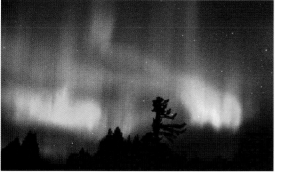

Aurora portraits from major displays on March 20, 1990, left, and June 10, 1991, facing page, bottom, were taken by Terence Dickinson on Fujichrome 400 push-processed to 1600.

Tracking the Target:

Milky Way Odyssey

A camera on a tripod can achieve some stunning results in astronomy, as we saw in Part 1. But the limitation imposed by the fact that we live on a spinning globe means the stars begin trailing across the camera frame after less than a minute. Stars become dashes rather than dots, and they no longer look like stars. The solution—and the gateway to a wonderful array of astrophotographic opportunities—is to compensate for the Earth's rotation by tracking the stars. Tracking mounts can be home-built or purchased complete with polar-alignment scope and battery-powered DC drive motor. With them, your camera follows the sky, and exposures can be as long as necessary to get the shot. The results, as evidenced on the following pages, are sometimes astounding. As in other categories of astrophotography, the camera-on-a-tracking-mount technique is enjoying more success than ever before thanks to the superb films now available. Inset photos, facing page, are two examples of modern films used in cameras atop tracking mounts.

Short exposures like this 25-second shot of Comet Hale-Bopp in moonlight by Peter Ceravolo are easy to take and offer a perfect entry to astrophotography. But a bit of success with camera-on-tripod photography naturally leads to the next step—the tracking mount—as shown on facing page.

Astrophotographer Glenn LeDrew monitors his equipment during a tracked photograph of Comet Hyakutake. He is using a Super Polaris battery-powered motor-driven equatorial mount holding two cameras and a guidescope (white). Landscape lighting is courtesy of the crescent Moon. Photo by Glenn LeDrew.

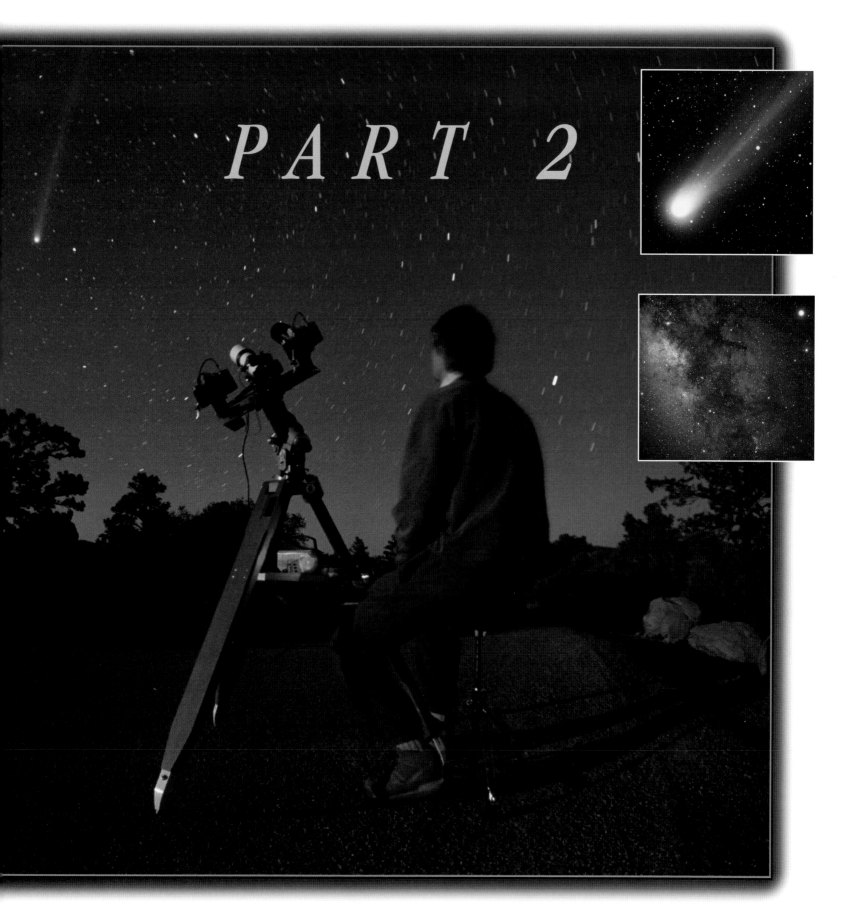

PART 2

MOUNTS
FOR SKY
PHOTOGRAPHY

You don't need a telescope to take outstanding astrophotos. Some astrophotographers have galleries of hundreds of beautiful pictures of the Milky Way, comets, nebulas and star clusters and have not used a telescope to take any of them. Instead, they used a camera with a variety of lenses attached to a tracking mount. Of course, the mount could be one normally used to hold a telescope, but simple homemade tracking mounts, such as the ones seen on these two pages, are inexpensive to build and produce impressive results.

The outfit pictured at left, made by Gary Boyle of Ottawa, Ontario, may look unsophisticated at first but, in fact, is a very well-thought-out version of what has come to be known as the barn-door tracker. A more stripped-down edition of the barn-door tracker, by John Childs of Brockville, Ontario, is shown in the upper three photographs on facing page. Most people who see such a device say, either out loud or to themselves, "That can't possibly work." It not only works, but with the relatively short exposures needed with modern films, the barn-door tracker makes more sense now than ever before.

Today's superb high-speed films can yield a fully exposed astrophoto in less than five minutes with an f2.8 lens. And how good are the results? The photo of Comet Hale-Bopp on page 67 was taken using a barn-door tracker. Another example is the Milky Way shot at the top of page 75. If your appetite has been whetted by those pictures, you may want to give serious consideration to the barn-door tracker before

This camera tracker, built by Gary Boyle of Ottawa, Ontario, is a rugged unit that allows accurate polar alignment and precise tracking using a guidescope. The dual-hinge design integrates an accessory platform to hold a timer and batteries for the guidescope cross-hair illuminator.

spending a lot of money on a commercial telescope equipped for astrophotography.

The Barn-Door Tracker

The primary attribute of the barn-door tracker is that you need no special equipment to build it and no motor or batteries to run it. It's driven by you, turning a hand crank. This is low-tech at its best.

The principle behind the barn-door tracker is that its hinge parallels the Earth's axis. Turning a hand crank and pushing on one of the two hinged boards compensate for the Earth's rotation. The camera, attached to the moving board, tracks the stars. No star trails. To work properly, the axis of the hinge must be aimed at the celestial pole, the rotation hub of the sky (very close to Polaris in the northern hemisphere).

The most expensive parts of the barn-door tracker are the heavy-duty camera tripod to hold the device and the ball-head camera clamp to hold your camera

This more conventional and less elaborate barn-door tracker (top three photos) can be built in an afternoon. The small digital clock, illuminated by a dim, red light, provides the reference for the operator to turn the drive bolt one-quarter rotation every 15 seconds. Commercial camera-tracking mount, right, has an integrated polar-alignment scope and a 6-volt DC drive motor.

at any orientation atop the tracker. Other than these two items, the materials are very inexpensive; you may find most of them around the house. Specific details of the design are up to you, but here are the basics.

In the less sophisticated model built by John Childs and shown on this page, two standard door hinges were used, whereas Gary Boyle selected a length of continuous cabinet hinge. But even a single standard door hinge will work. The drive bolt is a 4-inch-long ¼ x 20 carriage bolt, available at any well-stocked hardware store. In describing how his unit was made, Childs offers these instructions:

"Begin with two pieces of ¾-by-10-by-12-inch plywood and two door hinges. Two ¼ x 20 T-nuts are the only specialized hardware required. Cut the plywood pieces into two T shapes, and join the tops of the T's with the hinges. The only crucial measurement is the position of the hole that contains the first T-nut, which holds the drive bolt. Its center should be exactly 11⁷⁄₁₆ inches from the center point of the hinge axis. To secure the unit to a standard camera tripod, the bottom leaf of the barn door needs a ¼-by-20-inch threaded hole, like that found on the bottom of cameras. Attach the other T-nut here, but be sure to

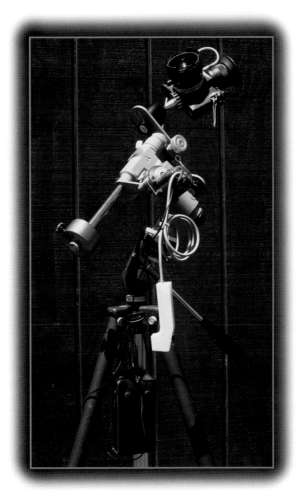

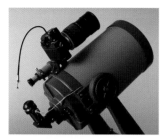

countersink the T-nut from the top so that the tripod pulls the T-nut down into the bottom board. Speed-bore bits do a nice job of drilling large flat-bottomed holes. A four-pointed handle constructed from one of the cut-out scraps makes turning the drive bolt at one rotation per minute easy."

Adequate accuracy for a typical 5-minute astro-photo is achieved by gently cranking the drive bolt clockwise a quarter-turn every 15 seconds so that it completes one rotation each minute. The axis of the hinges in Childs' design must be aimed at Polaris, with the drive bolt on the right as you face north. As a sight for the alignment, Childs mounted a ½-inch-diameter tube parallel to the hinges.

In Boyle's unit, there are several modifications on this basic design. The hand crank is the wheel from a child's stroller, with a ¼ x 20 bolt fitted into the axis. Turning this wheel counterclockwise one rotation per minute allows the upper platform to drop down by its own gravity the appropriate amount to track the stars. This means that Boyle's "door" closes and Childs' opens, but each at the same rate and each producing the same result.

Other Boyle modifications include polar-altitude bolt (curved lower bolt) and a polar-alignment scope, the small gray tube seen at extreme left in the bottom two pictures on page 64, made from the optics in a broken pair of binoculars. Boyle glued two threads inside the eyepiece to make a cross hair. The polar finderscope significantly increases the accuracy of the alignment of the mount to the celestial pole. But for the alignment scope to work, it must be exactly parallel to the hinge axis of the tracker. This is best achieved during daytime, with the mount tipped horizontally and aimed at a distant target. The polar scope's adjusting screws are then used to center the cross hairs on the distant target so that they stay centered while the upper board of the barn door is rotated on the hinge through 180 degrees. This brings the polar-sighting scope exactly parallel to the hinge axis. When the

In the classic piggyback setup, top left, the telescope and its mount become the tracking platform. Alternatively, center left, the camera can be attached directly to the mount. Polar-alignment scope integrated into the mount's polar axis, right, is a crucial aid for obtaining the accurate polar alignment essential for astrophotography. Bottom left, a small battery unit (silver) illuminates polar scope's cross-hair reticle.

scope is on Polaris, so is the tracker's hinge axis.

A further refinement in the Boyle design is the use of a guidescope, the little telescope he is looking through in the upper photo on page 64. The 33-power guidescope has cross hairs illuminated by a red battery-powered LED light. Excellent accuracy can be achieved by turning the main crank to keep the guide star precisely in the cross hairs. The guidescope is on its own miniature mount and can be aimed anywhere in the sky where a convenient star will do the job.

A barn-door tracker works beautifully for exposures up to about 10 minutes with 50mm and shorter lenses. Longer lenses, up to 135mm, can be used, but the required polar-alignment accuracy is much more

stringent, and the turning of the drive wheel must be smooth throughout the exposure. For best results—and less potential frustration—concentrate on shooting with 24mm-to-50mm lenses with a barn-door unit, at least initially.

Barn-door tracking mounts can be motorized, but at that level of sophistication, one might start thinking about an astronomical equatorial mount with motor drive, such as the one pictured at the bottom of page 65. This particular unit was used for more than a dozen pictures in this book, including, for example, the photograph on page 73 and the one on page 77 (large image). Not only does this mount have a battery-powered motorized drive, but it includes a six-power polar finderscope integrated into the polar axis. A similar polar scope is shown on a different mount in the picture above. (Use

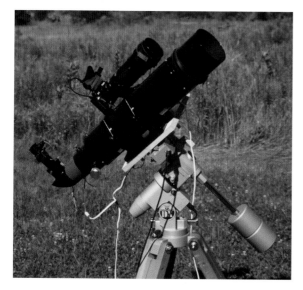

of the polar scope is described on pages 70-72.)

Small portable equatorial mounts like this are available commercially with or without the polar scope. Since polar alignment is crucial to achieving untrailed astrophotos, the models with the scopes are much preferred. Unfortunately, camera tracking mounts with integrated polar scopes designed specifically as camera trackers for astrophotography are not widely available on the astronomy market. The reason is fairly straightforward. It costs about the same to build a miniaturized precision polar equatorial mount, like the one pictured on page 65, as it does to build a similar larger mount suitable for holding a telescope.

Therefore, manufacturers tend to make the more popular telescope mounts rather than versions suited to camera tracking alone.

Most astrophotographers who graduate to commercial tracking mounts purchase a telescope mount. A good mount to look for is a used Vixen or Celestron Super Polaris, but be sure it has the motor drive at least for the polar axis (called the right-ascension drive). These mounts were very popular during the 1980s, and there are still lots of them around. A good start for finding one would be to check the telescope dealers listed in the Yellow Pages for the nearest large city to you. There are several new versions of the Super Polaris mount—one is called the Grand Polaris —and all of them will do the job.

PIGGYBACKING YOUR CAMERA

A telescope with an equatorial mount, either a fork mount, as pictured at top of facing page, or the German equatorial design shown above, operates on the same basic principle as the barn-door tracker: The polar axis, aligned parallel to the Earth's rotation axis, is driven by a motor to compensate for the turning Earth so that the telescope stays fixed on its celestial target. If a camera is attached to the telescope or

When used "wide open" at their lowest f-number, virtually all camera lenses shorter than 100mm focal length will exhibit two noticeable defects: astigmatism and vignetting. In this photo of Comet Hale-Bopp, bottom left, taken with a 50mm f1.4 lens set at f1.4, the center of the image is brighter than the edges (vignetting). Blowup of the photo's upper right corner, bottom right, shows distorted sea-gull-shaped star images toward the frame's edge (astigmatism). Both effects are greatly reduced by stopping down one to two f-stops. This lens, a Pentax, actually performs better wide open than most in suppressing astigmatism and, in this instance, did a good job recording the comet. Photo by Janice Strong and Jamie Levine. Above left, a 300mm telephoto and a 4-inch refractor "guidescope" share a ride on a Vixen Super Polaris DX mount. Wires carry DC power to heaters that prevent dew from fogging the optics during long exposures.

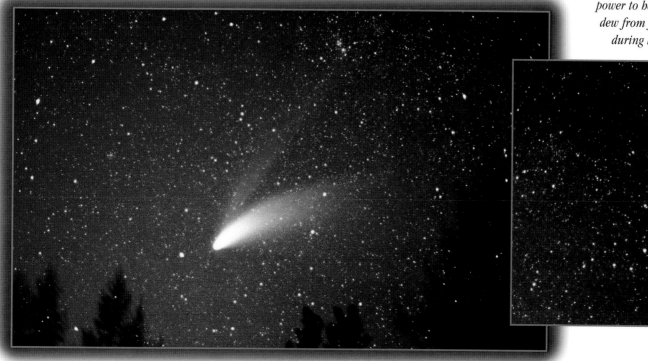

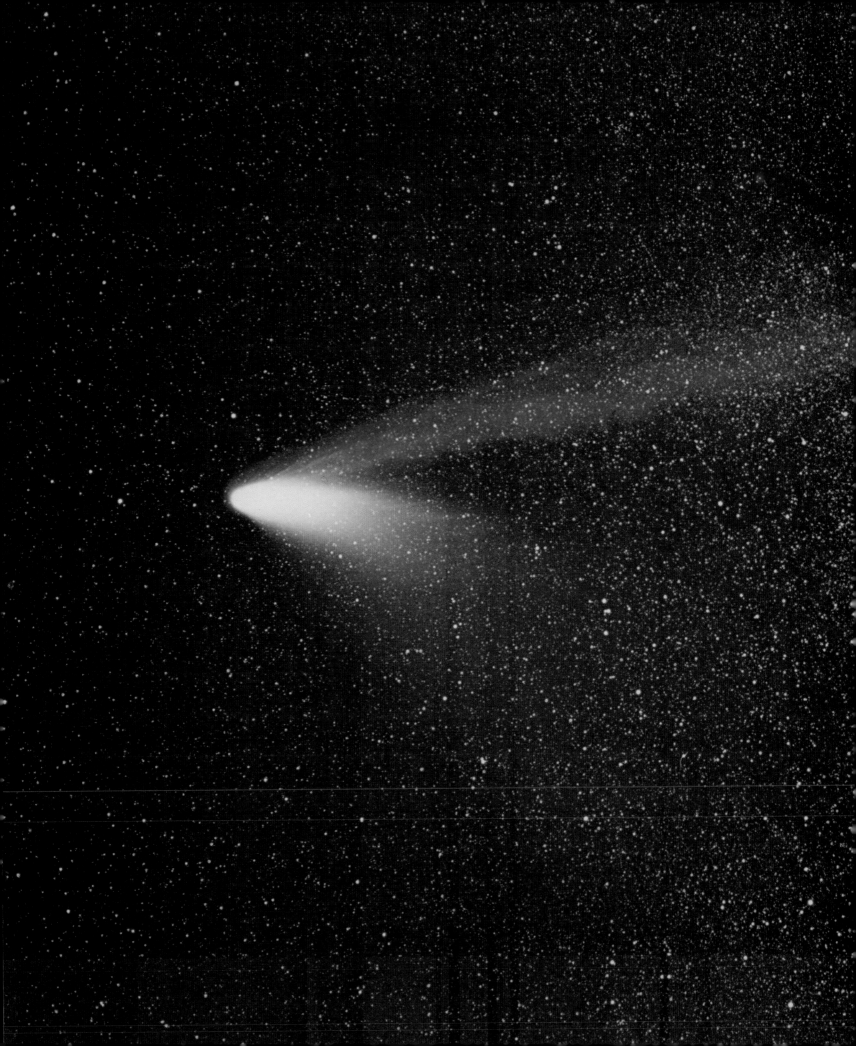

Brandishing its twin gas and dust tails, Comet Hale-Bopp cruised near the North America Nebula in the constellation Cygnus on March 8, 1997. Astrophotographer Tony Hallas used a medium-format Pentax camera with a 165mm f4 lens and gas-hypered Kodak Pro 400 PPF film. Two 5-minute exposures were combined to enrich the detail and color of the shot.

The photo-charts on these two pages are guides for aligning tracking mounts with polar-alignment scopes. The large pictures are for general naked-eye positioning using the Big Dipper and Polaris in the northern hemisphere and Crux, the Southern Cross, in the southern hemisphere. Insets show the exact location of the celestial poles. The fuzzy patch between Canopus and the south celestial pole is the Large Magellanic Cloud, a small nearby galaxy.

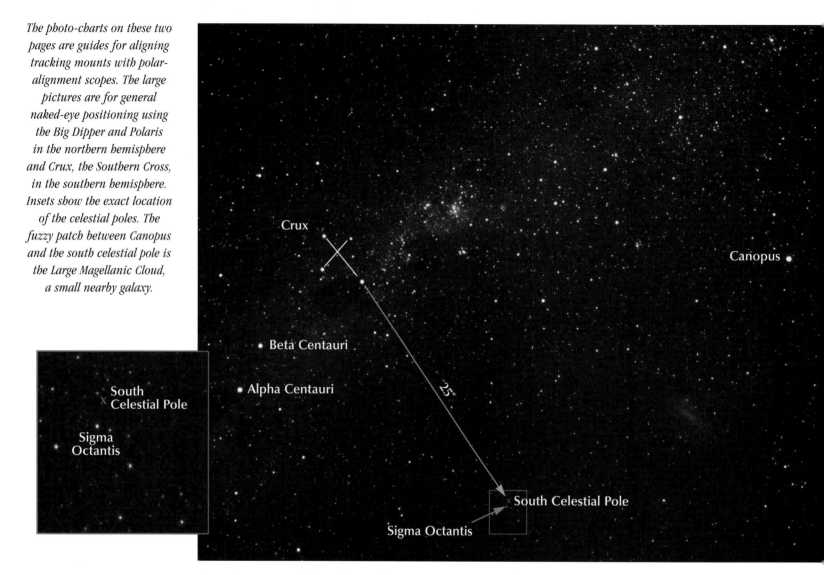

shares the mount with the telescope (an arrangement amateur astronomers call piggyback), it gets a free ride tracking the stars.

For instance, the two photographs above and facing page were taken with a piggyback setup. Both were exposures of about 5 minutes, though on different films (Scotchchrome 400, left; Kodak Ektachrome P1600 processed at 400, right). But the overall effect —pinpoint stars and enough exposure to show lots of faint stuff—is achieved.

There are at least six advantages with camera piggybacking: (1) the telescope's motor drive and equatorial mount automatically compensate for the Earth's rotation and track the stars; (2) as an optional accessory, most telescope manufacturers offer piggy-back brackets to clamp the camera to the telescope; (3) the telescope can be used as a guidescope to con-firm the mount's tracking accuracy; (4) the telescope mount's slow-motion controls can be used during the exposure to correct for errors in polar alignment or

in the mount's driving gears; (5) the camera can be attached or removed in about a minute without a fuss, making it an effective and practical combination; and (6) piggybacking is, in our opinion, an essential step in the learning curve leading to through-the-telescope astrophotography.

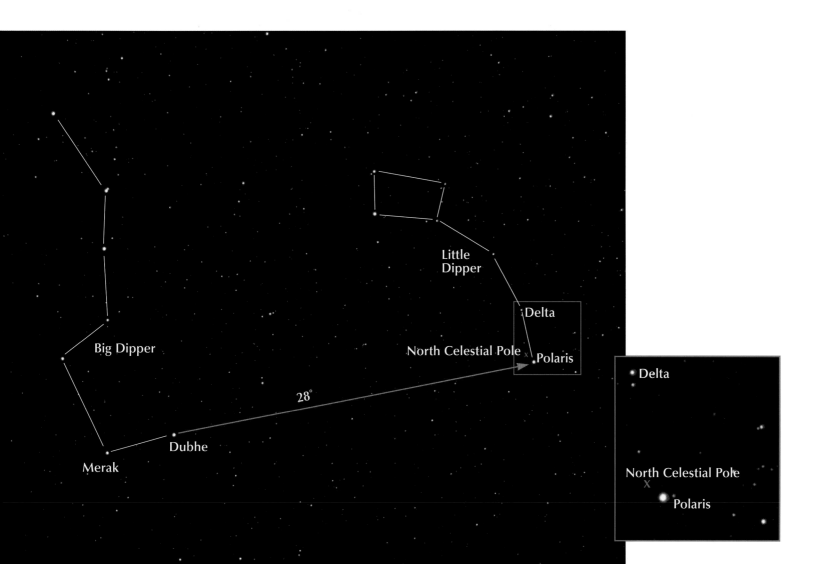

Little
Dipper

Delta

North Celestial Pole × Polaris

Big Dipper

28°

Dubhe

Merak

Delta

North Celestial Pole
×
Polaris

GUIDING TECHNIQUES

Piggybacking your camera on a telescope with an equatorial mount brings you fully into the world of guided astrophotography, where time exposures can extend to a half-hour or more, if necessary, and maintain pinpoint stars throughout. To achieve this accuracy requires very high precision in polar-aligning the mount. Accurate polar alignment is the key to success when using a telescope's mount for any type of astrophotography.

For portable setups, where the equipment is transported to the observing site and set up for each photo session, the preferred mount for piggyback shooting is the German equatorial with integrated polar-alignment scope. Why? Two reasons. First, the polar-alignment

Facing page, bottom, a photo taken through the eyepiece of a polar-alignment scope shows three small circles that are keys to exact positioning on the celestial pole. The small circle centered in the larger one is the position of the celestial pole. The small circle at right is for Polaris, and the one at far left is for Delta, in the Little Dipper.

procedure is quicker, and counterweighting the mount to balance the piggybacked camera usually involves simply adjusting the position of the counterweights. The fork equatorial requires optional counterweights to balance the camera. Ultimately, the fork equatorial mount works just as well but can take a few extra steps.

To polar-align using the integrated polar scope on a German equatorial mount (a typical unit is pictured on page 66), shift the telescope by adjusting the tripod so that Polaris—or, in the southern hemisphere, Sigma Octantis—is in the field. The inset photos on

pages 70 and 71 approximate a polar scope's field of view around these stars. The central bull's-eye or cross-hair point at the center of the polar scope's field of view should then be aligned as close as possible to the celestial-pole point indicated on the insets. This is usually done by using the mount's polar-adjustment knobs (the two pairs of knobs in the page 66 photo).

Many polar-scope eyepieces have Polaris offset points as well as a position to align the star Delta Ursae Minoris, the next star in the Little Dipper from Polaris. If these two stars are oriented in their positions in the polar-scope field, the alignment on the north celestial pole should be very accurate. Some polar scopes have comparable reticles for the stars around Sigma Octantis.

Fork equatorial telescopes generally do not have separate polar-alignment scopes but, instead, utilize the finderscope for alignment. For this to work, the finderscope must parallel the main scope. In other words, an object centered in the finderscope must be dead center in the main scope, and vice versa. Then the main scope must parallel the polar axis. To check this, position the main scope to parallel the fork tines and lock it in declination. (If you own a fork-mounted telescope, you are probably familiar with these terms, but if you're not, refer to your telescope's manual.) Then, while looking in the eyepiece, rotate the telescope fork around the polar axis. The star closest to the center of the field should not move. If it does, adjust the declination slow-motion control until it doesn't. If, at this point, the declination circles do not read 90 degrees, consult your manual to adjust them until they do.

Now, with the declination clamp still locked, you are ready to use the finderscope to point to the celestial pole. Shift the telescope by adjusting the tripod to get Polaris (or Sigma Octantis) in the field of view. If there are fine adjustment knobs on the wedge, use them. If not, get the celestial pole as close to the center of the finder's field as possible.

With the mount polar-aligned, the rest is easy. Aim the telescope so that the piggybacked camera is pointed at the desired target, lock the telescope's right-ascension and declination clamps, and open the shutter. For lenses 135mm and shorter, the telescope's drive motor should do a perfect job of guiding for as long as required. For longer lenses, you'll need an illuminated cross-hair eyepiece for making guiding corrections through the main scope. This procedure, which you should avoid initially to ensure that your polar-alignment technique is sound, is described in Part 3.

Piggyback tip: Most commercial piggyback mounts

clamp to the telescope or to the ring mounts used to hold the telescope tube to the mount. The camera is then screwed onto the piggyback mount and locked in a fixed position. Each time you move on to a new picture, the whole telescope must be pointed in that direction. This is not necessary. Only the camera needs to move. Solution: Attach a ball-head camera clamp to the piggyback mount so that only the camera needs to move for a new picture. This allows total freedom for the composition, and the telescope can remain in its most stable configuration.

Recommended Films

Driven by international competitiveness, the giant film-emulsion manufacturers—Kodak, Fuji, Konica, Agfa and 3M—have utterly revolutionized their products during the past few decades. Today's films are better in every way, especially for astrophotography. There are no "good old days" when it comes to great films of the past that are no longer manufactured.

Current films have tighter grain, more accurate and richer color and lower reciprocity failure than anything that has come before. (Reciprocity failure is a photographic term to describe a film's ability to keep soaking up light during an exposure longer than one second. A film with low reciprocity failure is good because it means that the film's sensitivity does not "die" during a long exposure.)

For this book, we have conducted exhaustive testing of *every* 35mm color film available as of late 1997. As expected, some are better for astronomy than others, and a few are outstanding. The eight listed below are the best now available for astrophotography.

Kodak Pro 1000 PMZ (color negative, for prints) is a superb high-speed film for constellation shots, auroras or any camera-on-tripod application where maximum speed is required. It is also good for deep-sky photography with long-focal-ratio telescopes or telephoto lenses, f/5 to f/12. Although fairly grainy by today's standards, this film is highly recommended for its speed and good color balance. This is a profes-

Photos at left show about 1 percent of the area of four 35mm slides as a close-up comparison of grain and sharpness of slide films used in deep-sky astrophotography. From top down: Kodak Ektachrome Elite II 100; Kodak Ektachrome P1600 processed at 400; P1600 processed at 1600; and Scotchchrome 400 processed at 800.

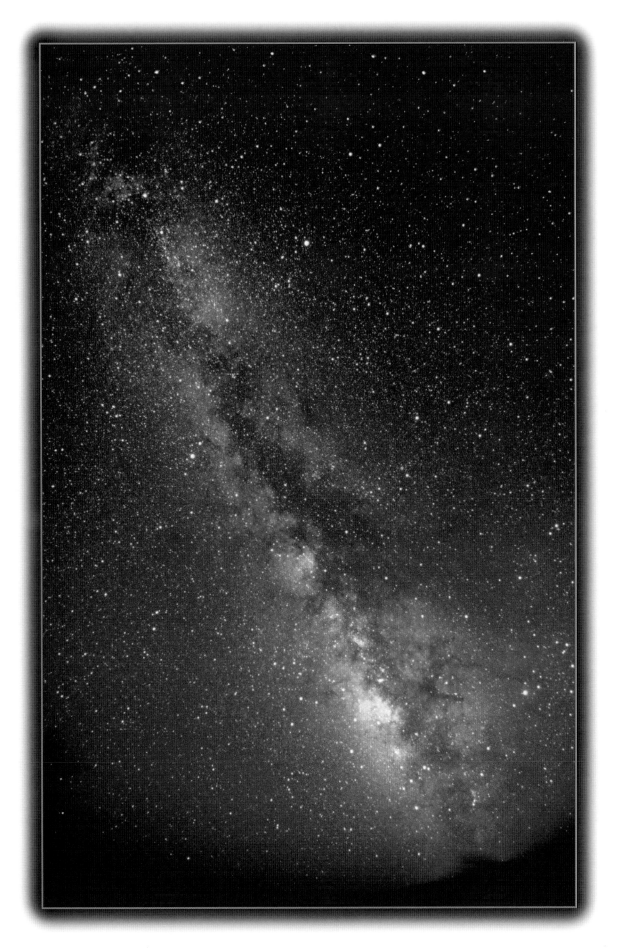

Under essentially perfect dark-site conditions, much longer exposures than normal are possible, yielding saturated high-contrast images of the splendors of the night sky. On a 7,000-foot plateau north of Douglas, Arizona, this super-wide-angle portrait of the Milky Way was captured by Terence Dickinson with a 15mm f2.8 Canon lens. Exposure was 33 minutes on Kodak Ektachrome P1600 processed at 400. No filtering or special processing was employed.

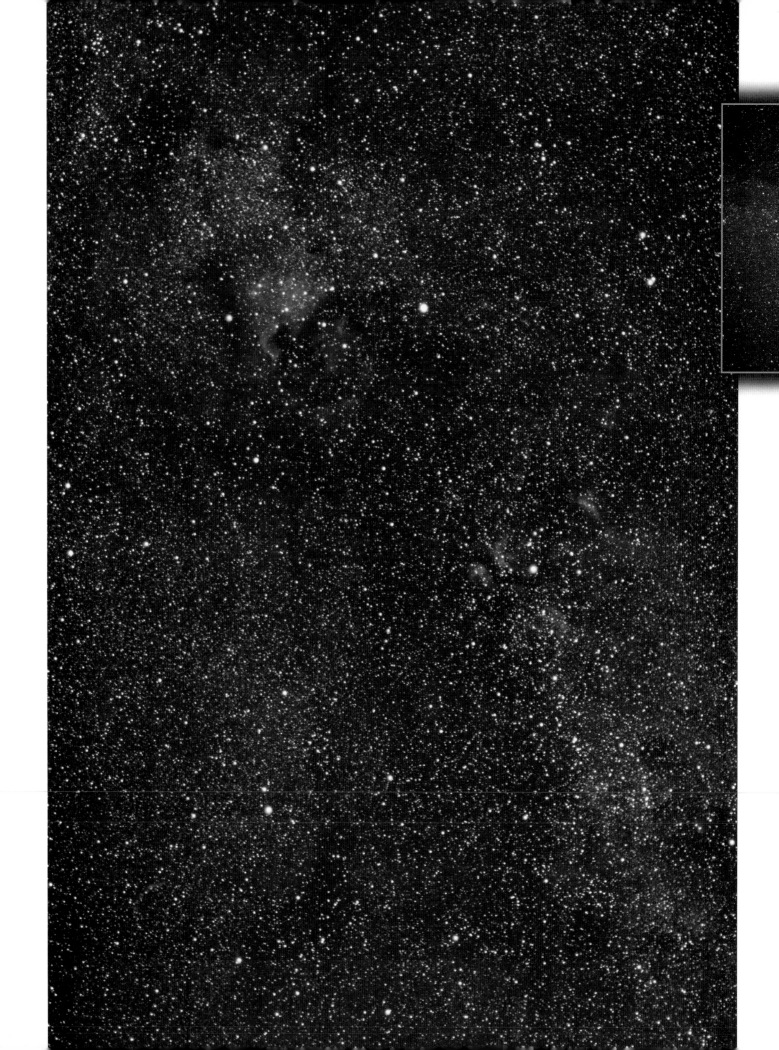

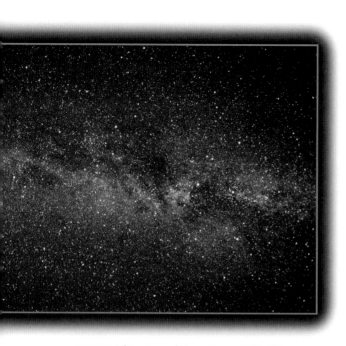

This view of the autumn Milky Way, above, is a 5-minute barn-door-tracked exposure at f2 on Kodak Ektachrome P1600 processed at 1600. Left, close-up of the North America Nebula region (just right of center in the photo above) was a 12-minute shot taken with an 85mm lens at f1.7 on Kodak Ektachrome Elite II 100. Photos on these two pages by Terence Dickinson.

sional film, which means you won't find it at the local one-hour shop. Look for a dealer in your area that caters to professionals and advanced amateurs.

Fujicolor SuperG+ 800 (color negative, for prints). Designed for professional sports photographers, this is a terrific astrofilm for everything from constellations to through-the-telescope deep-sky shots. Great color, good reciprocity characteristics and exceptionally good grain for its speed. Professional film.

Kodak Ektapress Multispeed PJM 640 (color negative, for prints) is another great astronomy film. Rich color, especially reds, and smooth grain similar to Fujicolor 800 make this a top-rated astrofilm for just about any use. Kodak calls this film "multispeed" because of its wide exposure latitude, which means that it can be underexposed or overexposed with good results—always a plus for astronomy. However, some astrophotographers have interpreted this designation as meaning that the film should be push-processed. Wrong. This is a 640-speed film and should be processed like any other print film. Professional film.

Kodak Pro 400 PPF (color negative, for prints).

Widely used by professional photographers, Pro 400 has excellent color rendition, particularly in the reds and blues, the primary colors of nebulas and galaxies. Fine grain and excellent reciprocity characteristics make this a standout, especially for longer exposures. Professional film.

Fujicolor SuperG+ 400 (color negative, for prints) is one of the finest astronomical films ever. It has the tightest grain and sharpness of any 400-speed film as well as excellent reciprocity and color balance. I have blown up some of my shots on this film to 16-by-20 prints, and the grain is still quite acceptable. Superb for piggyback photography and for shooting through telescopes of f/5 or faster focal ratio. Available in most camera stores.

Kodak Ektachrome P1600 (slide film). Designed for push-processing, this 400-speed film can, upon request, be pushed during processing to 800, 1600 or 3200 speed. Excellent color balance and moderate grain have made this a popular astronomy slide film. However, its speed rating is deceiving. When processed at 800, it is slower than any of the print films mentioned above. At 1600, it barely equals them. Professional film.

Kodak Ektachrome Elite II 100 (slide film) is an amazing film that starts off a bit slow early in the exposure but keeps on soaking up light long after most other films are down to a crawl. Terrific for piggyback and star trails. Fabulously fine-grained (see slide-film comparison on page 72), it can be push-processed to 200 or 400 with little increase in graininess. Slight greenish sky cast. Widely available.

Fujichrome Provia 400 (slide film). Noted for its excellent color balance in recording moonlit star-trail scenes and auroras. Professional film.

Some once highly regarded films have been relegated to also-rans with the introduction of the newer entries mentioned above. For example, Konica 3200, the fastest color-print film ever made, caused a sensation when it was introduced a decade ago, but by today's standards, it is as grainy as sandpaper. Furthermore, Kodak Pro 1000 PMZ is, in sky tests, almost as fast as Konica 3200 and much finer-grained, with superior color. Similarly, 3M's Scotchchrome 400 and Scotchchrome 1000 slide films, although actually faster than their rated speed, are very grainy and have been supplanted by Kodak Ektachrome P1600. Scotchchrome 800/3200, available only in Europe, is a 400-speed slide film intended for push-processing but is very difficult to obtain.

Kodak Gold Max 800, Kodak's answer to Fujicolor 800, has failed to catch on with astrophotographers.

The Milky Way seen in winter, below, and in summer, bottom, not only is angled differently but shows two different sectors of our galaxy. The summer view is from the Cygnus-Orion Arm inward; in winter, we gaze in the opposite direction, toward the Orion Nebula and outward. Both photos were 15-minute exposures with a 15mm f2.8 lens; winter on Scotchchrome 400 from Arizona, summer on Kodak Ektachrome P1600 (at 400) from Ontario.

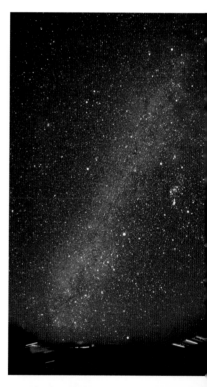

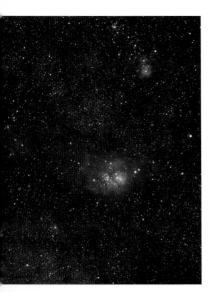

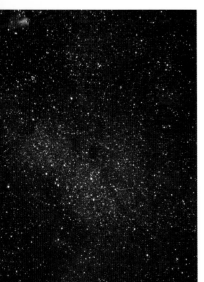

Our tests suggest that it is inferior to the Fuji film in all categories. Kodak Royal Gold 1000 is probably a better choice, but only if you can't get the excellent Kodak Pro 1000 PMZ.

Fujicolor 1600, once considered a top astronomy film, is grainy by today's standards and has muddy colors. Fujicolor SG+ 800 is a superior film.

MILKY WAY WIDE-ANGLE

One of the great joys of astrophotography is being able to use a normal camera with a standard lens to capture a spectacular panorama of our own galaxy revealing tens of thousands of individual stars. It's something that can never be seen in a telescope. Yes, a telescope will show as many stars as can be seen in a 10-minute photograph of a wide sector of the Milky Way, but not all at once. A telescope's field of view is too narrow. You just can't duplicate the wide swath of a camera lens or the remarkable color penetration that a time exposure on film will give you.

Regardless of the brand of your 35mm SLR camera, there will be wide-angle and super-wide-angle lenses available for it in addition to the standard 50mm "normal" lens that probably came with it. Typical wide-angle lenses are 28mm f2.8 and 24mm f2.8. You will definitely want a wide-angle lens for astronomy. It will prove to be one of your most-used accessories. Earlier, we saw how the 24mm or 28mm lens was ideal for camera-on-tripod constellation shots because of its ability to capture two or three constellations at once and to place them in context with one another. But when you have the advantage of guiding the camera as it rides piggyback on a telescope or

Composite photograph, bottom left, is a sandwich of two slides: a wide-angle Milky Way shot and an overexposed twilight photo of trees on the horizon. The result is striking, although not astronomically correct. Photo by Terence Dickinson. Top left, Lagoon Nebula region by Peter Ceravolo; center left, Sagittarius Star Cloud by Terence Dickinson.

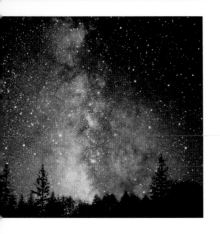

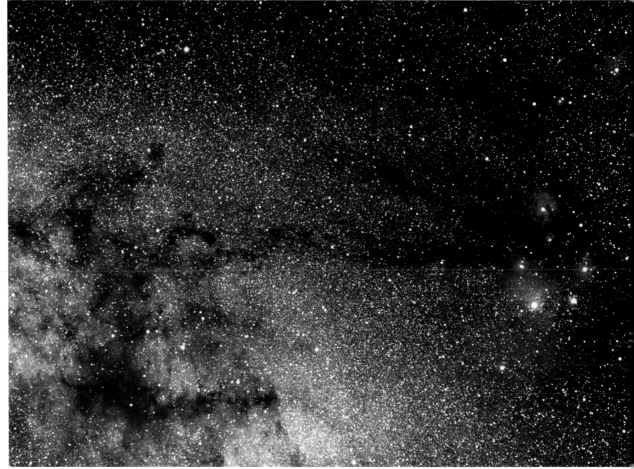

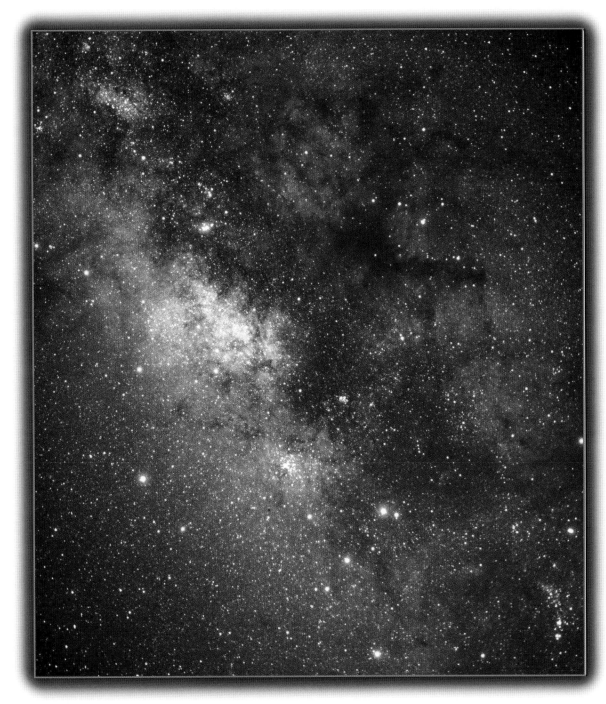

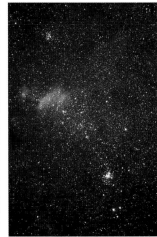

Pictured at left is the richest part of the Milky Way, in Sagittarius and Scorpius. Below is a close-up of the Scorpius Jewel Box, seen at bottom right in the main photo. On facing page, bottom, is a specially enhanced Jerry Lodriguss shot of the galactic dark horse, a complex of dark nebulosity between the Sun and the Sagittarius Arm of the galaxy. Photo data: left, 50mm at f1.7 for 5 minutes on Kodak Ektachrome P1600 at 400 by Terence Dickinson; below, 300mm at f2.8 for 10 minutes on gas-hypered Fujicolor 800 by Jerry Lodriguss.

on a polar-aligned equatorial mount, the results are dramatically different.

A wide-angle guided exposure containing, say, most of Cygnus and parts of neighboring Cepheus, as shown in the picture at the top of page 75, is completely different from a constellation shot with the outline of the main stars of the constellation down to sixth or seventh magnitude. In the 5-to-10-minute guided shot, the once distinctive constellation figure is now overwhelmed by the background stars that have emerged into plain view. Other objects, nebulas

in particular, that were completely invisible in the 30-second constellation shot are now blatant and give the photo a rich and unique texture impossible with shorter exposures.

For your first experiments in guided wide-angle sky photography, I recommend starting out with the 24mm or 28mm lens for several reasons. First, because of their versatility as part of the standard repertoire, both the 24mm and 28mm lenses are widely available. But second, and perhaps more important, these are the easiest lenses to use in guided astropho-

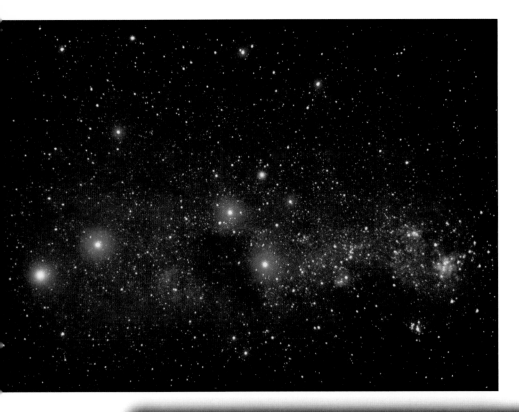

tography. Guiding tolerances are forgiving. A slight error in the equatorial mount's polar alignment often won't show up in a 5-to-10-minute exposure—or it might show up in the 10-minute shot but not in the 5-minute, resulting in at least one good picture.

For a 24mm or 28mm shot to produce pinpoint stars, simply aim your equatorial mount's polar scope *at* Polaris. That's all there is to it. Just don't get too ambitious by extending the exposure much past 10 minutes.

The idea with guided wide-angle photographs, of course, is pinpoint stars. It's a portrait of our sector of the galaxy. Any trailing that makes the stars look like streaks instead of points of light is ruinous and should be unacceptable to you except during the very beginning stages, when you've got nothing better in your emerging portfolio. But for immediate gratification, nothing beats the easy setup of the mount and the reliable results that come from shooting with a wide-angle lens.

Lenses with an even wider field of view, such as a 20mm or super-wide fish-eye lens of 17mm or shorter

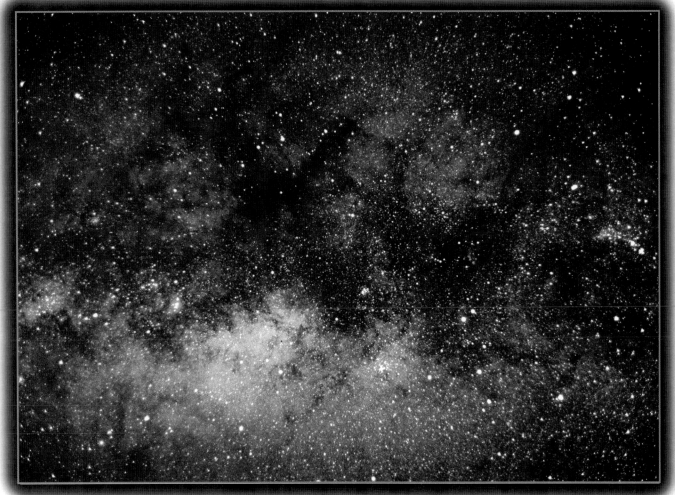

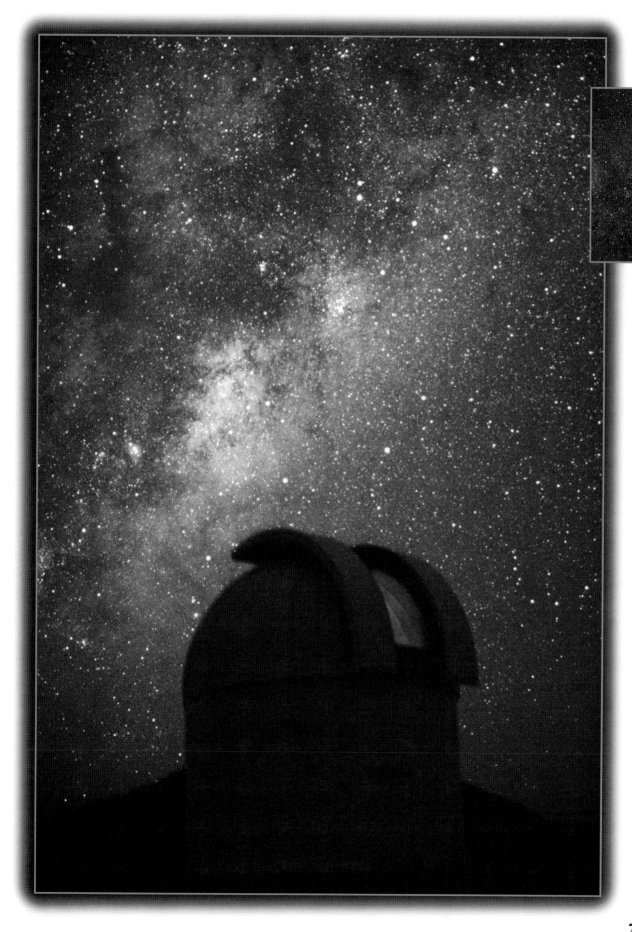

Photo at left, taken under superb conditions at Las Campanas Observatory in Chile, is a single 75-second exposure, not a composite, taken with a 50mm lens at f1.7 on Scotchchrome 400 push-processed to 1600. The camera was driven by an equatorial mount, but the trick in this type of shot is to keep the exposure short enough so that the foreground is not substantially blurred. Very fast film is a must. Above, the field around Alpha Centauri (bright star at right), the closest star to the Sun. Alpha Centauri is also seen at far left in the top photo on facing page. Below it is the bulging hub of the galaxy. Photos on this page by Terence Dickinson; photos on facing page by Alan Dyer.

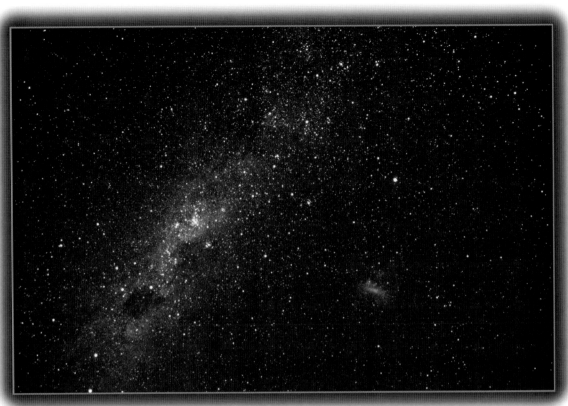

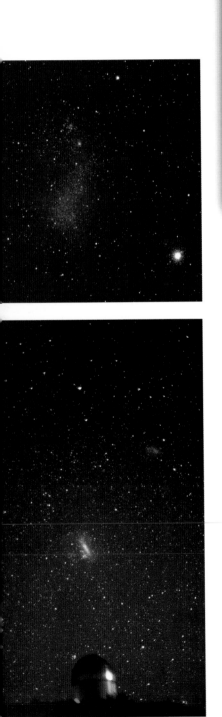

Above, a 24mm wide-angle view of the deep southern Milky Way. The Large Magellanic Cloud, the small patch at lower right, is a satellite galaxy of the Milky Way, floating in isolation 170,000 light-years away, about 20 times more remote than the star clouds of the Milky Way. In photo at lower left, both the Large and Small Magellanic clouds hang over an observatory in Chile.

SOUTHERN MILKY WAY

Astronomers have known for some time that Earth was born upside down. Nobody else seems to have noticed—or cares much—but most astronomy buffs wish the planet could be flipped so that the northern hemisphere faced south, and vice versa. That would mean the richest part of the sky would be seen overhead instead of being hidden below the horizon as it is now from most of the northern hemisphere.

The first thing the visiting northerner notices in Australian skies (or from anywhere in the southern hemisphere) is that familiar constellations are either upside down or missing altogether. But overshadowing the novelty and temporary confusion of the flipped constellations is a huge sector of new sky—dozens of constellations and a great swatch of Milky Way—that opens a stellar wonderland. It's almost like visiting another planet. The sky's best star clusters, globular clusters, nebulas and galaxies are all Down Under, not up here!

For a comparison: The Andromeda Galaxy is the brightest galaxy seen in the night sky over Canada and the United States. It is a faint, hazy patch to the un-

focal length, are wonderful to add to your collection. Some of my best shots have been taken with these lenses. Super-wide glass for 35mm cameras is much less common, however, and is therefore often significantly more expensive, both new and used, than the ubiquitous 28mm.

But working the other way through the lens repertoire, from wide-angle through normal and short telephoto (anything between 35mm and 135mm focal length), there is much available, sometimes at bargain prices on the used market. So your third lens, in addition to the 50mm that often comes with the camera and the 24mm or 28mm wide-angle, should be something in the 85mm-to-135mm range. When turned toward the Milky Way, these short telephotos, as they are called, are powerful probes of the galaxy.

aided eye. Binoculars reveal an oval smudge, and a telescope shows little more. From Australia, the Large Magellanic Cloud (a much smaller galaxy than Andromeda but 14 times closer) is a distinct gray oval to the naked eye, like a detached portion of the Milky Way. In binoculars, it becomes a swarming cloud of stars and nebulosity. The view in a large telescope is like peeking through a window into another universe.

During the southern-hemisphere winter—our summer—the center of the Milky Way Galaxy is seen directly overhead as a bulging glow, like a pregnant part of the gossamer body of the Milky Way (pages 4 and 78). Our galaxy's wheel-shaped structure is so obvious when the core is overhead that the Greek philosophers likely would have figured it out 2,000 years ago had they seen it that way. As it turned out, the question of the Milky Way Galaxy's shape wasn't settled by as-

tronomers until early in the 20th century, hampered as they were by northern-hemisphere viewpoints.

If you are traveling to Australia or anywhere else in the southern hemisphere, be sure to pack your binoculars, star charts and camera. If you can manage to include a tracking mount, you will return with a unique portfolio of starry skies utterly alien to northern observers.

Lens Quality

Over the years, we have tested more than 100 different 35mm SLR camera lenses made by more than a dozen manufacturers. If nothing else, the tests proved the old adage that you get what you pay for. The top-of-the-line lenses from Nikon, Canon, Pentax and Zeiss produced noticeably sharper star images,

Our nearest neighbor galaxy, the Large Magellanic Cloud, below, is a vast congregation of roughly five billion stars. Pinkish areas are active star-forming zones like the Orion Nebula. A 450mm f4.5 lens was used for this 20-minute exposure on Scotchchrome 400. Close-up of the Small Magellanic Cloud, facing page, top left, includes the globular cluster 47 Tucanae. Photos below and bottom of facing page by Alan Dyer; photos top and top left of facing page by Terence Dickinson.

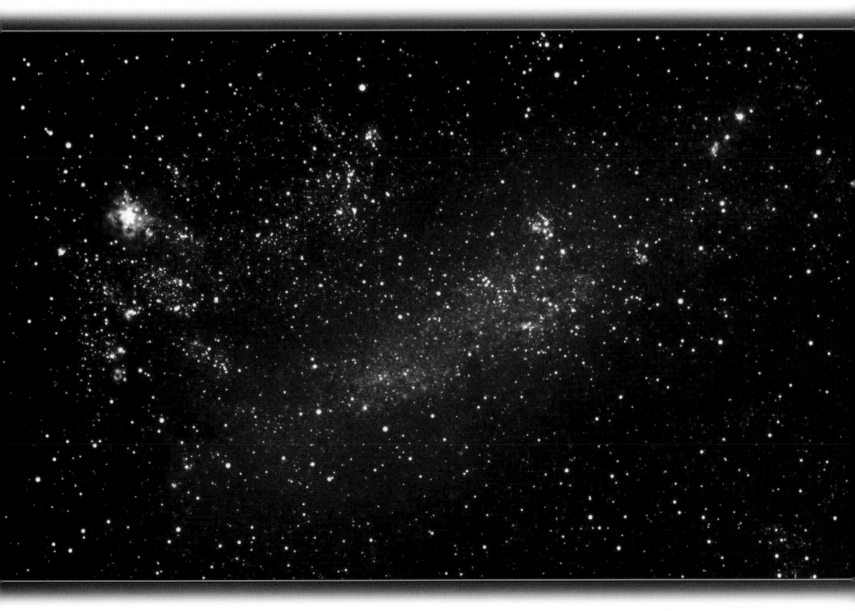

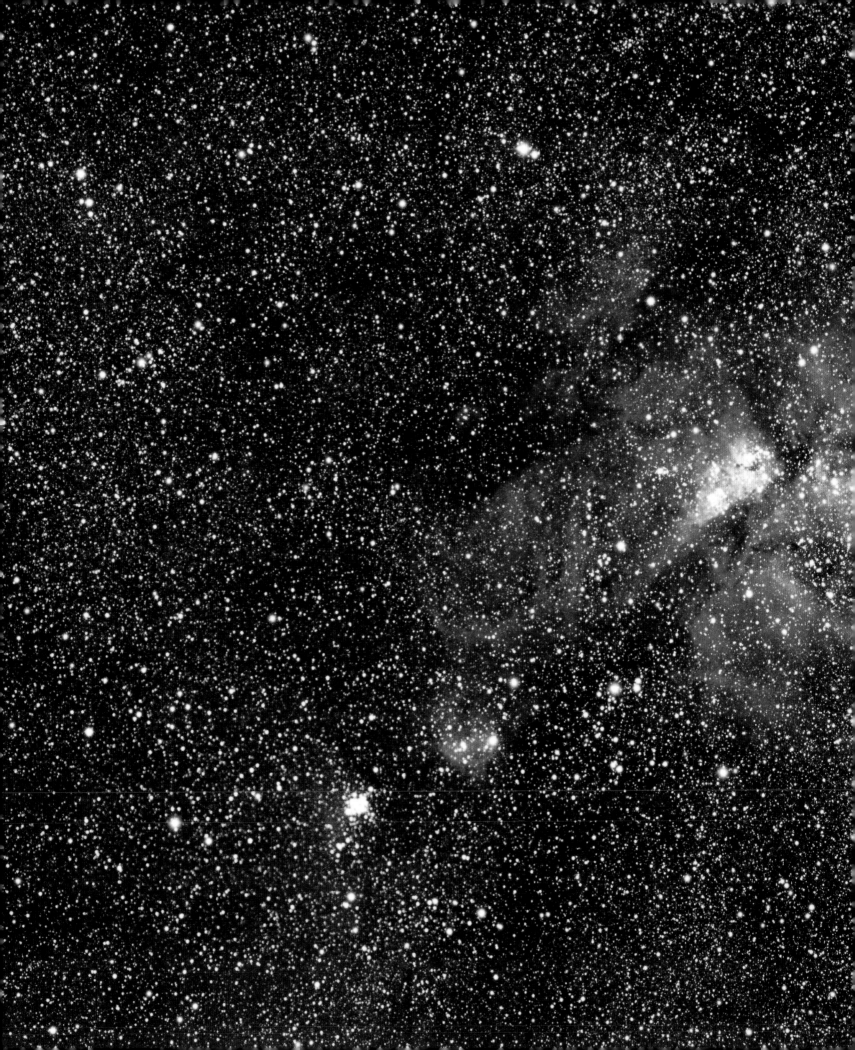

The Eta Carinae Nebula, the jewel of the southern Milky Way, is the largest star-forming region in our sector of the galaxy. Easily visible to the naked eye from the southern hemisphere, the nebula ranks among the most photo-genic objects in the heavens. This portrait, taken in Australia by Bob Sandness, was a 12-minute exposure on Fujicolor 800 with a 300mm-focal-length f1.5 Schmidt camera. The Schmidt camera is noted for its sharpness across the entire field.

particularly toward the edge of the 35mm frame.

Photographing star fields is the ultimate test for a lens. Brilliant point sources on a black background reveal the tiniest aberrations. Chromatic aberration, which marks the inability of a lens to bring all colors of the visible spectrum to the same focus, reveals itself as blue halos around the star image. The most common aberration, astigmatism, gives stars the form of broad arrowheads or sea gulls toward the corners of the frame. A third noticeable defect of astronomical images taken with 35mm camera lenses is vignetting,

Vignetting is not a lens aberration but a fact of life of optics. It occurs because the center of the field of view is receiving light rays directly down the axis of the optical system, whereas the edge of the frame is receiving the light rays at an angle. The result is that the light is more spread out at the edge of the frame and more concentrated at the center. It's not that the image is distorted; it's that less light is falling per square millimeter at the corner of the frame than on the same-sized area at the center. In some lenses, it amounts to a difference of 3 to 1. Super-wide-angle

Orion is the king of the constellations. Nowhere else in the sky are so many bright stars concentrated in a comparable area. Photo by Alan Dyer with a 50mm lens at f2.8.

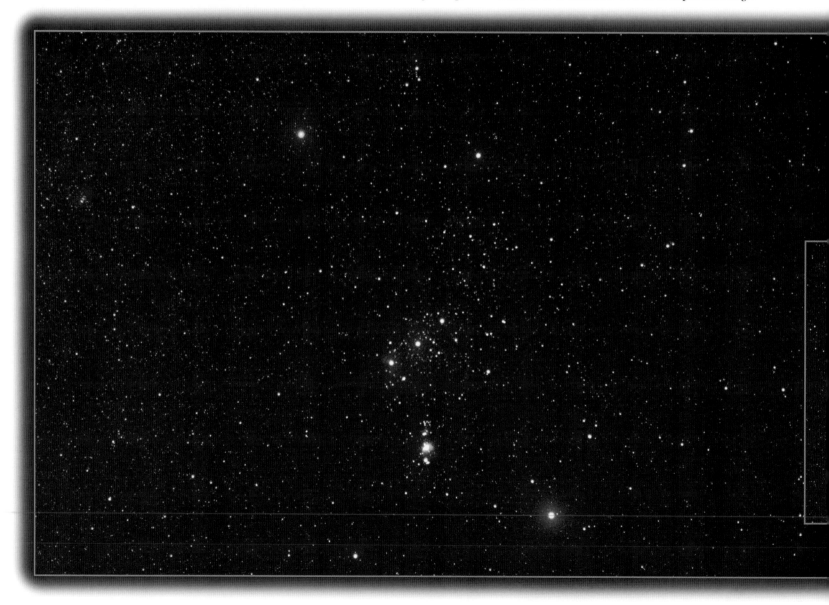

which is the obvious dimming of the image out toward the edge of the 35mm frame. This defect is particularly apparent in wide-field shots of large areas of the sky, where the sky background should be roughly the same brightness across the frame but obviously dims out toward the corners (for an example, see page 67).

lenses, such as 20mm and 24mm, are most affected by the phenomenon, and it is much less noticeable with telephoto lenses, although it's still there.

One technique that goes a long way to solving both true lens aberrations and vignetting is to stop down the lens from its fastest focal ratio (more about this on

page 89). It is extremely difficult to make a lens with edge-to-edge sharpness wide open (lowest f-stop), but there are a few legendary lenses that come very close: Nikon 105mm f2.5; Canon 15mm f2.8 fish-eye; Minolta 15mm f2.8 fish-eye; Nikon 180mm f2.8 ED telephoto; Canon 200mm f2.8 telephoto; Canon 300mm f2.8 telephoto; Canon 300mm f4 L-series telephoto.

We have yet to see any production lens between 100mm and 18mm focal length that is sharp corner to corner wide open.

ORION REGION

Being creations of human imagination, the constellations are collections of unrelated stars that just happen to form patterns in the sky. Some of the configurations are seemingly contrived, having no apparent relationship to the mythological character or creature they are named after. But a few of the constellations clearly do resemble what they were named for, and

Above, Orion and the Milky Way as framed by a 28mm lens. Moonlight exposure by John Nemy, top right, shows Orion rising over the Canadian Rockies. Bottom right, a close-up view of central Orion taken with a 180mm f2.5 lens in a 7-minute exposure on Scotchchrome 400 processed at 800. Although a great film in its day, Scotchchrome 400 is very grainy by modern standards.

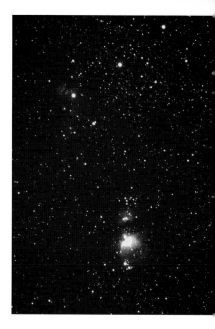

Orion is one of them. Along with Scorpius, Leo, Delphinus and a few others, Orion is instantly recognizable and outlines its namesake.

Orion forms a human stick figure, with the three-star belt, the shoulders above and the nimrod's knees below. In the area traditionally called Orion's sword lies the Orion Nebula, one of the sky's two most impressive stellar nurseries (regions of star formation). The other is the Eta Carinae Nebula, pictured on pages 82-83.

From top to bottom, Orion is three-quarters the length of the Big Dipper and is so photogenic that any lens can capture an interesting portrait, from the most expansive super-wide-angle to a narrower-angle lens that just takes in the belt and sword region. Orion's balanced, symmetrical shape, the concentration of the most interesting and brightest part of the constellation at its center and its proximity to the Milky Way make it a worthy target for any lens.

A 24mm lens is particularly effective for placing Orion's environment in perspective and for showing how Orion's stars point to the surrounding bright stars and constellations. The three-star belt points up and to the right to Aldebaran in Taurus and beyond to the Pleiades star cluster in the same constellation. The belt points down and to the left to Sirius, the brightest star in the night sky and the lead star in Canis Major. From the center of the belt straight up through Orion's head, a line extended more than twice the height of Orion itself reaches Capella, in the overhead region in midwinter at midnorthern latitudes. Capella is as bright as Rigel, the brightest star in Orion. All these relationships are visible in the photo on page 42.

Orion dominates the winter sky from the northern hemisphere. Its key central position among the winter constellations plus the impressive beauty of the configuration itself make it a natural target for celestial photography. To make the most of this asset, include a horizon in some of your shots of Orion. A 2-minute or so guided exposure will produce a horizon that is only moderately blurred and will display the giant hunter striding across the horizon or, in some cases—like the picture at top right— climbing up from behind it.

Orion is one of a handful of constellations in which many of the stars are physically related. Star formation has been active in and around the Orion Nebula for millions of years. The region is littered with hot blue stars, youthful and vigorous in their radiation and destined to burn out in less than 100 million years, a relatively short span on the time scale of the universe.

WINTER SKY TREASURES

The winter sky abounds with prime targets for astrophotographers. Anchored by Orion, the whole area that rides high in the south on midwinter evenings is littered with star clusters and nebulas. Start with wide-angle shots with Orion centered, then offset Orion to the right of the frame to catch the Milky Way (page 85, left). Then narrow in for a telephoto portrait of the Orion Nebula region (page 85, lower right).

When the temperature is near or below freezing, you may notice that your film is picking up more faint nebulosity than you might expect based on previous experience from shooting in warmer weather. In cold weather, film emulsion gains speed when used for a time exposure (or, more accurately, it loses its sensitivity to light more slowly). Around freezing, a 400-speed film acts like an 800-speed film. Be sure to take advantage of this cold-weather gift to the hardy photographer.

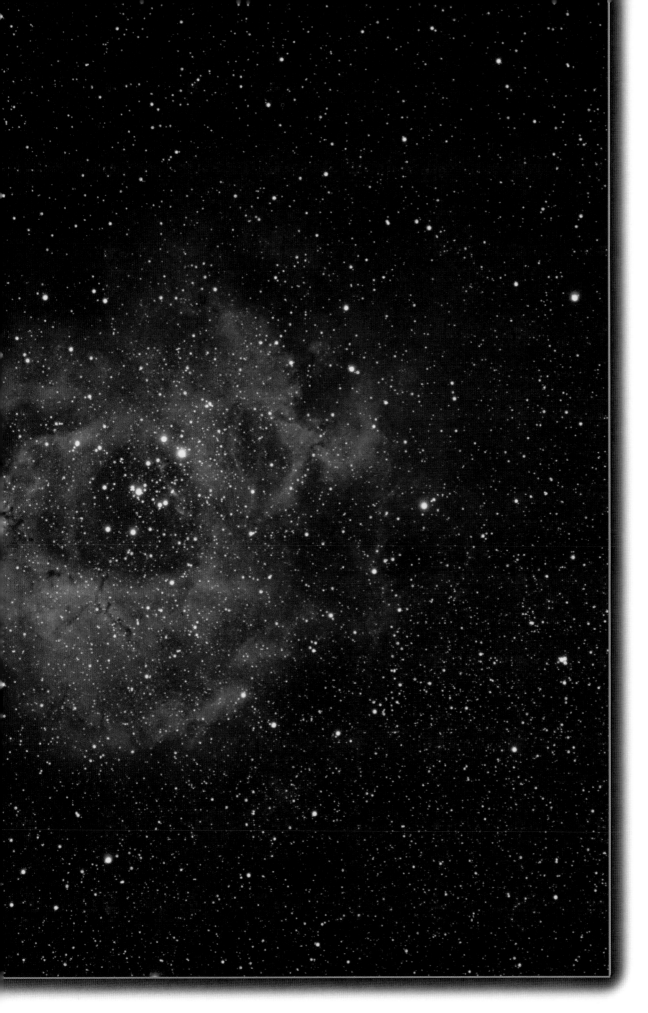

This glowing wreath of celestial dust and gas is the Rosette Nebula, a star-form-ing region near Orion (it's the small pink patch near the left edge of the photo on page 84). Jerry Lodriguss used an 800mm-focal-length f8 lens for this 50-minute shot on Fujicolor 800. On facing page, Alan Dyer used a Nikon 105mm f2.5 lens for this 15-minute exposure on Fuji-color SG+ 400 showing the Milky Way star fields around the nebula NGC1396, in the constellation Cepheus.

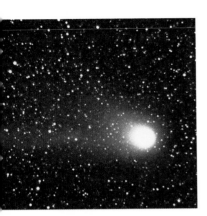

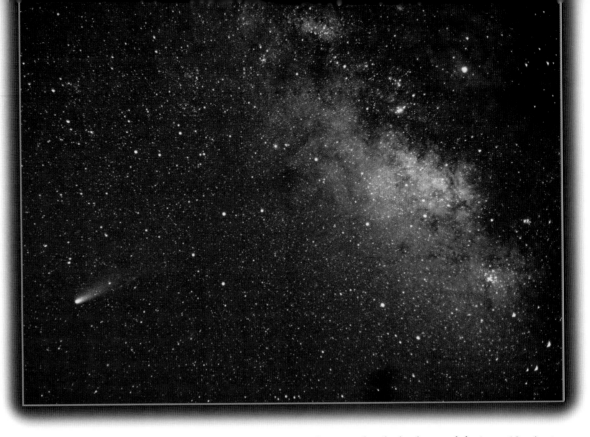

CAPTURING COMETS

The famous Halley's Comet, top right, was a bust on its return in 1986, as far as the general public was concerned. But, in fact, it was a respectable comet that lived up to astronomers' predictions, if not its own reputation. Ten-minute exposure from northern Arizona with a 50mm lens at f2.8 by Alan Dyer on Fujichrome 400, a favorite film in the mid-1980s. In the summer of 1990, Comet Levy, top, briefly reached the same brightness as Halley. This 30-minute exposure was taken on Scotchchrome 400 processed at 800 using a 300mm f4 lens. The 75-second shot of Comet Hyakutake, above, was taken with a 24mm lens at f2 using the same technique described on page 79. Two photos above by Terence Dickinson.

If wide-field guided astrophotography had no other purpose than photographing the occasional naked-eye comet, it would still be worth knowing how to do. Nothing can capture the grace and ethereal nature of these celestial vagabonds better than a tracked exposure that reveals color and detail in a comet's tail well beyond the capabilities of human vision.

Comet Hyakutake and Comet Hale-Bopp, two of the finest and most photogenic comets of the 20th century, offered interesting targets for the complete arsenal of guided cameras with both wide-angle and telephoto lenses. Everything was brought to bear on these comets—from fish-eye lenses to 400mm telephotos—and the result was a spectacular gallery of images, including the lifetime-best pictures for legions of astronomy buffs. What it proves, once again, is that cameras and lenses on tracking mounts which can produce untrailed stellar portraits are spectacularly powerful tools to record many of the sights the night sky has to offer.

In addition to their intrinsic elegance, comets can present a unique challenge to the astrophotographer—they move. A typical comet hurtles across the equivalent of the diameter of the Earth's orbit in just two or three months during its swing through the inner solar system. That means it can move a significant amount

relative to the sky background during a 10-minute exposure. Tracking the stars could result in sharp stars but a blurred comet.

Exactly that situation arose during the closest approach of Comet Hyakutake in late March 1996, when the comet moved as much as ¾ degree per hour. Exposures as short as 2 minutes with 135mm or longer lenses revealed some smudging of the comet. Longer exposures were severely blurred. The solution: track with a guidescope trained on the comet rather than the stars to keep the cometary detail as sharp as possible while letting the stars trail—or keep the exposure short.

In March and April 1997, Comet Hale-Bopp was at its best. This colossal comet was brighter than Hyakutake, even though it was 13 times farther away. Because of its distance, Hale-Bopp moved through the constellations at less than two degrees per day. Only relatively long exposures, more than 15 minutes, required tracking compensation. In general, you won't have to worry about blurred comets with 300mm or shorter lenses unless the comet is moving more than two degrees per day.

The F-Stop Quandary

One of the most frequently asked questions about piggyback-type astrophotography is, What f-stop should I use? The quick answer is to start with the lens wide open. This would likely be f2.8 with a 24mm or 28mm lens, f1.8 or f1.4 with a 50mm lens and f2.5 to f3.5 for a lens in the 85mm-to-135mm range. Just

dial in the lowest f-number, focus at infinity, and try it out. What you'll likely find is that the central region of the 35mm frame will look pretty good but the edges will display the aberrations shown on page 67: astigmatism and vignetting.

Both of these effects are reduced by stopping down the lens. A single f-stop difference, from f2 to f2.8, for example, will greatly improve the performance of most lenses. The best plan is to shoot a test roll using each of your lenses wide open and then stopped down in half-stop increments. An f1.4 50mm lens would therefore be tested at f1.4, f1.7, f2, f2.4 and f2.8. When your film is processed, examine the resulting sequence and note the point at which further improvement in edge-of-field image performance becomes almost undetectable, then use that setting from now on.

Depending on how fussy you are about image quality, the optimum setting for most lenses is between one and two f-stops from the wide-open setting. The prob-

lem, of course, is that the more the lens is stopped down, the longer the exposure must be to compensate. As with many things, it ends up being a compromise between perfection and practicality.

Inexpensive lenses are usually loaded with astigmatism, and the high cost of reducing this effect (expensive glass and exotic lens designs) is the main reason some lenses cost much more than others. Vignetting, on the other hand, is largely inherent in

Comet Hale-Bopp at its best on March 27, 1997. Gaseous tendrils sweep away from the comet's head, adding a blue fringe to the dominant but essentially featureless white dust tail. For this photo, Terence Dickinson used a 440mm-focal-length Ceravolo f2.3 Maksutov-Newtonian astro-camera for a 9-minute exposure on Fujicolor SG+ 400.

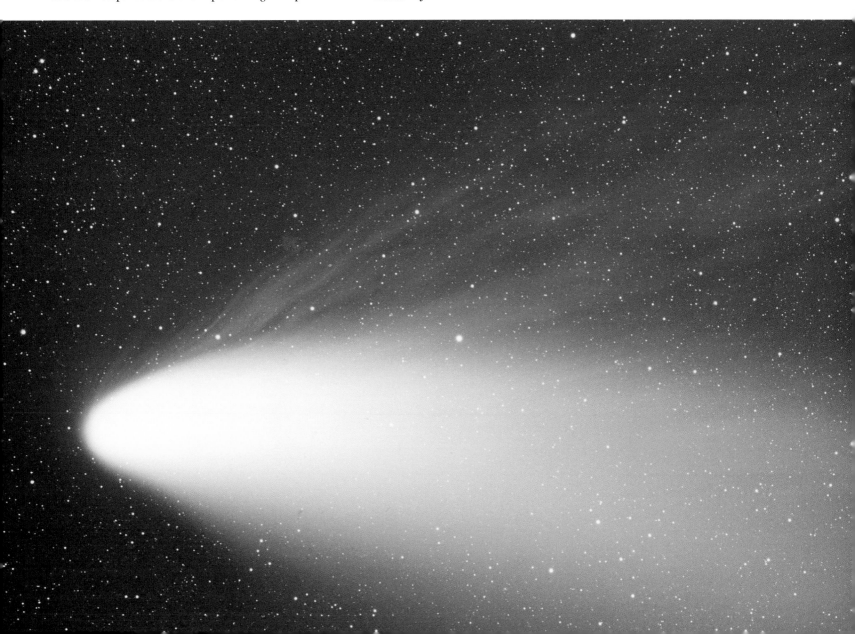

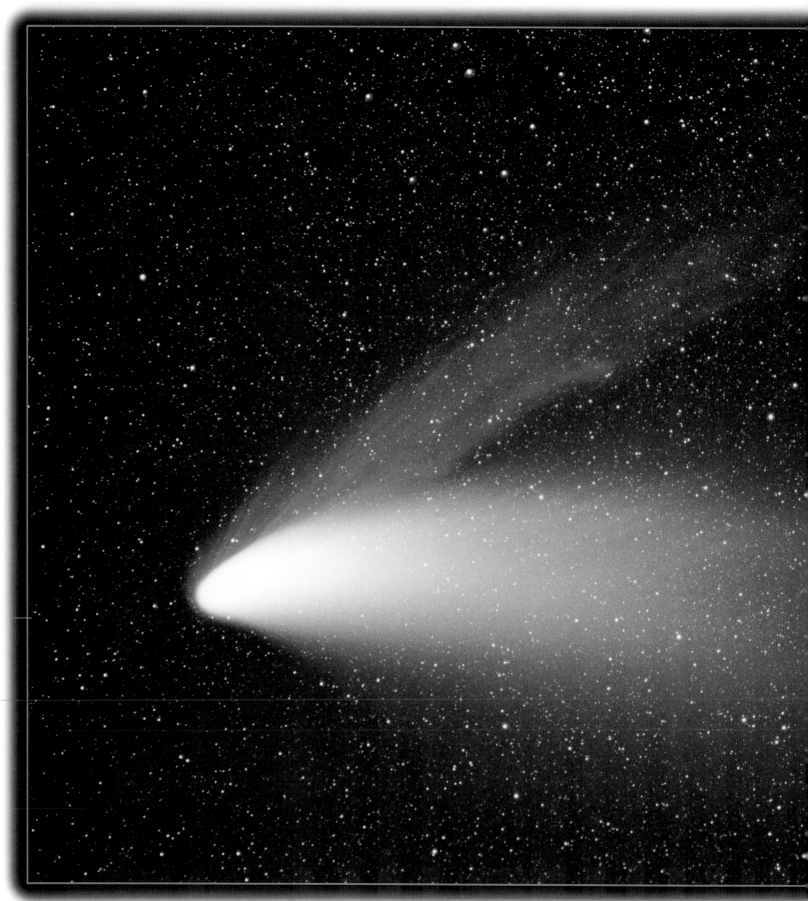

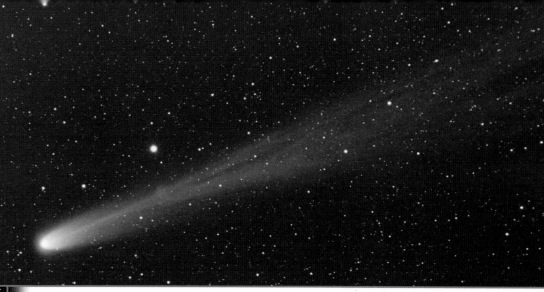

camera optics, and most of it cannot be designed out. Nevertheless, it, too, is significantly reduced as the lens is stopped down. Astrophotos are uncompromising in their ability to reveal lens aberrations. But it's a problem that can be controlled.

Observing-Site Selection

Great astrophotos can be taken just about anywhere. An eye for a good composition, the right combination of celestial clockwork and nature's cooperation…there are so many variables. But when you're going for the faint detail—the subtleties of the Milky Way, the outer reaches of a nebula or the wispy tendrils at the end of a comet's tail—you need a dark location, preferably at higher elevations.

Altitude is great if you can access it, but there are large parts of North America where this is not an option. Even more important, however, is the intrinsic darkness of the site. This means that the site *must* be more than an hour's drive from large metropolitan areas and their lights. A small glimmer on the horizon seen by the eye can easily produce a huge glow on the horizon in a 5-minute exposure. A lot more of the air over the source is being illuminated than the eye can pick up, but the film makes a fine record of it, to the detriment of astronomical objects in that direction.

Escaping horizon glow is a tough assignment as the lights of civilization become more pervasive. But great astrophotos can be obtained without driving completely away from the glow of a major urban area. By deciding in advance what objects you will be photographing, you can plot the direction of your escape from the lights so that the intended celestial targets are in the darkest part of the sky. This strategy works best when you travel to the south of a major city. With the glow to the north, you take your pictures toward the south, which is the most interesting part of the sky anyway, because it presents the maximum amount of seasonal change of the constellations.

Comet Hyakutake was an astrophotographer's delight in late March, above, and early April 1996, top. Hyakutake's tail was thinner but longer than Hale-Bopp's. Both pictures were 4-minute exposures by Terence Dickinson on Fujicolor SG+ 800 with a Tamron 180mm lens at f2.5. Left, using a Nikon 180mm f2.8 lens, Alan Dyer captured Comet Hale-Bopp on April 1, 1997, with an 8-minute shot on Fujicolor SG+ 400.

91

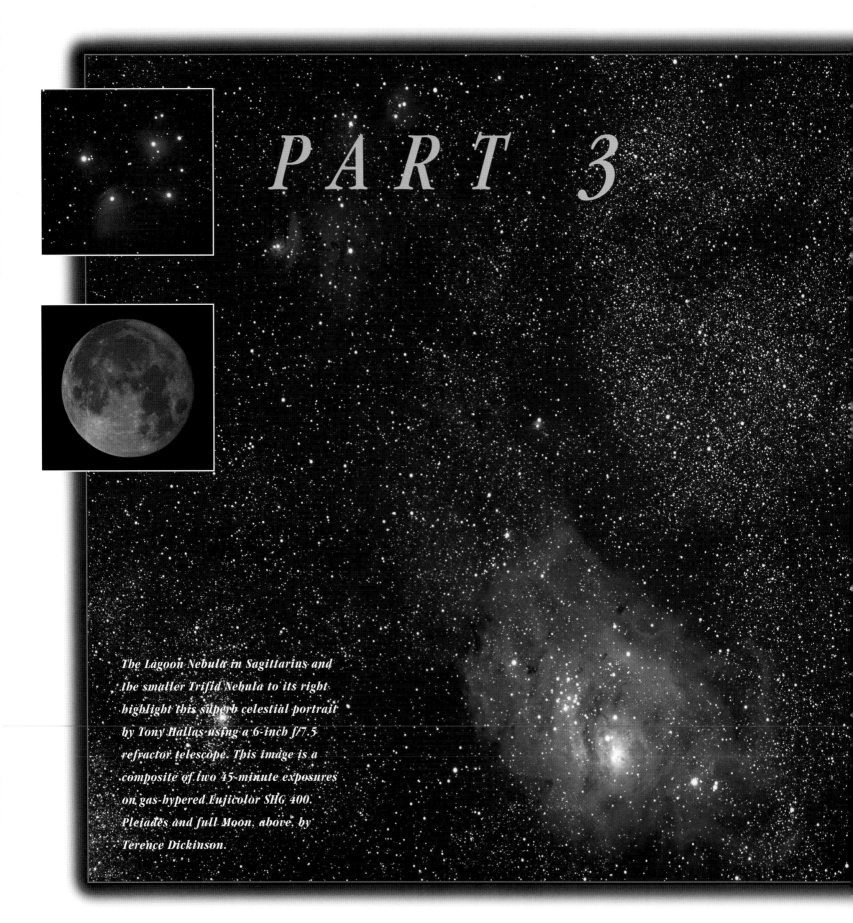

PART 3

The Lagoon Nebula in Sagittarius and the smaller Trifid Nebula to its right highlight this superb celestial portrait by Tony Hallas using a 6-inch f/7.5 refractor telescope. This image is a composite of two 45-minute exposures on gas-hypered Fujicolor SHG 400. Pleiades and full Moon, above, by Terence Dickinson.

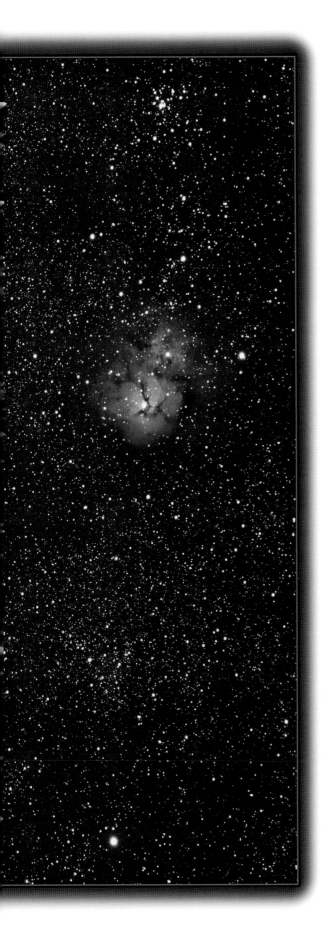

Probing Deeper:

Through the Telescope

Through-the-telescope astrophotography, also known as prime-focus photography, is what many embryonic backyard astronomers aspire to do from the first night out with a new telescope. However, owning a telescope that is potentially suitable for taking pictures is not enough. Astrophotography is an extension of amateur astronomy. A foundation of knowledge and experience in the basics of observing the night sky along with at least a taste of the less demanding types of astrophotography—star trails and piggyback shots with wide-angle lenses—are highly recommended *before* attempting to shoot anything through a telescope other than the Moon. We mention this at the outset here to emphasize that through-the-telescope imaging should be the culmination of your astrophotographic pursuits rather than the starting point. This is the deep end of the pool. It can be lots of fun down here, but most of us need to spend some time at the shallow end first.

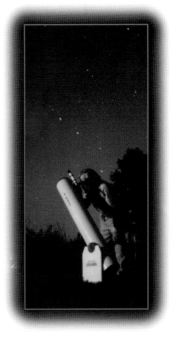

After spending a few evenings observing with a small telescope, almost every amateur astronomer dreams of photographing the wonders of the cosmos. Photo by Terence Dickinson.

CAMERA ON TELESCOPE

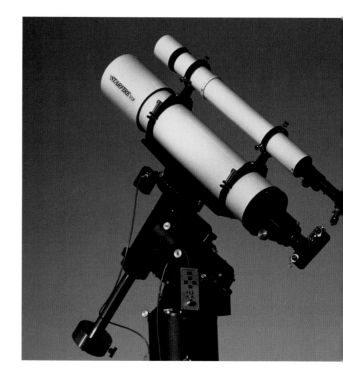

During the 1970s, Jack Newton used a trailer-mounted 20-inch f/5 Newtonian reflector for cold-camera astrophotography, above. The Astro-Physics 6-inch f/7 apochromatic refractor, right, is outfitted for astrophotography with an oversized German equatorial mount and a 3-inch refractor as a guidescope. The first step toward taking pictures through a telescope is coupling the camera to the scope. The standard camera adapter for attaching a 35mm SLR to a Schmidt-Cassegrain is shown at bottom left. The basic coupling for other types of telescopes, bottom right, consists of a camera T-ring and either a 1.25-inch or a 2-inch focuser adapter. A camera used with a lunar/planetary eyepiece projection coupling is shown at bottom of facing page.

Three types of telescopes are in wide use today, and all can be turned to astrophotography. The *refractor*, using lenses, spyglass-style, focuses the image at the rear of the telescope tube. The *Newtonian reflector* has a gently curved parabolic mirror at the bottom of the tube that collects the incoming light and reflects it to a secondary mirror near the top of the telescope, which in turn diverts the converging cone to a focuser at the side of the tube. The third type is the *Schmidt-Cassegrain*, which has a slightly curved lens at the front, called a corrector plate, and a primary mirror at the rear that focuses light forward to another mirror attached to the back of the corrector plate. The small corrector-plate mirror returns the light through a hole in the primary mirror to a focuser at the rear of the telescope.

All three classes of telescopes have been used to take superb astrophotos, and aficionados of each will argue the merits of one over the other. The fact is, there are outstanding examples of astrophotography with each type, and images from all three types of instruments are presented throughout this book. The common feature is that virtually all the shots were taken with telescopes with focal ratios between f/5 and f/8. This is the "sweet spot" for telescopic astrophotography, and it indicates one of the chief differences between through-the-telescope imaging and piggyback photography with camera lenses.

Most camera lenses used for astrophotography are f4.5 and faster, whereas the typical telescope focal ratio for astrophotography is f/4.5 and slower. The reason for this is that for visual use, the most versatile telescopes have focal ratios in this range. Also, the

main purpose of through-the-telescope photography is to get close-up views of celestial targets such as nebulas, star clusters and galaxies, so focal lengths in excess of 1,000mm are favored. The 6-inch f/7 apochromatic refractor shown above, for example, has a focal length of 1,100mm, and the 20-inch at top left has a 2,500mm focal length, both ideal for observing and for photography. Moreover, telescopes of excellent optical quality are commercially manufactured in focal ratios of f/5 to f/8 at a reasonable cost. Faster telescopes (f/2 to f/4.5) are extremely difficult to craft to exacting optical tolerances.

Although Schmidt-Cassegrain telescopes are typically f/10, both Celestron and Meade—the two major manufacturers of these instruments—offer telecompressor lenses that fit at the rear of the telescope to reduce the focal ratio to f/6.3. These lenses work very well, as they also flatten an inherent curvature in the Schmidt-Cassegrain's photographic field.

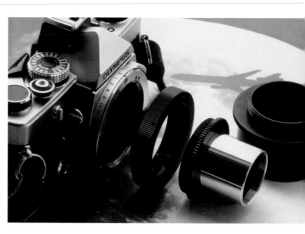

Although the terminology used to describe the focal ratio of telescopes is the same as that commonly used by photographers and camera buffs, the interpretation is different. To a photographer, a 200mm f4 telephoto lens has an aperture of 50 millimeters and a focal length of 200 millimeters. However, if an astronomer has a 200mm f/4 telescope, the telescope's aperture is 200 millimeters and the focal length is four times the aperture, or 800 millimeters. (Also, astronomical-equipment focal ratios are generally written with a slash, as in f/5, whereas camera focal ratios are not.) This perpetually confusing discordance is so established that there is no way it will ever change. In this book, we follow the established practices.

Camera couplings used to attach a 35mm SLR camera to the prime focus of a telescope come in two basic configurations: the manufacturer-supplied coupling from Celestron or Meade that threads in at the rear of a Schmidt-Cassegrain and, for other telescope types, the camera T-ring with a 1.25- or 2-inch adapter to go into the telescope focuser in place of the eyepiece. The 1.25-inch adapter is used only if the larger size is not accommodated by the telescope, because it has the disadvantage of significantly vignetting (blocking) the light reaching the peripheral part of the 35mm film's frame, leaving the edges and the corners blank. Some 2-inch adapters also vignette the frame, but usually only the corners. The best 2-inch adapter we have seen, which is from Astro-Physics, has a 45mm clear aperture, compared with 37mm to 39mm for most other commercial models.

A lot can go wrong during a 15- or 30-minute time exposure taken through a telescope. A telescope that is perfectly acceptable for visual use can be a nightmare when utilized for astrophotography. Generally speaking, commercial mounts made for telescopes that are primarily intended for visual use will prove inadequate for through-the-telescope astrophotography. Veteran astrophotographers generally opt for mounts made for larger telescopes than the one they

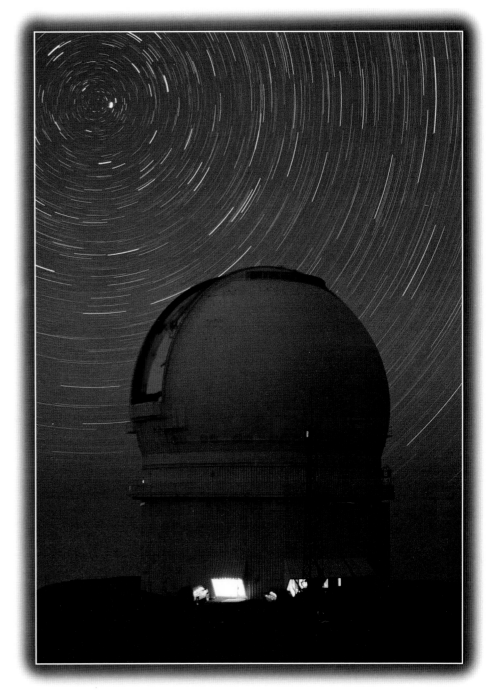

Major research observatories, such as the Canada-France-Hawaii Telescope, above, rarely take color portraits of celestial objects, either on film or with electronic-imaging techniques. Cutting-edge research relies on other types of imaging. The use of color-film emulsion for astrophotography is now virtually the sole preserve of amateur astronomers. Photo by Terence Dickinson.

The principle of an off-axis guider is illustrated in the two photos at the bottom of this page—one showing the camera in place, the other with it removed to reveal the small pick-off prism that feeds a portion of the telescope field to the guider eyepiece. A star selected for guiding is positioned in the eyepiece cross hairs. Off-axis guiders are often preferred on larger telescopes, while guidescopes are recommended with smaller-aperture instruments. Many astrophotographers are choosing to replace the cross-hair eyepiece with a CCD guider and let it do the work. Lumicon off-axis guider is seen at bottom center, facing page.

actually intend to use. The bigger mounts are more stable, have more accurate gearing and are less susceptible to vibration from wind. Mounts from Astro-Physics and Losmandy are favored by many astrophotographers for their rugged stability and accuracy.

GUIDING

The precision that astrophotography demands explains why the mount must be beefy yet track with the grace of a fine watch. If through-the-telescope star images are to appear small and round—the hallmark of a deep-sky astrophoto—the tracking accuracy should be around two arc seconds. (One arc second is 1/3,600 degree, or about the width of a dime at one mile.) This sounds impossible, but a good telescope mount can do it, though not without a bit of help.

The gearing in a well-designed equatorial mount should achieve an accuracy of plus or minus seven arc seconds, which means that while its drive motor is compensating for the Earth's rotation, its aim point

deviates no more than seven arc seconds either way from a mean position relative to the celestial sphere. Some mounts do better than this, but few can reach the criterion for perfect tracking—plus or minus one arc second. Gears can't be manufactured that accurately. There are two ways to overcome this deficiency, and you'll obtain the best results when both are utilized.

The first is periodic error correction, or PEC, which is essentially a recording of the mount's gear errors. Once the recording is fed into the mount's controller—a procedure often done at the factory—the controller automatically commands the mount's right-ascension drive to slow down or speed up to compensate for the gear errors. (The controller is

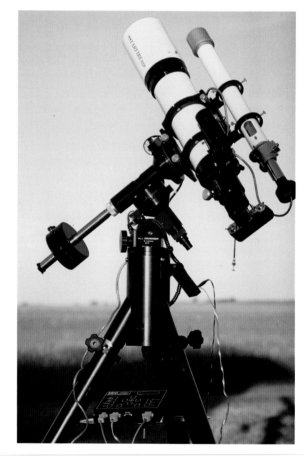

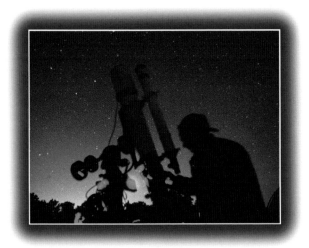

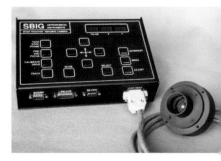

a 300mm, but not a telescope. That requires *guiding*.

In the dark ages of astrophotography (before 1991!), guiding had to be done manually, by eyeball, using either a guidescope attached to the telescope on adjustable ring mounts or an off-axis guider (two photos at bottom of facing page). Both guidescope and off-axis guiders have illuminated cross-hair eyepieces for visually tracking the guide star throughout the exposure. As the star drifts from the cross hairs, the telescope operator pushes one of the mount's control-paddle buttons to slow down or accelerate the right-ascension or declination motor to bring the star back to the cross hairs. The cross hairs must be continuously monitored for manual guiding to work. Not much fun on a cold night.

Some people still do manual guiding, and they have our sympathy. However, with CCD auto-guiders —available from the Santa Barbara Instrument Group and Meade for as little as $400—the era of manual guiding has almost drawn to a close. Not only do CCD guiders relieve you of hunching over the guiding eyepiece throughout most of an astrophoto session, but they guide more accurately than a human can. We have both used CCD guiders for years. If you are serious about your astrophotography through a telescope, get a CCD guider. Imagine retreating to the house and having a snack or using a second telescope to enjoy the celestial sights while your robotic CCD guider does all the work. Isn't technology wonderful?

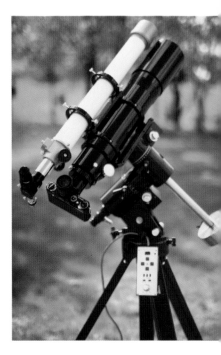

The final link in the chain leading to perfect astrophotos is polar alignment. Polar-alignment scopes (see page 71) can be used to position your telescope mount's polar axis to within a couple of arc minutes of the celestial pole. That's close enough for through-the-telescope exposures up to about 30 minutes. For longer exposures, extreme precision in polar alignment is advised to avoid field rotation (a trailing of some stars in the field as they rotate around the guide star because of poor polar alignment). The best solution is a permanently mounted telescope in an obser-

the push-button paddle seen attached to the mount in the photo at right.) Periodic error correction reduces the mount's gearing errors substantially—enough for tracking a piggyback 200mm lens, possibly

Small, highly portable f/6 to f/8 refractors, such as the Astro-Physics models shown on these two pages, become excellent astrophotographic systems when teamed up with equatorial mounts intended for somewhat larger telescopes. The guidescope on the telescope at right has a battery-powered illuminated-reticle eyepiece (see close-up, bottom left) intended for visual guiding during the exposure. The guidescope on facing page is fitted with a Santa Barbara Instrument Group ST-4 CCD auto-guider, shown in close-up on facing page, far left, top. ST-4 autoguider control box, top right; the CCD chip is the tiny rectangle inside the CCD head. Bottom right (left to right), f/6.3 Schmidt-Cassegrain telecompressor lens, off-axis guider and camera T-ring adapter.

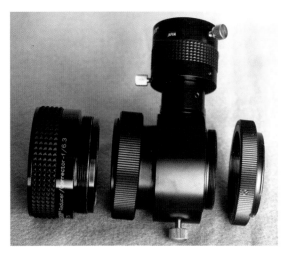

vatory where the scope's polar alignment can be tweaked over many nights for high accuracy. Here's how to do the tweaking, whether the telescope is permanently mounted or not:

After setting the mount as close to the celestial pole as you can, aim the telescope at a star due south, about halfway from the horizon to overhead. If possible, put an illuminated-reticle eyepiece in the telescope to keep track of the star's motion. Otherwise, defocus the star and place it on the north edge of the field of view. Ensure that the mount's drive is running. Ignore any drift the star makes east or west, but watch for a drift north or south. It may take a few minutes to show up.

If the star drifts north, the polar axis is aimed to the left of the actual pole for northern-hemisphere observers. If the star drifts south, the polar axis is aimed to the right of the pole. Move the mount in azimuth in the appropriate direction, then go back to the star, and repeat the process. Eventually, no drift should appear even after 20 minutes.

Now, point the telescope at a star in the east, fairly low to the horizon. Observe it for a while, again ignoring any drift other than a shift north (toward Polaris) or south. If the star drifts north, the polar axis is aimed above the actual pole. If it drifts south, the polar axis is aimed below the pole. Adjust the altitude of the polar axis accordingly. Go back to the east star, and watch again. The drift should have improved. Finally, repeat all the steps until no detectable drift occurs. (If this is done in the southern hemisphere, substitute "south" everywhere we have said "north," and vice versa.) Such a tedious procedure is best reserved for permanent setups or for astrophotographic situations in which only perfection will do.

Focus

Everything else can work perfectly, but if the telescope is not focused so that sharp star images are falling on the film, nothing else matters. In some of the equipment pictures in this book, you will see a magnifier attachment on the 35mm cameras. These accessories magnify the ground-glass focusing screen, making it easier to bring stars in the field of view into sharp focus and to see the object being photographed. Even with the magnifier, sharp focusing is easier if the telescope is turned to a bright star. A magnifier made

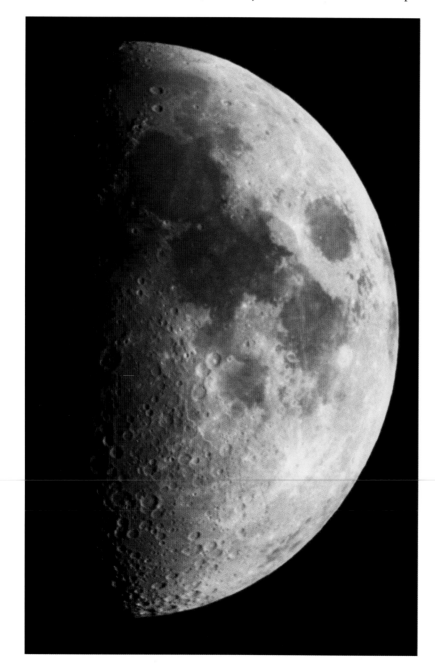

Use exposure guide on page 142 for shots of the entire Moon. For close-ups of the lunar terminator, below, expose for about 1 second at f/30 with 100-speed film, regardless of the lunar phase.

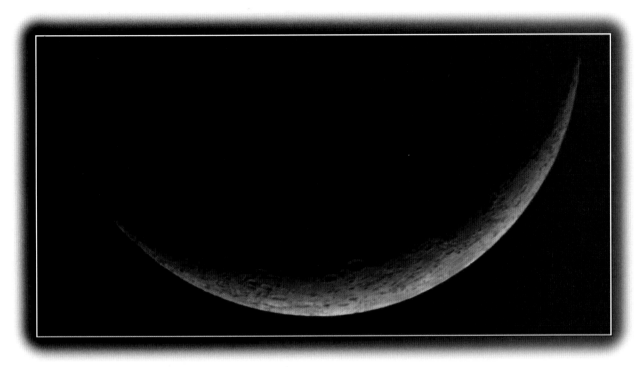

of a telescope eyepiece can sometimes be rigged up to serve the purpose of magnifying the focusing screen. Magnifiers used by graphic designers and professional photographers also work.

This camera-focusing-screen business is one of the major frustrations when using 35mm SLR cameras for deep-sky astrophotography. Most of these cameras have dim screens made for daylight applications. One answer is the Beattie Intenscreen, intended for low-light viewing, although it is available for only a limited number of camera models. Taurus Technologies offers astrocameras and special focusers that completely circumvent viewing through the 35mm SLR's ground-glass screen by using a telescope eyepiece for both focusing and locating the target object. Some of Taurus's devices incorporate a 35mm astrocamera; others accept any fully mechanical camera, regardless of how impractical its focusing screen might be for astronomy. For many astrophotographers, elimination of the camera view screen from focusing duties is a welcome development.

EXPLORING THE MOON

The Moon is a spectacularly alien world when examined by telescope. Even binoculars reveal dozens of craters in sharp detail. So near is the Moon—just 100 times the width of North America away—it is the most inviting target for budding astrophotographers. And the Moon is comparatively easy to shoot.

But despite the Moon's looming presence in our night sky, it is deceivingly puny in a telephoto lens. In a 300mm lens, for example, the full Moon is just 2.7mm wide on a 35mm slide or negative. A telescope is really the essential tool to make the Moon big enough for impressive photographic results.

Almost any telescope will do the job. A T-ring and

Photo data: All photos on this page by Terence Dickinson: top and bottom right, 6-inch f/7 refractor on Kodak Ektachrome Elite 100; bottom left, 24-inch reflector on Fujichrome Velvia 50. Photos on facing page, top to bottom, by Terence Dickinson, Jack Newton and Brian Tkachyk.

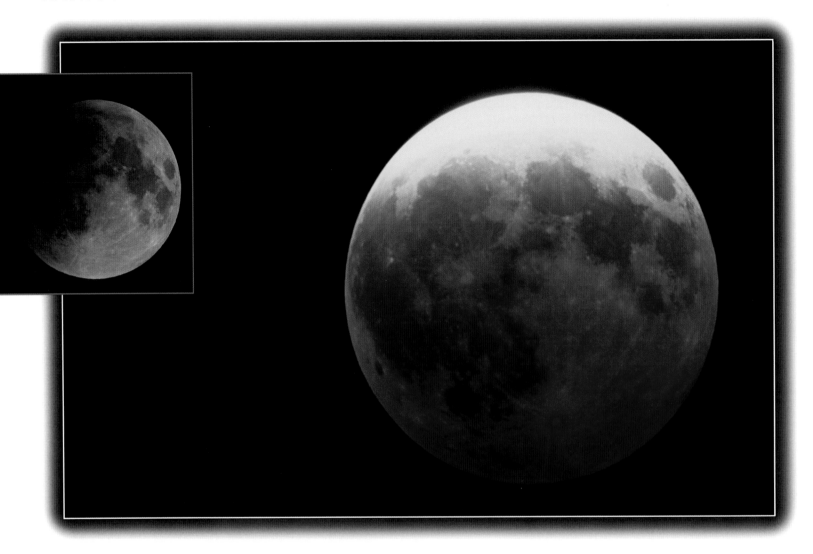

The near-total lunar eclipse of March 23, 1997, above (large image), had the classic coppery hue that makes these events so memorable. Terence Dickinson used a 30-second exposure with a 6-inch refractor at f/10 and Kodak Ektachrome Elite II 100 pushed-processed to 400. Early stages of a partial lunar eclipse, inset, by Terence Dickinson. The Moon just before totality, right, by Jack Newton.

the standard adapters described on pages 94 and 95 will get your camera hooked up. Focusing is easy on such a bright object. The biggest potential problem—mirror slap—emerges when the 35mm SLR camera's shutter actually fires. Mirror slap occurs when the camera's mirror flips up to allow light from the scene to reach the film plane. Unless the telescope has a sturdy mount, the telescope will vibrate and the shot will be fuzzy. Some cameras have a mirror lock-up feature, which eliminates much of the problem.

LUNAR ECLIPSES

A total lunar eclipse occurs when the Moon is completely within the Earth's shadow. The Moon is dimmed but usually does not disappear, because a small amount of sunlight leaks through the Earth's atmosphere, giving the Moon a coppery hue. The whole event is easily visible to the naked eye. If you can see the Moon on eclipse night, you can see the eclipse.

Photography can provide a memorable record of the event, but because lunar eclipses can vary significantly in brightness from one to the next, the following exposure guidelines are just rough approximations for 400-speed film used at f8. Always bracket: partial phases, 1/250 second; partial phases near totality, 1/4 second; totality (yellowish

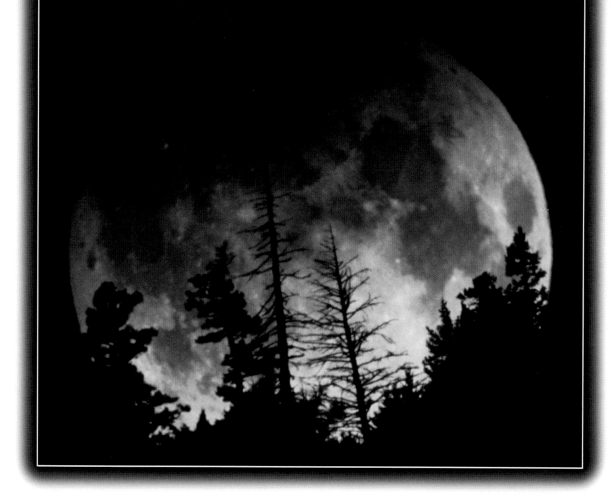

bronze eclipse), 1 to 10 seconds; totality (coppery brown eclipse), 10 to 100 seconds.

Upcoming total eclipses of the Moon visible from North America occur on January 20, 2000; January 9, 2001; November 8, 2003; October 27, 2004; March 3, 2007 (eastern half of continent); August 27, 2007 (western half of continent); February 20, 2008; and December 21, 2010.

An eclipsed Moon near the horizon, above, provides a rare opportunity to compose a unique shot. Jim Failes used an 8-inch Schmidt-Cassegrain telescope to catch the Moon as it descended behind a distant mountain. Alan Dyer shot the rising partially eclipsed Moon, below, at dusk on May 24, 1994.

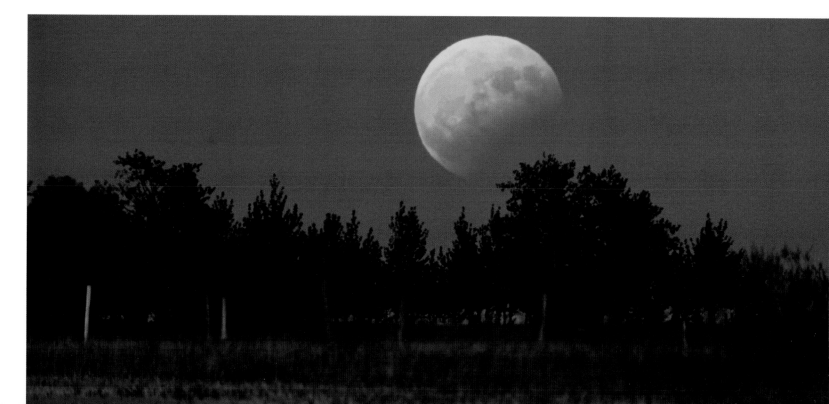

SOLAR ECLIPSES

There are two types of solar eclipse, total and partial. During a partial eclipse, the Moon covers a portion of the Sun—interesting, but not spectacular, and safely visible *only* with proper filters. A total eclipse of the Sun, by contrast, is a stupendous sight, as the Sun is completely covered by the Moon, leaving the pearly corona easily visible without eye protection.

Observing a total eclipse of the Sun in a cloudless sky is an intense, some would say spiritual, experience. Veterans of several eclipse expeditions say that you should spend your first one simply watching and taking in the full power and beauty of the phenomenon. Photographing the event means concentrating at least partly on your equipment, but the reward is a lifelong memento of those precious few minutes of totality. (A rough eclipse exposure guide is given in the caption at left.)

Upcoming total solar eclipses occur on February 26,

1998, in the Caribbean; August 11, 1999, in Europe (the path of totality sweeps from northern France to Rumania); June 21, 2001, in southern Africa; and October 3, 2005, in Spain and North Africa. Not until August 21, 2017, does the Moon's shadow pass over North America.

Filters

With color emulsion, very few filters can be employed for deep-sky photography that don't force an unacceptable color shift. After all, the main purpose of filters is to filter out certain parts of the spectrum. Color film is designed to embrace the entire visible spectrum. But color emulsion also has additional sensitivity to wavelengths at the ultraviolet (extreme blue) end of the spectrum, to which the eye is relatively insensitive. This is why the standard filter at the front of your camera lens is likely designated UV or 1A, both of which block ultraviolet light.

In practice, the filters are probably more useful for protecting the lens's front surface from scratches and fingerprints. In any case, for astronomical color-emul-

For just a few seconds at the beginning and end of a total solar eclipse, the edge of the Sun peeks above the rugged craters and mountains at the Moon's limb, producing the dramatic diamond-ring effect, above. Photo by Robert May. Midtotality, right, with the corona—the Sun's diffuse atmosphere—surrounding the black disk of the Moon's night side. For this shot, Jack Newton used a Celestron C90 (a 90mm f/10 Maksutov-Cassegrain telescope) for a 2-second exposure on Kodak Ektachrome 400. If possible, the eclipse photographer should try for shots all the way from 1/250 second to several seconds on 100-speed film at f8. Telephoto lenses and telescopes with focal lengths from 500mm to 1,500mm are recommended. A leafy tree created hundreds of natural pinhole projectors, facing page, bottom left, spreading a blanket of partially eclipsed crescent Suns across the ground. Photo by Jack Newton.

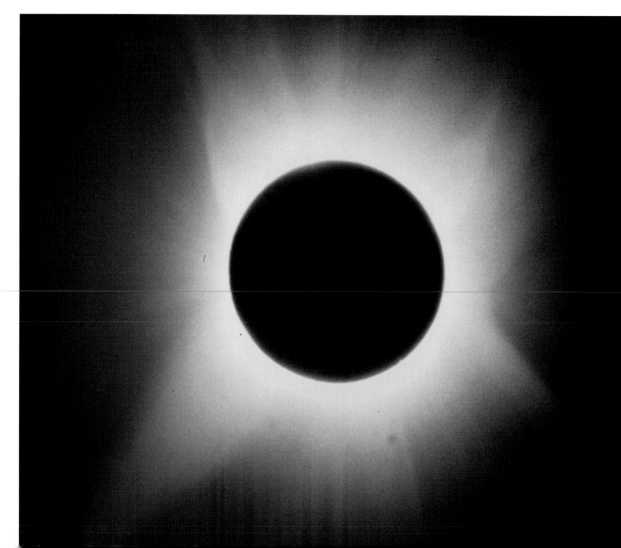

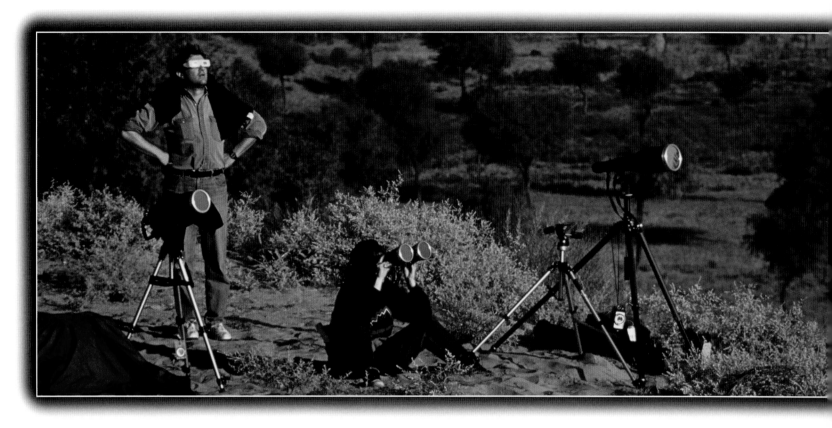

sion applications, the difference is hardly noticeable.

The Earth's atmosphere is never completely transparent at night. Dust and aerosols (minute droplets) from distant volcanoes, forest fires, dust storms or nearby industrial activities block starlight and are illuminated by the lights of civilization. There is also a subtle natural sky brightness known as the airglow, a weak auroralike phenomenon that varies from night to night. The result of any of these interferences is that some nights, a certain film in a 15-minute exposure will have a brighter background than other nights with the same film and exposure under what may appear to be identical conditions. Our response: all the more reason to keep shooting!

For most color-film-emulsion astrophotography, we go filterless or, at most, use the very gentle UV or 1A

filters. One exception is Lumicon's Deep-Sky Filter, which effectively works to block yellow and blue wavelengths coming from artificial light sources, such as streetlights, and the airglow. The filter is designed to admit the predominant red and green emissions from nebulas, hence it is sometimes called a nebula filter. The Deep-Sky Filter's use with color film is limited for two reasons. First, it can be used only with negative film, because it can introduce a color shift that has to be corrected before the prints are made. Second, the filters are quite dense, requiring a compensation that at least triples the normal exposure. The pictures of nebulas and galaxies by Jack Newton later in this chapter show that the Deep-Sky Filter really does work with color emulsion, but here's what he had to do.

The fastest color-print film ever made—Konica

Half a world away from home, two eclipse chasers in India, above, watch the partially eclipsed Sun ascend into a blue sky on October 24, 1995, the day of a total solar eclipse. Full-aperture solar filters and glasses are mandatory for all solar viewing except during the dramatic minutes of totality. Photo by Donald MacKinnon. Left, an annular eclipse photographed by Alan Dyer.

The normally invisible solar corona shows its delicate streamers at the height of totality during the eclipse of July 11, 1991, as seen from La Paz, Mexico. This exceptionally detailed shot through an Astro-Physics 5-inch f/8 refractor was taken on medium-format film using a radial gradient filter, which suppresses the light reaching the center of the image in order to prevent it from overwhelming the subtle outer detail. Photograph by Roland and Marj Christen.

3200—was used in medium format (six-centimeter-square film) with a cold camera to give an already fast film its maximum possible speed. With this setup, it still took half-hour exposures to get the filtered shot at f5. Slower-speed films were tried, but they worked on only a few high-surface-brightness objects. The Deep-Sky Filter does work, yielding very dark skies while allowing the light of the target nebula or galaxy to come through. This filter is more likely to be applied successfully with fast lenses (f2 to f2.8), where the increased exposure can be accommodated.

Image Enhancement

The most common procedure in through-the-telescope astrophotography is to shoot the target unfiltered with the best available film—usually color negative—and apply color correction, if needed, during the making of the photographic prints. Now, the wide use of powerful desktop computers has made it possible to have complete control over the preparation of the final image. The key is to have the negative or slide digitally scanned. For just a few dollars, the image can be scanned to a Kodak Photo-CD. Your local photo dealer can arrange this, or you can seek out a professional imaging service. Such an imaging service can also scan an image to a file and load it onto a disk you supply, such as an Iomega Zip disk.

It's best to have a bunch of pictures done at once, as there is a setup fee for each job. The standard Photo-CD scan has a resolution of about 2,000 lines per inch, which translates to 3,000 lines for the long dimension of a 35mm slide and 2,000 for the narrow dimension (a 35mm frame is 24 by 36 millimeters). This is plenty of resolution for most purposes. Using software like Adobe Photoshop (our favorite), the image can be infinitely manipulated—increased in contrast, color-balanced, cropped—to allow you to bring out the maximum amount of color and detail that was in your original negative or slide. Once the image processing is completed, the result can be saved, called up on anybody's computer and sent anywhere in the world in JPEG format via an E-mail attachment. Most professional imaging services can convert a digital file into a 35mm slide for your collection.

Many of the pictures in this book have been enhanced or color-corrected using Photoshop. This in no way affects the integrity of the pictures. The original negative or slide emulsion has done its best to record the image, and any help it can get to make that detail visible is simply rendering the image more accessible and aesthetically pleasing. And the fact

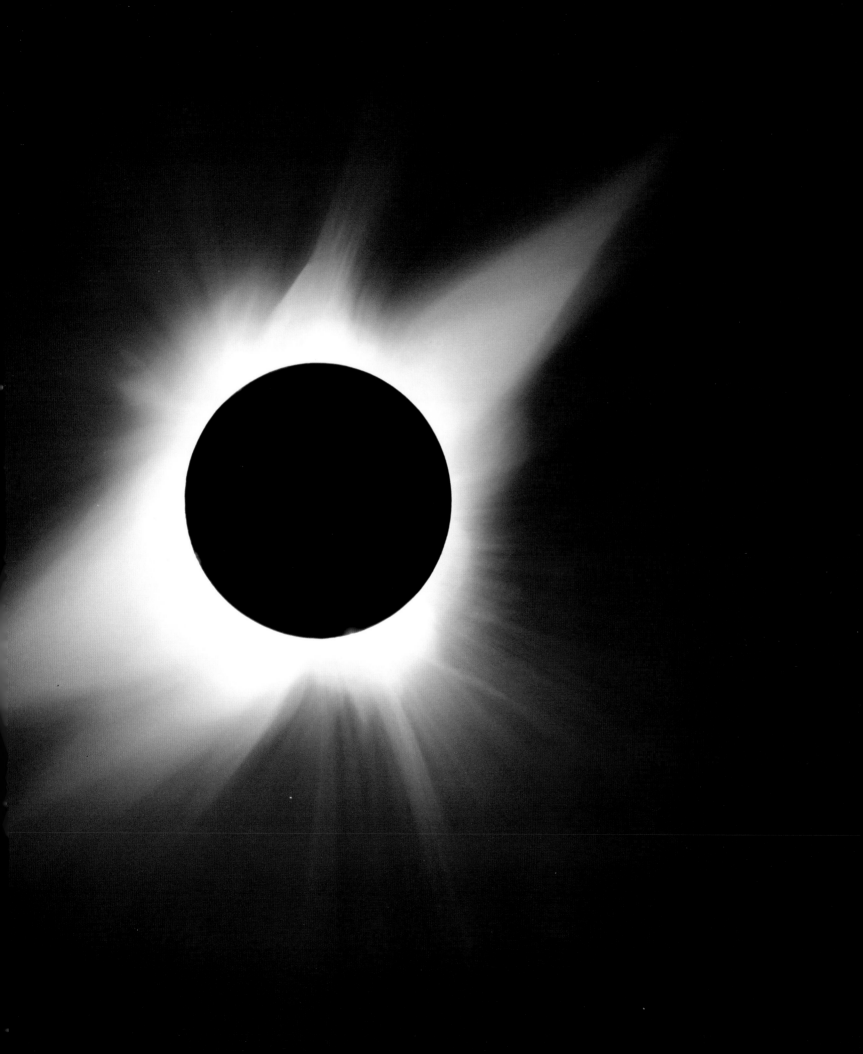

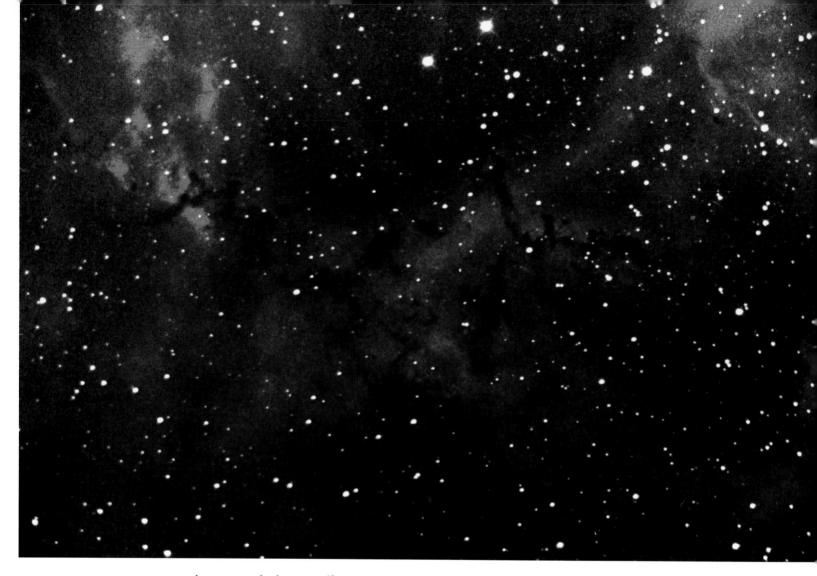

that you can do this yourself on your own computer increases the personal satisfaction and involvement that you can realize in astrophotography.

Going further, more contrast and finer resolution can be achieved by stacking two pictures of the same object. This, too, is possible to do with Adobe Photoshop. An excellent example of this technique is Jerry Lodriguss's image of the galactic dark horse and Antares region on page 76. Jerry's Web page (see page 140) contains more detail on image stacking than we have room for here. But it is clear that this type of image processing, though still in its infancy,

is destined to become a mainstream method of dealing with astrophotos in the 21st century.

Image stacking was pioneered by photographers such as Tony Hallas in the 1980s, but at that time, it was done mechanically, with the two negatives carefully sandwiched to superimpose exactly, a time-consuming process that is generally limited to astro-photography with larger-format film. This is a very specialized high-end niche in astrophotography, but the results are spectacular, as you can see in the images throughout this book by Hallas and George Greaney, who also uses this technique.

Film-Performance Variables

Let's suppose you are taking a daytime snapshot with your 35mm SLR camera. The light meter recommends a setting of 1/250 second at f8. If you manually override the setting, you could click the f-stop setting to f11 (thereby contracting a diaphragm in the lens), and only half the amount of light would arrive on the film. To compensate, you could double the exposure to 1/125 second.

The same principle applies with lengthy time exposures used in astronomy, whether by camera or by telescope. If, for example, the exposure table on page 141 calls for a 5-minute exposure at f2.8, that time would be doubled at f4. At least, that's the theory. In practice, though, we have to consider another effect, a film phenomenon not encountered in daytime photography called reciprocity failure—the progressive reduction in a film's ability to soak up light during long time exposures. Reciprocity failure varies with each film label in an unpredictable way.

Not only does reciprocity failure kick in with most films after less than a minute, but the rate at which the film's sensitivity declines can be determined only through actual in-the-field testing. Moreover, reciprocity failure often differs in each of the three color-sensitive layers embedded in color emulsion. This "differential" reciprocity failure means that some films are subject to wild shifts in color balance during long exposures; most often, the sky background turns shades of green or brown. Although the major film manufacturers can supply reams of data about their products, they generally do not measure characteristics for exposures longer than 10 seconds, which is just about where the astrophotographers start and most other photographers end.

Another factor to be aware of in the "astrofilm follies" is that each time a film's name is changed, the new version can be the same, better or worse. For instance, Kodak Ektachrome Elite II 100, an outstanding

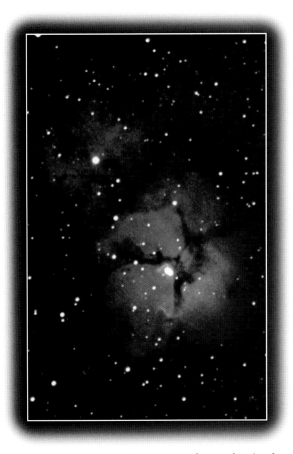

astrophotography emulsion, comes from a family of duds. Every 100-speed Ektachrome film before it, going back decades, was a terrible astrofilm. Then, for reasons unknown perhaps even to Kodak, a film with superb reciprocity characteristics suddenly emerged. Thus, in the world of astrofilms, pedigree means little. In general, however, the situation today is the best ever. The current generation of 35mm films is finer-grained and much better at soaking up light over long time exposures than emulsions of previous decades. (The best films for astrophotography as of late 1997 are listed beginning on page 72.)

The exposure tables on page 141 are simply guidelines for the best astrofilms. If at all possible, at least initially, take more than one picture of the same

The Jack-Newton-designed cold camera, right, used for all the cold-camera images in this book, takes advantage of film emulsion's increased sensitivity to light at low temperatures. Dry ice placed in a reservoir in close proximity to the film keeps it near minus 78 degrees C (−108°F). All pictures on these two pages were taken by Jack Newton with this camera on a 25-inch telescope.

Stellar youth and old age are contrasted in the celestial scenes on these two pages. The Trifid Nebula, left, and the Rosette Nebula, facing page, top, are both star-birth zones capable of generating hundreds of new suns from their troves of celestial gas and dust. (For a wider view of the Rosette, see page 87.) Stellar doom has set in at the bottom of facing page as doughnut-shaped clouds of star-stuff—the Helix Nebula, left, and NGC2438 in the star cluster M46—are puffed off two Sunlike stars. All pictures on these two pages were 30-minute exposures shot in the late 1980s by Jack Newton with a 25-inch f/5 Newtonian reflector using a cold camera, pictured below, on medium-format (six centimeters square) Konica 3200 with a Lumicon Deep-Sky Filter.

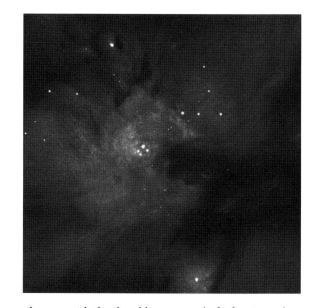

object, varying the length of your exposures for each different film. Keep notes regarding site, sky conditions and lens or telescope used. Note temperature, too, because that's yet *another* factor which affects film performance. For every drop of 20 Celsius degrees (35 Fahrenheit degrees), most films gain about one f-stop of speed; that is, a 400-speed film acts like 800-speed film around 0 degrees C (32°F) and like 1600-speed film at minus 20 degrees (–4°F), and the process keeps going. At minus 40 degrees (–40°F), a 400-speed film is running at about 3200 speed. Once again, these are rough guidelines, and they vary from one film to another, but when the temperature gets close to freezing or below, all films show this increase in speed to some degree.

An ingenious way of tapping into this effect is the cold camera, which uses dry ice at minus 78 degrees C (–108°F) to freeze the film and dramatically increase the speed. The cold camera (a version of which was developed by Jack Newton in the late 1970s) is, generally speaking, the tool of a bygone era. It's not that the principle or practical application of the cold camera has changed at all over the years but that films have. For instance, the best astrophotography film available in the 1970s was something called High-Speed Ekta-

chrome, with the then blazing speed of 160. Not only was this a slow film, but it had terrible reciprocity characteristics as well as an ugly shift to the green in long exposures. But it was all we had. The cold

The Flame Nebula, seen in broader context on page 110, is imaged below by Jack Newton's 25-inch telescope.

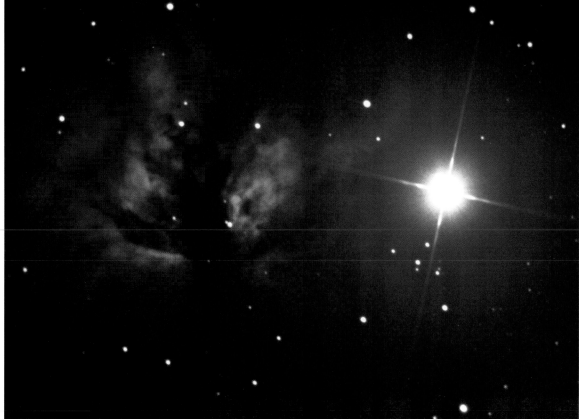

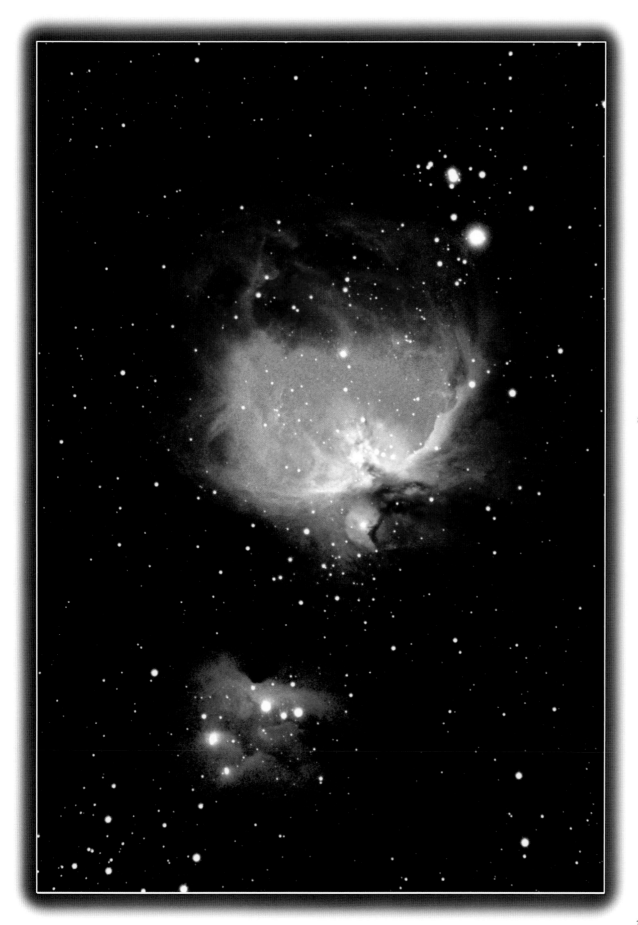

This shot of the Orion Nebula by Jerry Lodriguss shows considerably more detail at the nebula's core than the image of the same object on page 1. Although both photos were taken with similar-sized Astro-Physics refractors, the page-1 image is a print from a single negative, while the photo here is the result of computer enhancement using digital scans of two Kodak Ektapress PJM negatives. One was a 30-minute shot that overexposed the central region but captured detail in the nebula's outer regions; the other was a 5-minute exposure that held the central detail. Using Adobe Photoshop software, the two pictures were merged to retain the best aspects of both. Facing page, top right, rendering by Adolf Schaller of the visual telescopic appearance of the Trapezium region at the core of the Orion Nebula. Facing page, top left, most films record the Dumbbell Nebula as red, but this 25-inch-telescope shot on the now obsolete Kodak VR-1000 shows its true greenish hue. Photo by Jack Newton using a cold camera on medium-format (six centimeters square) Konica 3200 with a Lumicon Deep-Sky Filter.

The Horsehead Nebula region of Orion, among the most frequently photographed of the entire sky, contains a magical mix of obscuring dark clouds of galactic gas and dust interwoven with scarlet emission nebulas —more celestial gas and dust illuminated by nearby stars and by stars actually embedded in the nebula. The brilliant star just left of center is Zeta Orionis, the lower left star in Orion's belt. Tony Hallas used a 7-inch f/7 Astro-Physics refractor to take two 45-minute exposures on gas-hypered medium-format Kodak Pro 400 PPF, which were then sandwiched and further enhanced to obtain this impressive image.

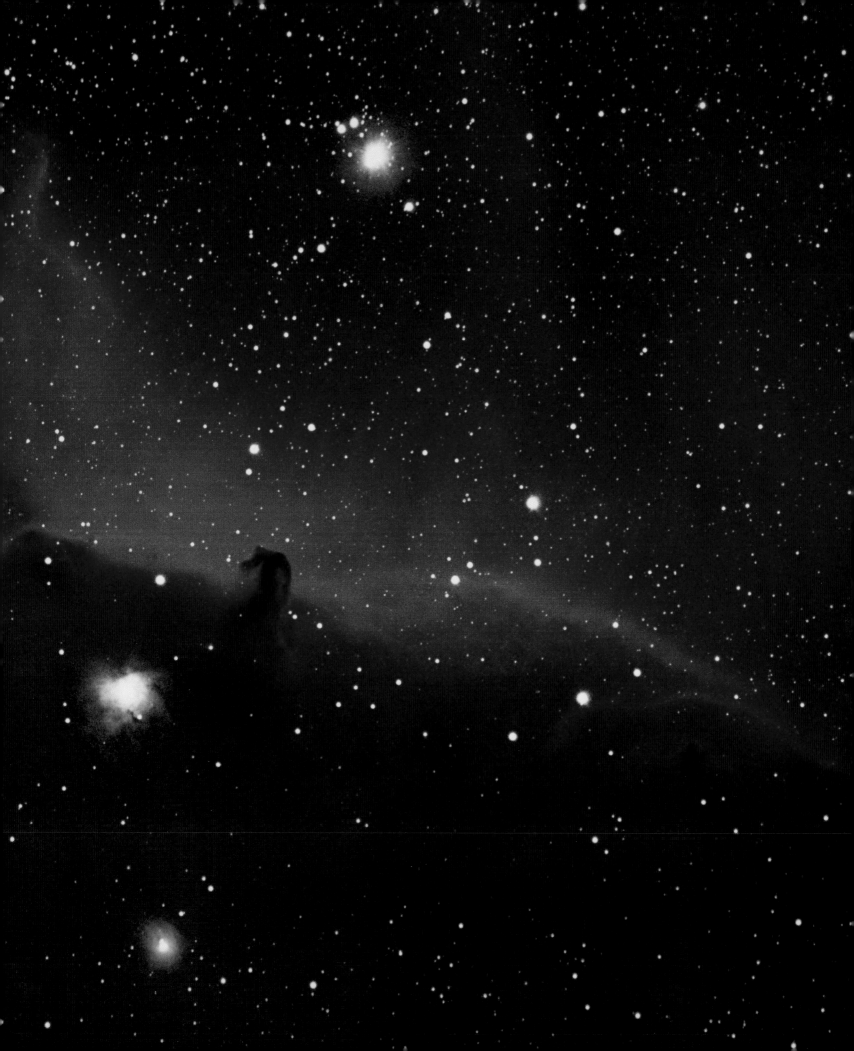

camera turned High-Speed Ektachrome and other films of the era into comparatively outstanding performers, the low temperature effectively increasing the film's speed to somewhere around 1600 to 3200.

Today, however, films like Kodak Pro 1000 PMZ and Fujicolor SG+ 800 produce results at ambient

emulsion technology will go with regard to astrophotography. Certainly the manufacturers will attempt to make films finer- and finer-grained. Today, a typical 400-speed film looks like a 100-speed film from 1980. There's no telling how far this can go, but certainly more changes in this direction

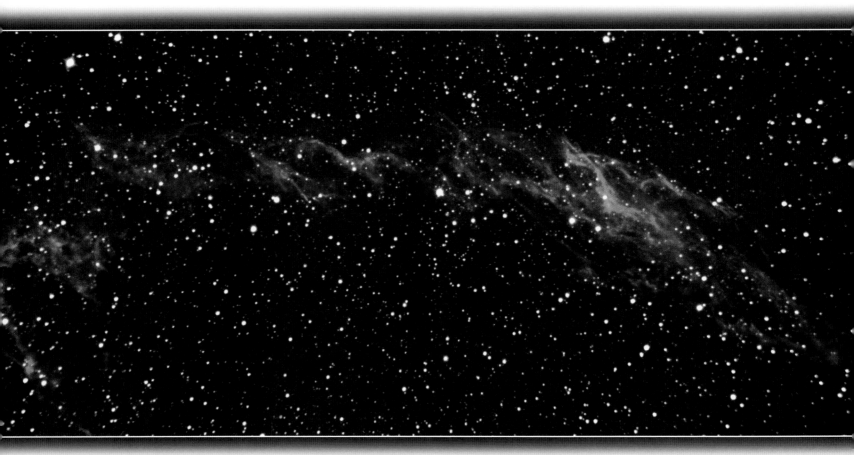

temperatures that equal or surpass the performance of cooled films of a generation ago. The new films are simply that much better. So the cold camera is virtually obsolete. In theory, the cold camera could increase the speed of modern films significantly, but it is cumbersome to use and not worth the effort anymore.

There's no predicting which way the evolution of

are to be expected over the next decade.

But the other part of the equation for astronomy —favorable reciprocity characteristics for exposures of many minutes' duration—remains less certain. Our favorite films as of the late 1990s all have outstanding reciprocity characteristics. We can only hope that even better emulsions are forthcoming.

Arching across the starscape like a ghostly celestial rope, the Veil Nebula, above, is the tattered remains of a supernova that exploded 30,000 years ago. Look for this nebula tucked in the lower left corner of the picture on page 74. The Swan Nebula (M17), right, is also known as the Omega Nebula.

Film Hypering

Gas hypersensitization of film, or "hypering," as it is known in amateur-astronomy jargon, is a treatment by which the film is placed in a partial-vacuum chamber and bathed for hours with a noncombustible mix

the superb new films that have arrived on the market.

Rather than review the how-to specifics of gas hypersensitization of film, we refer you to an excellent discussion of this subject on Jerry Lodriguss's Web page (see page 140). Jerry has thoroughly researched and tested this technique and gives all the details.

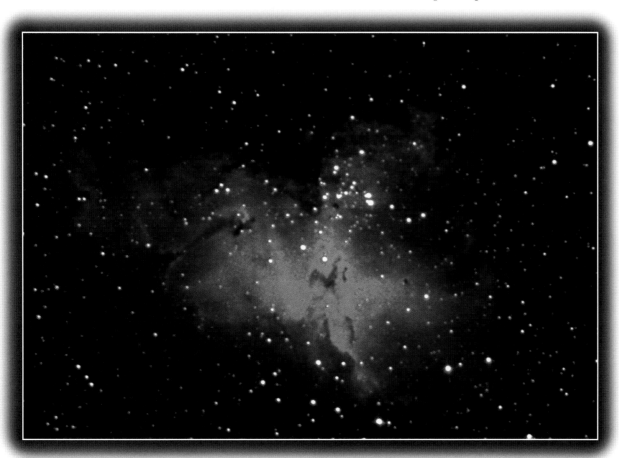

The Eagle Nebula (M16), left, is a major star-forming region in the Sagittarius Arm of our galaxy. Shown below is the section of the Veil Nebula near the fifth-magnitude star 52 Cygni. All pictures on these two pages were shot in the late 1980s by Jack Newton with a 25-inch f/5 Newtonian reflector using a custom-built cold camera on medium-format (six centimeters square) Konica 3200 with a Lumicon Deep-Sky Filter. The outstanding speed and excellent reciprocity characteristics of today's films have reduced the need for a cold camera.

of hydrogen and nitrogen gas to purge moisture from the emulsion. This has much the same effect as the cold camera but for different reasons. Once considered essential for serious astrophotographers, especially for through-the-telescope imaging of faint deep-sky objects, gas hypersensitization is still used today, but not as extensively as it was. Again, this is a result of

But the bottom line is that with modern color films, the gain from gas hypersensitization is one to two stops, or stated another way, a 400-speed film will act like an 800- or a 1600-speed film. This gain usually comes at the expense of color shifts that must be corrected later. Is it worth the trouble? Well, you have to be the judge of this, but more

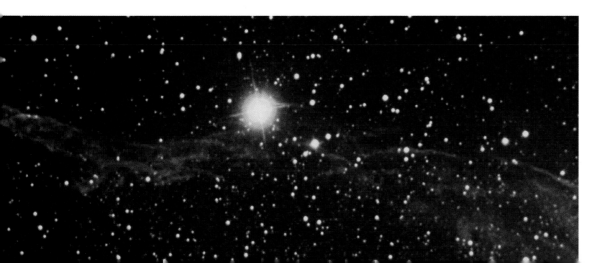

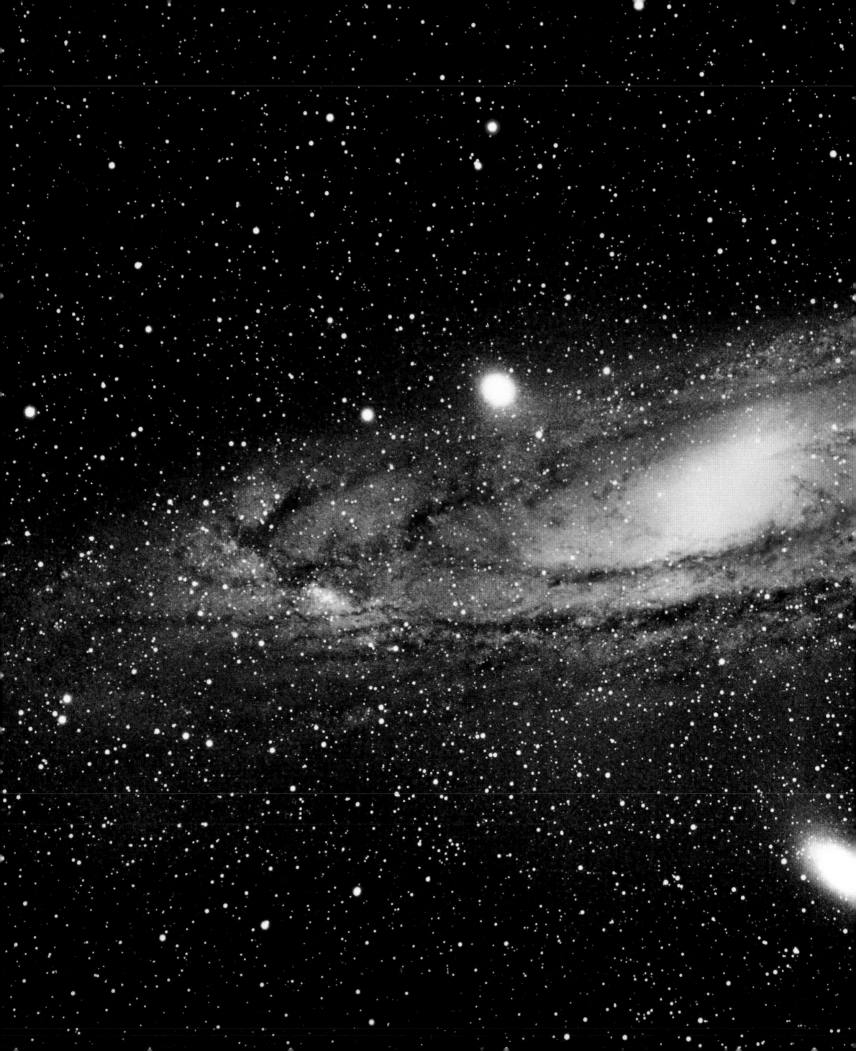

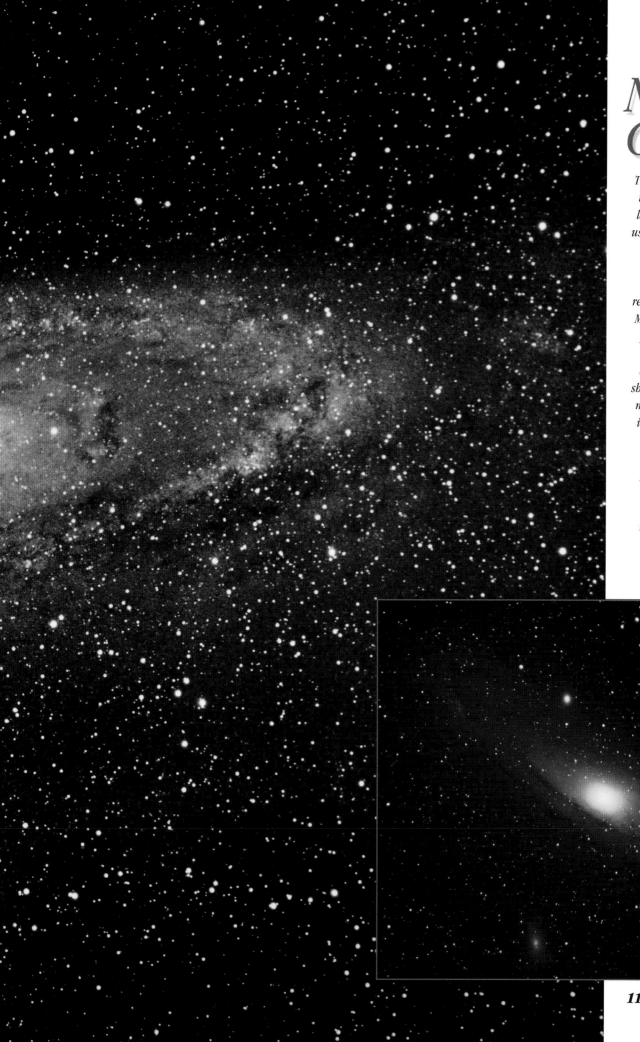

NEARBY GALAXIES

Two 6-inch refractor shots of the Andromeda Galaxy. The large image, by Tony Hallas, uses the same instrument and exposure as were used for the Lagoon Nebula shot on page 92, both of which required a dedicated night on Mt. Piños, in California, and plenty of expert darkroom work in addition to the double 45-minute original shots. In contrast, the smaller, much less successful picture is a 50-minute exposure on Kodak Ektachrome P1600 (processed at 800) taken from Terence Dickinson's backyard. Note that poor polar alignment resulted in field rotation at photo's upper right.

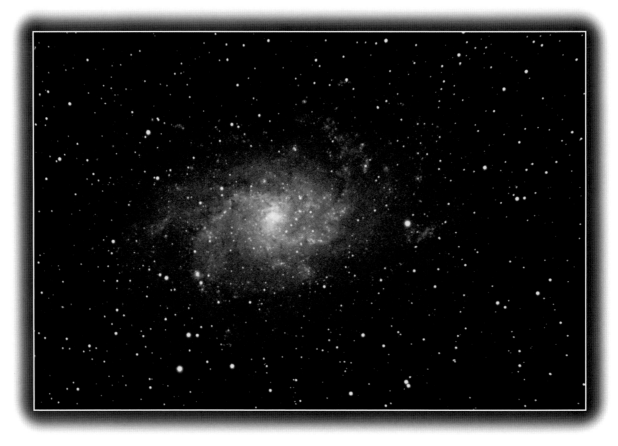

and more astrophotographers are using the new films right out of the box. None of the film-emulsion images in this book taken by either of us was gas-hypersensitized.

Black-and-White Film

Very few of the images in this book are black and white. We love the aesthetics of color photography. The stars are different colors. Nebulas are colorful. Galaxies have color. Planetary surfaces have color. Color is inherent in the universe. Yet anyone who has looked through a telescope knows that visually, color is often very difficult to detect. Most celestial objects look white or shades of gray. There are exceptions:

the planets, some of the brighter stars, colorful double stars and a few brighter nebulas. But most of the celestial objects that come up as colorful subjects on film and in CCD images appear colorless because human vision is not sensitive to color at very low light levels. Apparently, there was no evolutionary need for this for human survival. But color emulsions and CCD cameras (using tricolor filter techniques) are capable of detecting colors in astronomical objects.

Since both of us are personally heavily biased toward color in our astronomical images, we'll make only a brief mention of black-and-white astrophotography here.

Years ago, home darkrooms and black-and-white photographic developing and printing were a fairly

At about the same distance as the Andromeda Galaxy, the Triangulum Galaxy (M33), facing page, top, is a much smaller spiral galaxy, faintly visible in binoculars. This shot by Jerry Lodriguss is a computer composite of two 90-minute photographs on gas-hypered Fujicolor 800 through a 5-inch f/8 Astro-Physics apochromatic refractor. Another Lodriguss shot, facing page, bottom, using the same instrument but just a single 70-minute exposure on gas-hypered Fujicolor 800, shows the star cluster NGC6939 and the galaxy NGC6946 in Cepheus.

commonplace hobby. Today, they're a rarity. Furthermore, there is now only one black-and-white film suited to the long exposures required for astrophotography. That film is Kodak Technical Pan 2415, an extremely fine-grained slow-speed scientific film used mainly by microscopists. Straight out of the box, this film is useless for astrophotography, but when gas-hypersensitized, its sensitivity magically increases by a factor of about 10. The detail, clarity and sharpness of this film are unparalleled, but these results can be achieved only in a home-darkroom setting, where the photographer retains control of the process from beginning to end. The use of Technical Pan 2415 in astrophotography is discussed at length in *A Manual of Advanced Celestial Photography* by Wallis and Provin (see page 140).

Five spiral galaxies, ranging from 13 to 50 million light-years from Earth, as captured by Jack Newton with a 25-inch f/5 Newtonian reflector using a cold camera on medium-format (six centimeters square) Konica 3200 with a Lumicon Deep-Sky Filter: NGC253, top left; M101, top right; the Whirlpool Galaxy (M51), bottom right; and M66 and M65, bottom left. See page 133 for a comparison M51 shot with a CCD camera.

117

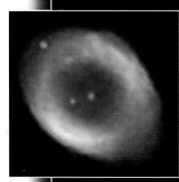

PART 4

If we could observe our own galaxy, the Milky Way, edge-on from a distance of 50 million light-years, it would look something like NGC4565, seen here. No telescope on Earth has ever taken a color-film-emulsion photo showing this much detail in NGC4565. But a CCD camera attached to a 25-inch telescope, facing page, has the power to produce this image by Jack Newton. Insets: CCD images of the Ring Nebula, top, by Jack Newton and the Helix Nebula, bottom, by Doug Clapp.

CCD Imaging:
More Power to You

Imagine taking pictures of galaxies that no human has set eyes on before. With the amazing power of a CCD camera attached to a moderate-sized backyard astronomer's telescope, it's possible to do this even in moonlight. This revolutionary development has added a new dimension to astrophotography that greatly enlarges the possibilities already offered by traditional film emulsion. So vast is the potential that it has taken the field of amateur astronomy by storm since the introduction of CCD cameras for astronomical use in the early 1990s. There are now so many options for the astrophotographer that there is really no limit to the amount of time, effort and, yes, money that can be poured into it. But with the ever-increasing use of computers, both in the workplace and in the home, and the declining prices of CCD cameras and their accessories, this pursuit can only grow as we enter the 21st century. It is impossible to cover all aspects of CCD imaging in the space remaining, but here's an introduction to this dynamic new field.

Jack Newton is dwarfed by his 25-inch Newtonian telescope.

CCD CAMERAS

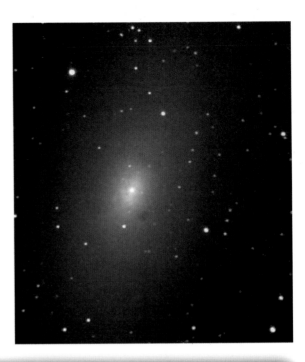

One of the many advantages of CCD cameras is their ability to image small areas of the sky at very high resolution. Below is a region beside the nucleus of the Andromeda Galaxy; at right is Andromeda's companion galaxy M110. Jack Newton used the 25-inch f/5 Newtonian telescope pictured on page 119 and a Pictor 1616 camera for both images.

The most significant revolution in photography since the invention of photographic film more than a century ago is taking place right now. And backyard astronomers are at the center of the change, as more and more astrophotographers are making the switch to electronic imaging. Driving the digital revolution is the introduction of affordable CCD cameras.

A CCD camera is a digital-age version of a photographic camera. Film is replaced by a silicon chip called a charge-coupled device (CCD). Most CCD chips measure only millimeters across, much smaller than a frame of 35mm film, but they contain hundreds of thousands of tiny square pixels. Each

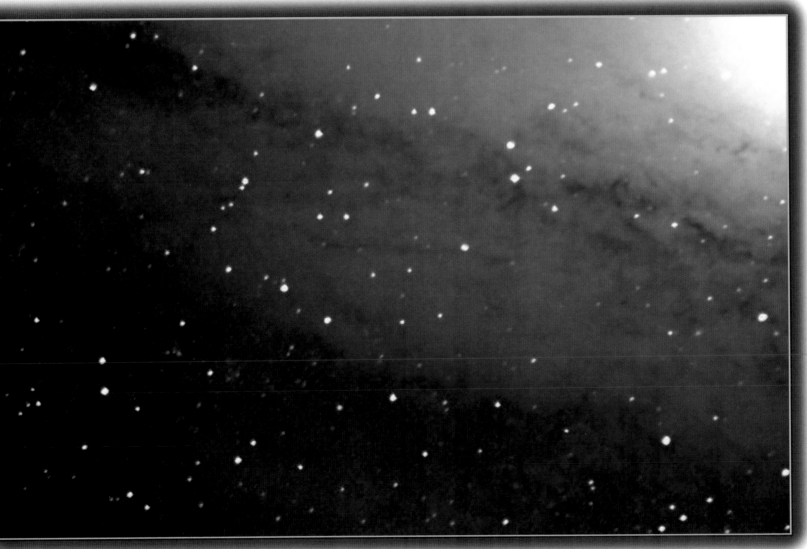

light-sensitive pixel records the amount of light that strikes it during an exposure and converts the reading into an electronic signal. At the end of an exposure, the signals from the thousands of pixels are quickly read off, row by row, pixel by pixel, into a stream of data. This data is digitized into binary code—the language of 1's and 0's that computers use—then sent to a computer to be saved on a hard drive and displayed on a monitor.

Astronomical CCD cameras are like home video camcorders—they often use similar chips—but video cameras take only short exposures, at a rate of 30 per second, and store their output on tape. Until recently, most home camcorders stored their data as analog signals subject to tape dropout and noise. But new Digital Video (DV) cameras are taking over. These still use tape but store their output of 30 frames per second as digital data, which is less prone to the degrading effects of videotape.

Any camcorder or video camera, digital or not, can be turned into an astronomical camera, though one with limits. Zoom the lens to its wide-angle position, then aim it into the low-power eyepiece of a telescope. You'll be surprised at how much detail you can record on the Moon. Zooming in the lens provides more magnification, perhaps enough to record details on the disks of Mars, Jupiter and Saturn.

The trick is holding the camera steady. One method is to place it on a tripod tilted to aim the camera into the telescope. The problem is that the telescope turns to track the sky, so the camera and tripod must be moved every few minutes.

If you can remove the lens from your video camera, there is a better method. (Only high-end camcorders, such as the Canon L1, or dedicated low-light video cameras sold by astronomy dealers allow this.) With a C-mount camera adapter, the camera

can then slide into the telescope's focuser like an eyepiece or a prime-focus 35mm camera.

However, video cameras—even low-light models—are not suitable for taking images of faint astronomical objects. The same applies to the new generation

Jack Newton's observatory, top right, on Vancouver Island currently houses a Meade 16-inch f/10 Schmidt-Cassegrain with a 7-inch f/9 apochromatic refractor riding piggyback. At rear, a bank of three computers controls all aspects of telescope operation—target acquisition, auto-guiding and image retrieval. The telescope can also be controlled by a fourth computer in a separate warm room, where image processing takes place. Pictor CCD cameras, right, are attached to the two telescopes. Photos by Jean-François Grant-Godin.

of digital snapshot cameras now offered by every major camera maker. Neither can take single long exposures.

That's where the CCD camera comes in. It is designed to take exposures that can last from a fraction of a second to many minutes. Even if you could use a camcorder CCD chip for a long exposure, the images would be swamped by electronic noise filling up the pixels during the exposure. The noise comes mostly from heat. So all astronomical CCD cameras are inter-

nally cooled. In fact, each five-to-six-degree (C) drop in temperature cuts the electronic noise in half.

Some homemade and kit CCD cameras pump liquid through a radiator on the back of the camera. Most commercially available CCD cameras use a more convenient method known as Peltier cooling—the chilling effect comes from a special chip that removes heat when powered up. Some cameras have two-stage Peltier coolers. A first-stage cooler chip sits directly behind the actual CCD imaging chip, while a second, larger cooler is attached to the back of the first. Better cameras include a temperature regulator to ensure stable operating temperatures. A constant operating temperature ensures that the electronic noise remaining in the image stays at a consistent level throughout a shooting session, making it easier to subtract electronically later.

The Lure of CCD Imaging

It's easy to get hooked on CCD imaging. It often happens the moment that first image appears on the computer screen, only seconds after it was taken. That's one big advantage of CCDs over film: they

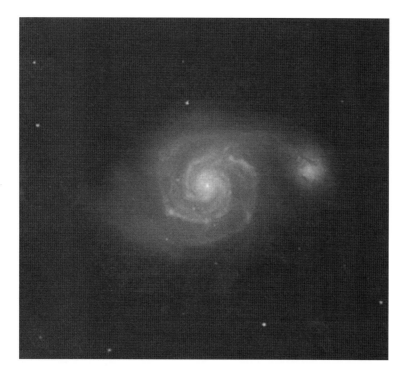

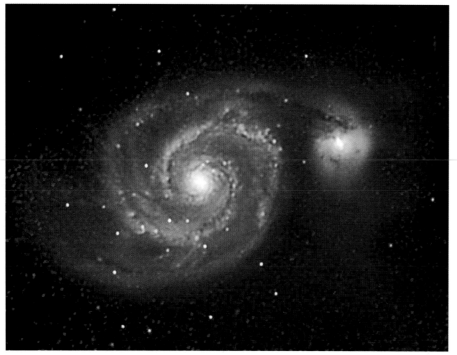

CCD images are made up of hundreds of thousands of pixels, each recording a brightness level. When red, green and blue images are combined into a full-color image, the pixels are still there, facing page, top left, containing both brightness and color information. A CCD image of the galaxy M51, bottom left, taken through Jack Newton's 16-inch is compared with a drawing of the same galaxy, top left, as seen through a 15-inch telescope by astronomical illustrator Adolf Schaller. Though the visual image has impressive detail, the CCD reveals much more—and in color! The lower image on facing page shows curving tendrils emerging from M51 that are not detectable by eye or with standard film emulsion. This is a maximum-detail CCD shot by Jack Newton using the 7-inch refractor for four "co-added" 10-minute exposures. The galaxy itself is vastly overexposed to reveal the outer arms. The accompanying image of part of M51 was taken with the 25-inch at full Moon to show the versatility and power of CCD imaging. Top right, facing page, another view of the CCD setup at Jack Newton's observatory.

CCDs can record in mere minutes, sometimes seconds, what it takes film an hour or more to pick up. Short exposures don't require the super-accurate drive and guiding demanded by hour-long photos.

While their lack of reciprocity failure contributes to their speed, the main reason CCDs are so sensitive is that they are much more efficient at converting photons of light into an image. With film, only about 8 percent of the light striking the film is chemically captured by the silver halide molecules in the emulsion.

provide instant results. It's possible to fix mistakes such as bad focus or tracking errors right away so that you end the night knowing you've got good shots. No more waiting days or weeks to finish off a roll of film and develop it.

Because CCD images are digital data, they can be stored on any computer hard drive or floppy disk. They can even be sent electronically to on-line friends as E-mail attachments. Even more seductive is the fact that CCD images can be "processed" in a snap on a computer. Software programs such as Adobe Photoshop make it easy to enhance images, bringing out hidden details that are often lost in even the best film portraits of galaxies and nebulas. Reworking digital images makes for a good project on cloudy nights.

CCD cameras also work well for city-bound astrophotographers, or astro-imagers. Because they are very sensitive to infrared light, CCD cameras are not as bothered by light pollution from typical streetlights that pump out mostly blue, green and yellow wavelengths. Used with a deep red filter, CCDs can record very faint objects, even from within a city or at full Moon. Imaging can be done on any clear night from any backyard, not just on rare trips to dark-sky sites.

With both film and CCDs, the longer the exposure to light, the denser the resulting image. But CCDs have a further major advantage over film—they are linear. An image taken for 10 minutes is twice as dense as one taken for 5 minutes. Film, on the other hand, suffers from the shortcoming of reciprocity failure. As the exposure wears on, film actually becomes less sensitive to light and fails to pick up fainter targets. With many films, a one-hour exposure may not pick up much more detail than an exposure lasting only 20 minutes.

The linear response of CCDs makes their images far superior for accurately measuring the brightness of objects such as asteroids and stars. But it also contributes to the prime advantage of CCDs: their speed.

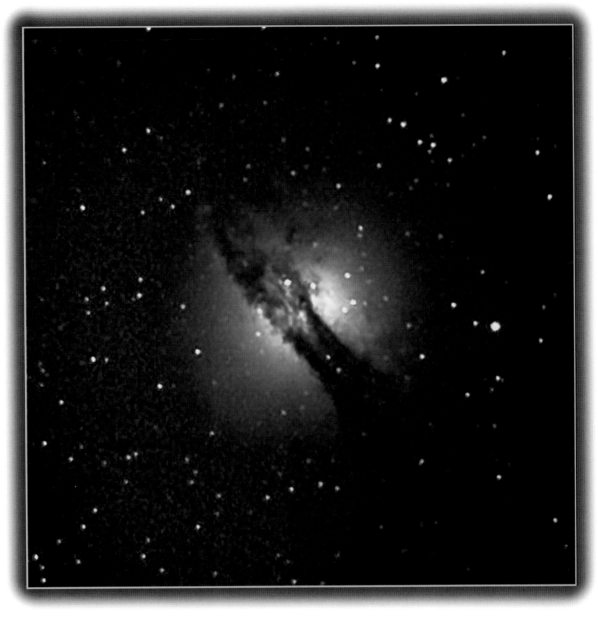

Making a color CCD image: This series of four images, below and on facing page, shows (from left to right) the Crab Nebula taken with red, with green and with blue *filters and the final combined full-color picture. Image assembly was done on computer using Adobe Photoshop software. CCD images by Jack Newton.*

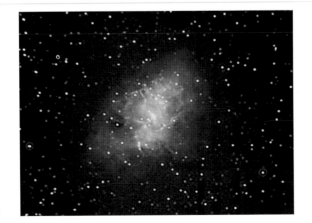

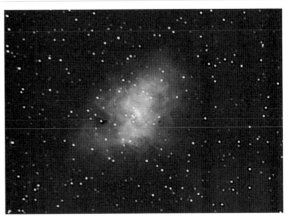

By comparison, a CCD camera converts up to 90 percent of the incoming photons into an electrical signal, a dramatic improvement over film. Even under light-polluted skies, CCD cameras can capture faint stars and galaxies that the fastest film can never record.

More amazing still is that it's possible to create the effect of a single long exposure by combining a series of short easy-to-take "snapshots." For example, the recording power of a single 20-minute exposure can almost be matched by taking four 5-minute exposures and combining them electronically. Most CCD camera manufacturers provide software that can automatically "co-add" a series of consecutive exposures. Meade Instruments offers a "shift and combine" feature with its Pictor Series cameras. The Santa Barbara Instrument Group's cameras come with a "track and accumulate" program.

While single long exposures are generally less "noisy" than a series of short exposures, there are real advantages to the stacking method. Because there is less of a chance for guiding errors and atmospheric turbulence to blur star images, shorter exposures often result in tighter star images. Long exposures can produce an effect known as blooming, which produces streaks of light shooting off bright stars. This happens when pixels overfill and spill their electrons to adjacent pixels in the same row. Short exposures prevent this form of overexposure of bright objects.

Co-adding images reveals the true power of the CCD camera. With the combination of a 25-inch telescope and a CCD camera, I can randomly shoot anywhere in the sky away from the Milky Way, take five or six 10-minute co-added exposures and pick up faint background galaxies that quite likely have never been seen before by anyone. Amazingly, there are more galaxies than stars in every image. This is tremendously exciting for me. As an amateur, I can reach beyond what even the largest telescopes in the world can record using film.

The ultimate example of the power of CCDs comes

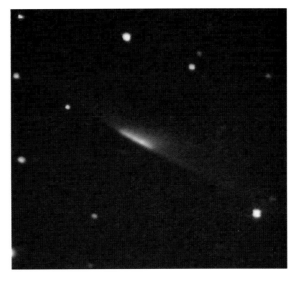

from the Hubble Space Telescope. In December 1995, the Hubble imaged a "blank" area of sky just north of the Big Dipper for a total exposure time of 10 days! Astronomers took 342 separate images through a variety of filters, using exposure times of 15 to 20 minutes each. Called the Hubble Deep Field, the co-added images revealed no fewer than 1,500 galaxies as faint as 30th magnitude.

Ready for the challenge, I decided to pit the power of my 25-inch telescope and Meade Pictor 1616 CCD camera against the Hubble Deep Field results. Selecting the same area of sky, I took five 10-minute exposures. My image (reproduced on page 137) shows 32 galaxies and 4 stars down to a limit of magnitude 22—and this with exposures taken under poor seeing conditions and with a first-quarter Moon in the sky! The power of the CCD camera is truly awesome.

Choosing a CCD

Most CCD cameras available to amateur astronomers are 16-bit models. Each pixel's output is digitized with 16 bits of data, giving these cameras the ability to record 65,536 shades of gray. Lower-cost

Meade Pictor 1616 CCD camera, above, with a custom-built filter-wheel accessory in place. Left, Comet Shoemaker-Levy 9 shortly after its discovery in March 1993, imaged with a Santa Barbara Instrument Group's ST-6 CCD on Jack Newton's 25-inch telescope. This was the comet that crashed into Jupiter in July 1994. At far left on facing page are a few wisps of the Cassiopeia A supernova remnant, discovered photographically with the 200-inch telescope at Palomar Mountain in 1958. This image, taken with Newton's 25-inch, demonstrates that it is now possible for amateur astronomers using CCDs to detect objects that were at the limit of the world's largest research instruments just two generations ago. Similarly, the color CCD image of galaxy NGC5128, facing page (large image), shows structure and detail that until recently were beyond the capabilities of amateur equipment. This image was taken by Jack Newton in Florida with a portable 12-inch Meade Schmidt-Cassegrain.

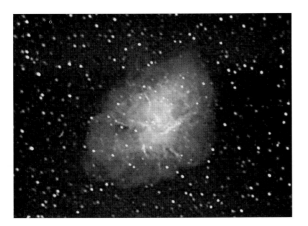

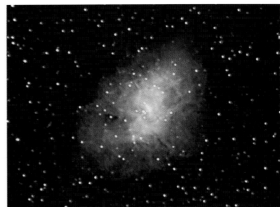

Two views of the same face of Mars, above, one (color) taken by the Hubble Space Telescope's CCD camera and the other by Don Parker using a CCD camera on his 16-inch telescope. The idea that amateur telescopes could approach this level of resolution was considered ludicrous as recently as the 1980s.

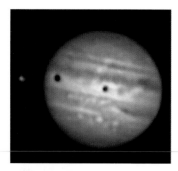

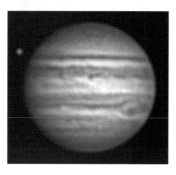

cameras can record 4,096 shades of gray (for 12-bit cameras) or 256 shades (for 8-bit cameras). Eight-bit units are fine for those who want to dabble in black-and-white CCD imaging, but their images will look cruder and less photographic than those taken with 12-to-16-bit models. Anyone wanting to do color imaging should consider nothing less than 14-to-16-bit cameras. Lesser cameras will not produce images "smooth" enough to create pleasing color renditions.

In addition to its bit depth, an important characteristic of a camera that often determines its price is the size of its chip. There are dozens of imaging chips on the market, ranging from tiny 3-by-5-millimeter chips (250 by 368 pixels) to massive 50-by-50-millimeter arrays (2,048 by 2,048 pixels). The larger the chip, the more sky it can record, making it possible, for example, to image an entire nebula rather than just a small portion of it.

But selecting a CCD camera involves more than simply buying the biggest camera you can afford. It is far more important to match the size of the camera's pixels to the focal length of your telescope and to the type of imaging you expect to do.

The pixels in a CCD chip are measured in microns, or thousandths of a millimeter. Some cameras, such as those based on Kodak's KAF-0400 and KAF-1600 chips, have pixels that measure 9 microns across, or 9/1,000 millimeter. By contrast, the rectangular pixels in the Santa Barbara Instrument Group's ST-6 CCD camera are three times larger, at 23 by 27 microns across. Cameras with smaller pixels can, in theory, achieve a higher resolution, but with CCDs, smaller pixels aren't necessarily better.

I've found that images of deep-sky objects such as galaxies and nebulas are best when the telescope and CCD camera combination produces an image scale of about 1.5 arc seconds per pixel. A scale of 1 arc second per pixel, for example, might produce a sharper image theoretically, but in practice, the difference may not be noticeable. The reason is that during long deep-sky exposures, tracking errors and turbulence from poor seeing inevitably enlarge stars to several arc seconds across. At best, my auto-guider can achieve a 1.5-to-3-arc-second guiding accuracy during a 5-minute exposure. These factors limit my resolution to 1.5 arc seconds under ideal circumstances. Having a CCD camera with greater resolution will not necessarily produce sharper photos, but it will increase exposure time. For monochrome (black and white) imaging, it is not much trouble to expose longer when taking a single image. But for tricolor imaging to obtain true color, this is a major concern.

Planetary Pixels

Recording fine details on any of the planets demands maximum resolution—0.7 to 0.2 arc seconds per pixel. The planets are bright, requiring exposures of less than 2 seconds, so small guiding errors are not an issue. With luck, the short exposures can freeze moments of excellent seeing, capturing extremely fine detail, perhaps as much as the eye can detect. Many planetary photographers are now using cameras with the KAF-0400 chip. Another good choice is Texas Instruments' TC-255 chip, which is used in the Santa Barbara Instrument Group's ST-5 and Celestron's PixCel 255.

Using one of these cameras on an 8-inch f/10 Schmidt-Cassegrain equipped with a 2x Barlow lens (yielding a focal length of 4,000 millimeters) produces a resolution of about 0.5 arc seconds per pixel. The sharpness of the CCD image is now limited by the resolution of the telescope (it's "diffraction-limited"), not by the atmosphere or the tracking ability.

To calculate the image scale of a CCD camera

on your telescope, divide the camera chip's pixel size in microns by the telescope's focal length in millimeters, then multiply by 205. For example, Meade's Pictor 416XT camera has 9-micron pixels. A standard 8-inch f/10 Schmidt-Cassegrain has a 2,000-millimeter focal length. This combination provides $(9 \div 2000) \times 205 = 0.9$ arc seconds per pixel.

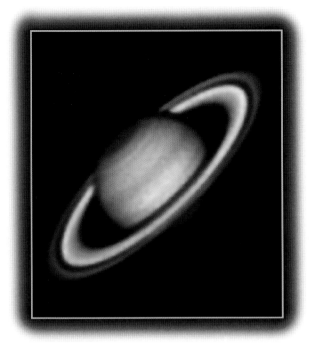

For deep-sky imaging, this would be over-sampling the subject, because it covers too small an area of the sky per pixel. One alternative would be to use a Meade or Celestron f/6.3 focal reducer on the telescope. With the telescope now operating at an effective focal length of 1,200 millimeters, this same 9-micron camera yields 1.5 arc seconds per pixel—right at our 1.5-arc-second-per-pixel optimum. Another choice is to use a CCD camera with 15-to-25-micron pixels, yielding 1.5 to 2.5 arc seconds per pixel without the telecompressor.

It isn't necessary to switch cameras to change pixel sizes. Altering the size of the pixels can be done by "binning." This electronic option combines pixels into 2-by-2 or 3-by-3 blocks to produce larger but fewer pixels.

For instance, the Pictor 416XT's 9-micron pixels can be binned to 18-micron pixels. Used in this mode on our standard 8-inch Schmidt-Cassegrain without a telecompressor, the camera now yields 1.8 arc seconds per pixel, a good combination for deep-sky imaging. And yet the camera also

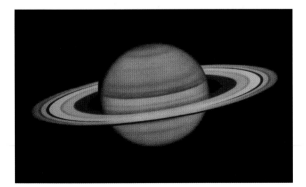

works unbinned for planetary imaging when needed.

Binning has several other advantages. For one, the larger pixels can capture more electrons, making them less susceptible to overexposure and to the streaking effects of "blooming." Another plus is that the image files are smaller, display more quickly and take up less hard-drive space.

For these reasons, I almost always use the 2-by-2 binning option on my Pictor 1616 CCD camera, which effectively gives me 18-micron pixels. With the 16-inch Schmidt-Cassegrain at f/6.2 (using a telecompressor), this yields 1.5 arc seconds per pixel, ideal for deep-sky imaging. Most of the CCD images reproduced in this chapter were taken with an ST-6 camera attached to my former main instrument, the 25-inch f/5 Newtonian. That combination gave a similar 1.6 arc seconds per pixel, hence the earlier recommendation.

For planetary imaging, such as the upper image of Jupiter on page 126, I use a 3x Barlow to increase the 16-inch's natural f/10 focal ratio to f/30. With the

A pioneer in high-resolution CCD imaging of the planets, Don Parker, facing page, has perfected the technique using a 16-inch Newtonian telescope at his home in Coral Gables, Florida. His images reveal more detail than any film-emulsion photographs ever taken by any telescope on Earth. Today, Parker's planetary portraits are regularly used by research astronomers to track changes in the appearance of Mars, Jupiter and Saturn. Keen visual acuity, as shown in the drawing of Saturn, bottom left, by Paul Doherty using a 16-inch Newtonian telescope, can occasionally surpass what Parker's images reveal. Facing page, bottom left, the lower CCD image of Jupiter is by Parker; the upper one is by Jack Newton. In the Newton image, taken August 24, 1997, the left black dot is the shadow of the Jovian moon Ganymede falling on the planet's cloud belts. The other dot is Ganymede itself, which has a darker surface than Jupiter's clouds. The shadow appears bigger because the sensitive CCD picks up the penumbra, a grayish "halo" around the main shadow. Mars images, right, by Don Parker show a partial rotation of the planet. Saturn, top left, also by Parker, is seen as it appeared in the early 1990s, with the rings fully open to our view.

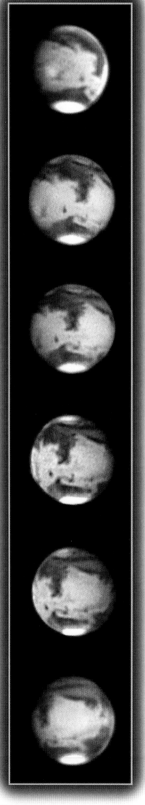

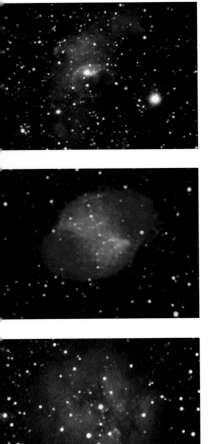

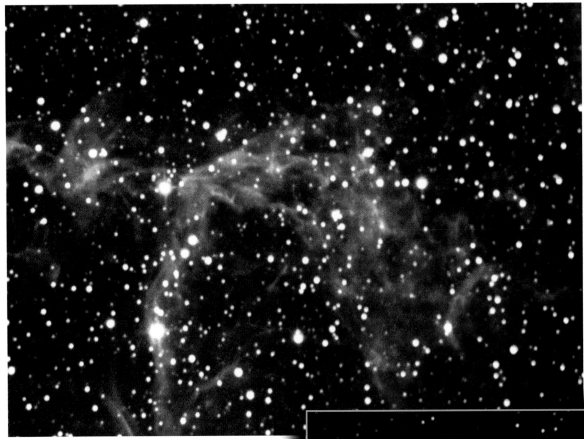

Three CCD images by Doug Clapp, above, show (top to bottom) the Bubble Nebula (NGC7635), the Dumbbell Nebula (M27) and the Cocoon Nebula (IC5146), all taken with an ST-6 CCD camera using a 10-inch f/6.3 Schmidt-Cassegrain telescope and Photoshop software for the tricolor processing. The feathery knots and tendrils of the Veil Nebula in Cygnus are captured in close-up detail, top right, by a CCD camera coupled to Jack Newton's 25-inch reflector telescope. This section of the Veil is seen on page 112 at extreme left. The Crab Nebula (M1), right, by Jack Newton.

Pictor camera, still binned 2-by-2, the resolution now leaps to 0.3 arc seconds per pixel, enough to reveal lots of detail in the giant planet's clouds.

A Home for Your CCD

Of course, the camera is just part of the imaging system. You also need a computer with adequate speed to operate the camera's software and enough storage capacity on the hard drive (the more, the better!) to keep your images. All cameras come with operating software for DOS or Windows computers; a few, notably the Santa Barbara Instrument Group's and Celestron's cameras, have the option of MacOS software. The software that comes with CCD cameras allows for basic image preparation, but most digital astrophotographers prepare their final images with specialized programs used by professional graphic designers.

The array of gear needed at the telescope makes a home observatory the most convenient arrangement for CCD imaging. Computers and cameras can be left wired and ready to use, perhaps with the computer sitting safely in an adjacent "warm room." The ability of CCDs to capture good images even within city limits makes a backyard observatory worth considering. With a laptop computer, you can also take images

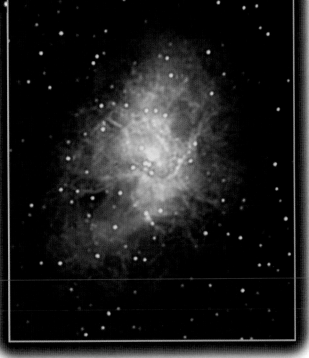

away from home under better skies. Find a site with AC power, if you can—CCD cameras and portable computers will drain batteries very quickly. Power is also required for the telescope mount's drives as well as dew-prevention heaters, if needed, making portable setups a major production.

IMAGING TECHNIQUES

A CCD camera is a powerful tool for recording faint objects. However, getting the best-looking results requires a basic understanding of what makes up the image. Buried in the image are annoying features such as dark current, bias amplifier noise, hot pixels, cold pixels and vignetting. Fortunately, all of these unwanted artifacts can be removed. But before you take any image, you have to get the object in focus.

Getting Focused

The two most difficult tasks for first-time CCD users are acquiring the object on the tiny CCD chip and getting it sharp. Remember, you can't actually look through a CCD camera. What's worse, the field of view of most CCD cameras on a telescope is much less than the diameter of the full Moon—mere arc minutes.

While it is possible to focus a CCD camera at night at the telescope, I suggest that first-time users try this daytime technique:

First, make sure that your finderscope and telescope are perfectly aligned. This will help you aim the main telescope. Then cover the aperture of your telescope with a cardboard mask with a one-inch hole cut in it. This allows only a small amount of light to pass through to the CCD camera. By stopping down your telescope, you can capture daytime images for practice. Now, point the telescope at an object as far away as possible. I use a 20mm eyepiece equipped with a cross-hair reticle to center objects accurately.

Set the exposure time to a fraction of a second, and take a shot. This is the moment of truth! If no image appears on the computer screen, try using the software adjustments to lighten the image. If that fails, increase the exposure time. If the screen is light and will not improve with software tweaking, try a shorter exposure. When you do see an image, chances are that it will be blurry. Carefully change focus in one direction, and reshoot. Keep shooting until the image comes into focus. You can easily spend an hour or more achieving first-time focus.

Now, mark this hard-won position of best focus with tape or some other indicator. Remove the camera from the telescope, and replace it with the cross-hair eyepiece. Don't touch the telescope focus! Instead, slide the eyepiece back and forth to focus it. You

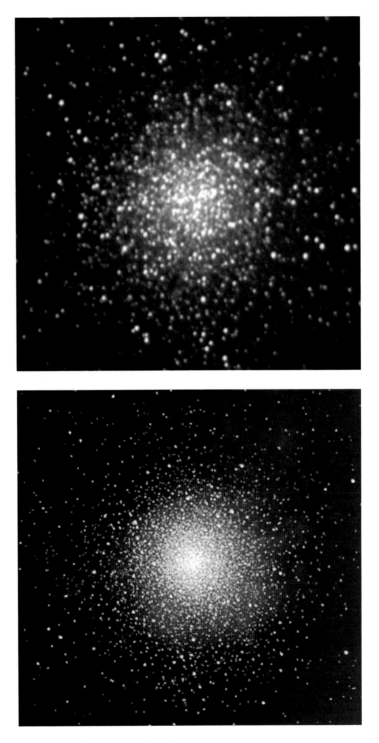

The Hercules globular star cluster, also known as Messier 13 (M13), is about 24,000 light-years from Earth. Here, it is imaged, top, by an ST-6 CCD camera on a 25-inch telescope by Jack Newton and is visually rendered, above, by Adolf Schaller using a 15-inch Newtonian telescope.

Two of the most photogenic celestial objects, the Ring Nebula, above, and the Eagle Nebula, bottom, display the end of a star's life and the birthplace of new stars, respectively. CCD imaging captures more of the true color of these rich, textured objects than color-film emulsions can. Jack Newton used the same 25-inch telescope for these CCD images as he did for the color-film shot of the Eagle Nebula on page 113.

may need an extension tube to allow the eyepiece to reach focus. With the locater eyepiece in focus, find your next target. Replace the eyepiece with the CCD camera, and snap a picture. The new image will likely require little, if any, focus adjustment. This is the setting you use at night.

If this sounds daunting, several CCD companies sell accessories that will allow you to look through the main telescope using a low-power eyepiece, with the CCD camera attached. A flip of a mirror then directs light to the CCD chip. These flip-mirror viewers are best suited to Schmidt-Cassegrain telescopes, with their generous focus range.

Dark Frames and Flat Fields

Despite the cooling every CCD camera has, heat still takes its toll. During a long exposure, thermal noise accumulates in the pixels, adding a background graininess to the image. When the CCD image is downloaded from the chip, another effect called "readout

noise" is also recorded on the image. This comes from the internal amplifier and electronics in the camera.

Suppressing these unwanted signals requires taking a "dark frame." This is an exposure taken for the same duration and at the same temperature as the original exposure. The difference is that the CCD camera is covered and light-tight during the dark exposure. The camera literally takes an image of its own noise. I combine three or more dark frames to produce a smooth, averaged "master" dark frame.

Dark frames don't have to be taken for each exposure. I use a library of master dark frames taken at various temperatures and for various durations, picking the one that matches the specifications of the image I've just captured. This saves time at the telescope. The technique is possible only with cameras that have regulated temperature controls. The alternative is to take a dark frame for every image, effectively doubling the time required to capture an image.

Another strategy is to create a thermal frame, a dark frame with the bias subtracted. Some software

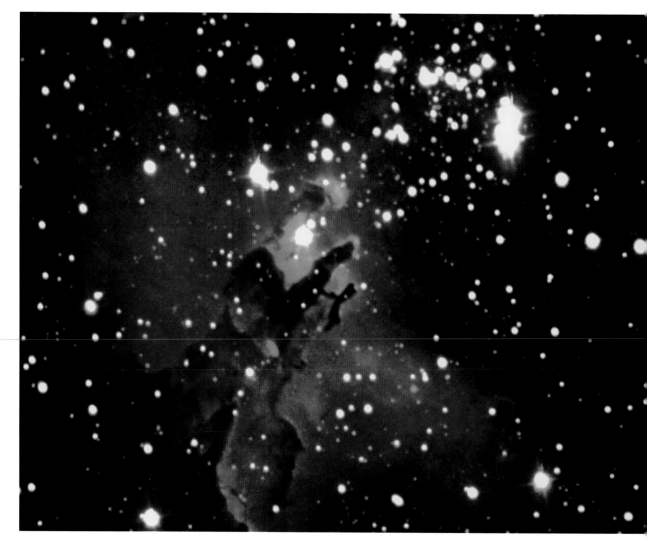

manufacturers, such as MaxIm DL and Pictor, provide an algorithm to scale the thermal frame to fit the length of exposure. This software subtracts the bias and the thermal, then mathematically divides the flat field into the image, electronically eliminating all these sources of noise and blemishes.

Besides thermal noise, CCD images can be marred by pixels of uneven sensitivity, dust specks or out-of-focus particles that cast doughnut-shaped shadows onto the image. Adapter tubes can also block light hitting the corners of the frame, causing "vignetting" or uneven illumination of the chip.

A flat-field exposure corrects all these problems. This is a short exposure of an evenly lit blank field, perhaps a white screen. The simplest way to acquire a flat field is to take an image of the sky at twilight. I choose an exposure that gives an overall density of about one-third of the pixels' capacity. I take a minimum of three such images, then co-add them to produce a smooth "master flat." Ideally, a new flat-field set should be taken each time the camera is removed and reinserted into the telescope.

A final step is to remove hot and cold pixels. These show up as bright or dark specks on the image. In this process, a computer algorithm takes wildly deviant pixels and averages them against neighboring normal ones. The software reassigns a proper value to the odd pixels.

After stepping through dark frames, flat fields and pixel fixing, the image may still require some basic enhancement of brightness and contrast to enhance the object. This is a simple step on a computer. The end result should be an unblemished, detailed image good enough to make any astrophotographer proud. There's one catch—it's in black and white.

Capturing Color

Most astronomical CCD cameras record images only in shades of gray. As a rule, color chips—although found in every video camcorder—are impractical for astronomical imaging. In color chips,

Compare the CCD image of the Swan Nebula (M17), top right, to the cold-camera shot of the same object on page 112. Both are impressive, but the CCD camera's sensitivity advantage over film is evident. Color film normally records the Owl Nebula (M97) as a red object, bottom right, but the combined tricolor CCD image reveals its true hue. Both images by Jack Newton.

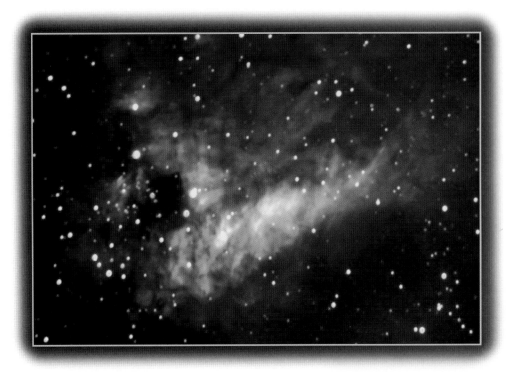

rows of adjacent pixels are covered in successive sets of red, green and blue filters. These work fine for daytime shooting, but not for night-sky shots. Pinpoint star images would inevitably fall on just the red or the blue or the green pixel, producing a rather messy image with poor resolution.

Instead, creating a color image means taking three exposures of every subject: one each through a red, a green and a blue filter. These images are then digitally combined in software to produce a single tricolor image. While this is certainly more work, tricolor imaging produces "true-color" views of astronomical objects that depict their appearance more accurately than do most film portraits.

The culprit plaguing film is again reciprocity failure. During long exposures, the color-sensitive layers of conventional film lose their ability to record light at different rates. If, say, the red layer is more efficient than the green or blue layers, the film will record the sky and everything in it as too red.

Now, CCD cameras don't react to all colors of light equally either. Most cameras, for example, aren't nearly as sensitive to blue light as they are to red. But this is easy to compensate for—simply make the blue exposure longer than the red one. By adjusting the relative exposure times of the red, green and blue exposures, it's possible to create a perfectly balanced true-color image.

Another reason film falls short of true-color views is that color films inevitably fail to properly record the green Oxygen-III emission lines that are

131

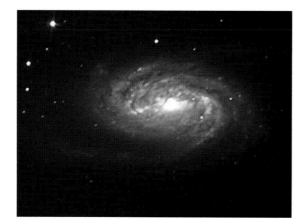

the strongest component in the light of many emission and planetary nebulas. These wavelengths of 495.9 and 500.7 nanometers fall in a part of the spectrum that neither the blue- nor the green-sensitive layer in regular film picks up well. In film portraits, for instance, the Owl Nebula in Ursa Major is portrayed as being red. Its real color, however, is a beautiful aquamarine. The Veil Nebula, too, is blue-green, not bright red as film records it.

Striking a Balance

In my opinion, the Santa Barbara Instrument Group sells the best set of red, green and blue filters. These filters efficiently transmit over 90 percent of the wanted color. The green filter has also been designed to transmit the Oxygen-III emission lines. Santa Barbara, Meade, Celestron and several other manufacturers offer motorized filter-wheel accessories for their cameras. These attach in front of the CCD and are controlled by the camera's software to automate the process of taking successive images in three colors.

However, the filters from all manufacturers also allow near-infrared light to pass. CCD chips are particularly sensitive to the near-infrared, a trait that complicates tricolor imaging. For example, if your blue filter has a strong "IR leak," then your color images will be overly blue. The solution is to filter out near-infrared. Most manufacturers supply IR blocking filters with their tricolor filter sets and wheels.

The other complication with filters is that because they reduce the amount of light going to the CCD, longer exposures are required. This is added to the fact that images in a tricolor set must have as little noise in them as possible to produce a pleasing color image. In black-and-white images, the eye is more forgiving of random noise. But color images are marred by color variations in noisy areas of the image. A

CCD images of four galaxies, located between 35 and 60 million light-years from Earth, taken through a 25-inch f/5 Newtonian reflector: NGC2903, top; M66, right; M109, below; and NGC4605, bottom. All images on these two pages are by Jack Newton.

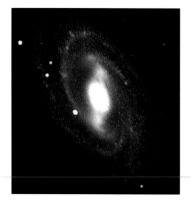

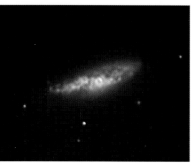

noise-free image requires a longer exposure, perhaps several exposures co-added together.

Because most low-cost CCD chips are more sensitive to red light than to blue, exposure times through each filter will not be the same. So before taking your first tricolor set, you need to discover what ratio of exposure times will produce a proper color balance. For a daylight test, I suggest using the telescope you will be shooting through at night. This is important because I've found that the spectral response of filters can be affected by the focal ratio of the system, the number of reflecting surfaces, the number of glass elements and other factors.

To color-balance a CCD camera, telescope and filter set, I take images during the day of a Kodak gray card, a standard photo target designed to reflect all colors equally. This procedure works best on an overcast day with lots of diffuse sunlight. Start with a red filter, and record an image with an average pixel density of about 60 percent of the so-called full-well capacity. This should be explained in your camera's instruction manual. Record the length of exposure.

Next, take an image with the green filter, and adjust the exposure to produce the same pixel density as the red image. Repeat the procedure for the blue. To test your color accuracy further, image a subject with lots of color (a color chart or flowers), then compare the final image to the original.

You will likely end up with an exposure ratio of one part red, two parts green and five parts blue. Applying this ratio to the night sky will give you an accurate true-color image, emulating what your eye perceives as a proper color balance when the subject is illuminated by the Sun.

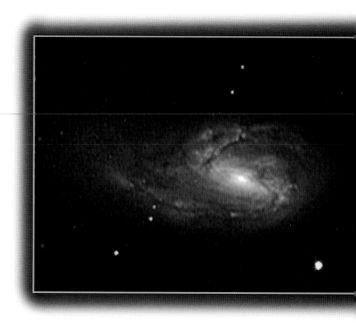

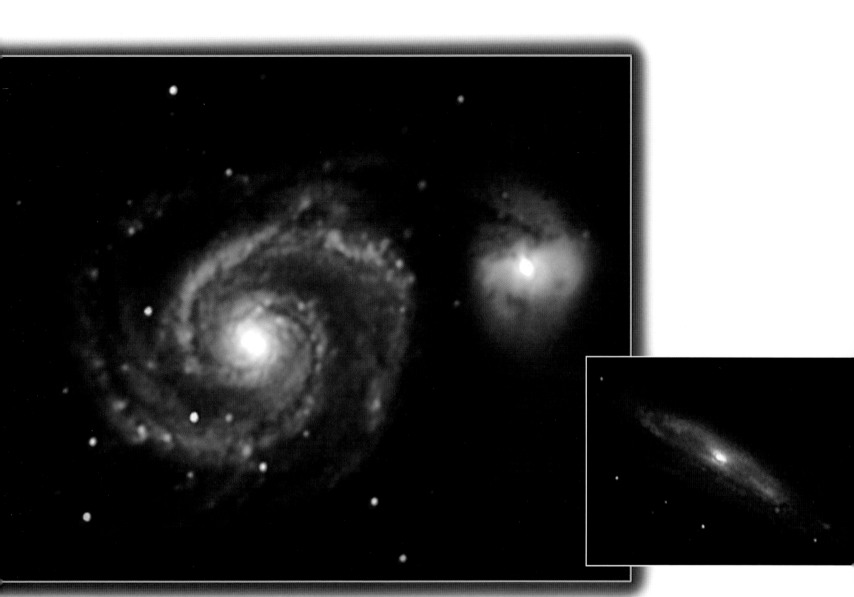

IMAGE PROCESSING

Most CCD-camera manufacturers provide software to assemble tricolor images. However, I first process the separate black-and-white images in a software package called MaxIm DL. At this stage, I use a powerful function called "maximum entropy deconvolution" to sharpen each image. This tightens star images and reveals fine structure in the spiral arms of galaxies, for example. A similar process was used by astronomers to sharpen images from the Hubble Space Telescope before its optics were fixed.

I subtract the dark frame, divide the result by the flat field and remove hot and cold pixels to generate a clean image. I often use a function called "histogram

Galaxies are the CCD-camera user's favorite targets. The comparatively small imaging surface of CCD chips combined with their high resolution and incredible sensitivity to light make them extremely effective for capturing these dim, remote cities of stars. The all-time favorite is the Whirlpool Galaxy (M51), here imaged with Jack Newton's 16-inch telescope at f/6.2 using a Pictor 1616 CCD camera with its 1.6 million pixels binned in groups of four. Inset, galaxy M98 is 60 million light-years distant, about twice as far away as M51.

equalization" to extract details from deep within the central bright regions of nebulas and galaxies without losing the detail in the faint outer regions.

At the end of the processing, I save each of the three images in the FITS (Flexible Image Transport

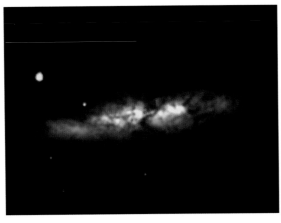

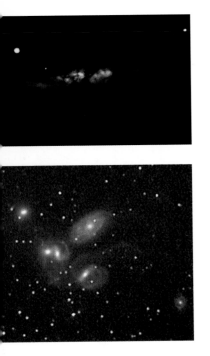

Comparison of a Jack Newton 25-inch-telescope CCD image of the galaxy M82, top right, and the best-ever color-film shot of the same object, top left, taken with a cold camera attached to the U.S. Naval Observatory's 42-inch reflector. Similarly, the 25-inch CCD image of the five galaxies known as Stephan's Quintet, above, equals anything previously taken on film with much larger telescopes. Below, 25-inch CCD image of the galaxy M65, about 40 million light-years distant.

System) format, a standard for scientific images. This is important, because there is a good chance that future software versions will allow you to extract even more details from your old images. The FITS format retains all the original 16-bit image data, ensuring that the details are there to extract.

I then resave the images as 8-bit TIFF (Tagged Image File Format) files so that I can load them into Adobe Photoshop, a popular image-processing package available for both Windows and MacOS. I use MaxIm DL, taking one keystroke to perfectly combine the red, green and blue images into precise alignment. (Adobe Photoshop also has a "combine" function for this type of work.) Finally, a stunning full-color image emerges on the screen.

The process is certainly not simple, nor is it economical. But it is immensely powerful and rewarding, yielding images that rival conventional photographs from the world's largest telescopes—all from your backyard telescope and desktop computer.

The CCD galaxy images on these pages, taken with a 25-inch telescope, show more detail than the best film photographs taken with the Mount Wilson 100-inch telescope, and they come very close to matching the finest photographic results from the Palomar 200-inch telescope before it was converted to CCD imaging just a generation ago. Such power in the hands of an amateur astronomer is an astonishing development.

GALAXIES

The final frontier in astrophotography is galaxies. No astronomical object exemplifies the majesty of the universe more powerfully than a galaxy floating in the blackness. A galaxy is a stellar metropolis, vast and imperial, ordained by gravity and embracing billions —sometimes trillions—of stars. There are more galaxies in the universe than there are people on Earth. Images from the Hubble Space Telescope reveal that *at minimum*, there are 50 billion galaxies in the universe. That's simply the total the Hubble could see if it were to photograph the entire sky at its highest resolution, a task which would take centuries. Undoubtedly, there are billions of galaxies too small or too faint for the Hubble Space Telescope to pick up.

Of this immense population, only a handful of the nearest galaxies can be imaged in any significant detail using standard film techniques. This is where the power and resolution of CCD cameras simply overwhelm the more traditional medium of photographic emulsion.

Big Bang Background

Evidence continues to build supporting the idea that the universe began with a titanic event about 13 billion years ago, a fireball of creation that scientists rather prosaically call the Big Bang. Today, astronomers observe the still-expanding universe by measuring the redshift velocities of clusters of galaxies receding from each other like the dots on an inflating balloon.

In this context, one of the most-asked questions is, If all the galaxies are moving away from us, does that mean we are at the center of the universe?

All evidence suggests that the universe would look essentially the same no matter which galaxy we observed it from. Every galaxy sees all the other galaxies hurtling away from it. Apply the inflating-balloon analogy: Picture yourself using a magic marker to pepper an uninflated balloon with dots to represent galaxies. Then inflate the balloon. As it expands, the dot galaxies retreat from one another. Each dot galaxy "observes" the same thing. There is no center, nor is there an edge. The balloon's surface is a two-dimensional

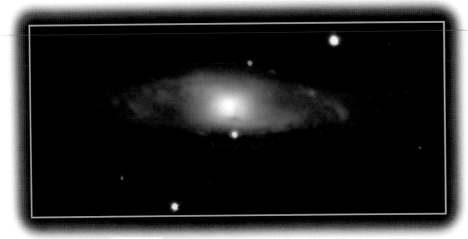

representation of the three-dimensional universe.

However, there is another element in the scenario that does put us at the center in one sense. We are in the present, and everything else we see is in the past. We see the distant universe as it was, not as it is. A star in the Big Dipper 75 light-years away is seen as it was a human lifetime ago, because the light from that star has taken 75 years to reach Earth. But that's small-scale stuff. Where the effect begins to count is from one galaxy to another. Light reaching us from a galaxy five billion light-years away is five billion years old. We see the galaxy as it was five billion years ago, before Earth even existed.

What this means is that we perceive the universe as if from the center of an onion, with each layer outward from the center representing an increasingly earlier epoch. If we could look far enough, then, we might be able to see all the way back to the beginning. And that, in fact, is what is done when astronomers examine the background radiation—at least, it is as close to the beginning as we will ever get. The background radiation is the first radiation emitted by the hot, young universe 300,000 years after its birth, and it has been detected by microwave telescopes.

The background radiation has reached us from near the beginning of time and from the edge of space as we perceive it. Nothing more remote can be observed. The background radiation represents an impenetrable wall of energy that marks the boundary of our universe. It appears all around us, because the universe is all around us. We are observing its earliest era.

Thus from the point of view of *what we observe*, we are at the center of the universe; the edge is the beginning, the center is the present. However, this is

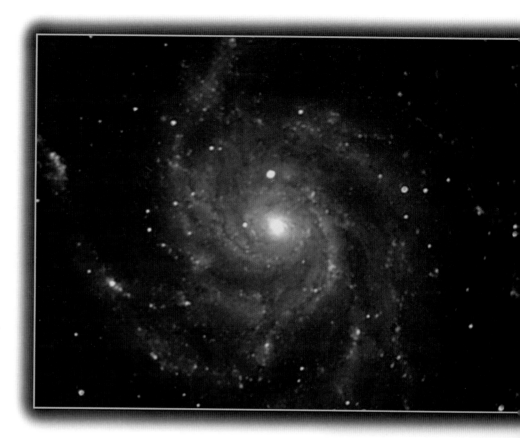

an illusion, a time-machine effect caused by the finite speed of light that brings us ghostly images of what was, not what is. Moreover, every observer on every other galaxy would see the same thing, the same concentric spheres of the past enveloping them as they do us. To some other civilization, our galaxy is seen as it was billions of years ago. We are the past in somebody else's present.

These observations continue a trend established in astronomy more than four centuries ago, before the invention of the telescope, when the Polish astronomer Copernicus proved that Earth is not centrally placed in the universe but, instead, orbits around the Sun. By the early 20th century, definitive evidence emerged showing that the Sun is well offset from the center of the Milky Way Galaxy. By the late 1920s, enough other galaxies had been discovered to prove that ours is just one among millions. By the 1950s, the census of known galaxies had grown into the billions. Then superclusters of galaxies were recognized, and we learned that our Milky Way Galaxy resides on the outskirts of one of them. The picture has thus unfolded to reveal the current scenario: We live on a small planet orbiting a slightly brighter-than-average star in the outer sector of an ordinary galaxy on the fringes of what appears to be an ordinary supercluster of galaxies in what may or may not ultimately prove to be an ordinary universe in an ocean of universes.

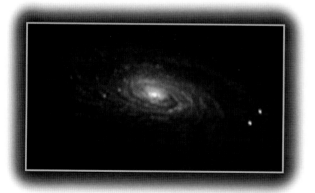

Four magnificent spiral galaxies—M101, top; M61, right center; M106, bottom right; and M88, above—were imaged with a Santa Barbara Instrument Group ST-6 CCD camera attached to Jack Newton's 25-inch telescope.

HUBBLE DEEP FIELD

In December 1995, the Hubble Space Telescope was aimed at an apparently "empty" region near the Big Dipper for a 100-hour exposure. The resulting picture, known as the Hubble Deep Field, shows the sky littered with galaxies up to 10 billion light-years away. A handful of stars in our galaxy can be distinguished by their four-spike appearance, caused by mirror supports in the telescope. Everything else is galaxies. The picture covers an area in the sky no larger than a grain of sand held at arm's length. The pair of images above show a reduced version of the Hubble Deep Field, left, and Jack Newton's CCD image of the same sector of the sky, right, which records 32 galaxies—not bad for an earthbound amateur astronomer!

This CCD image of NGC6781, a 12th-magnitude planetary nebula, was taken by Jack Newton with a 16-inch Schmidt-Cassegrain.

RESOURCES

ASTROPHOTOGRAPHY AND CCD-IMAGING SUPPLIERS

Astrophotography-Capable Telescopes

Astro-Physics, 11250 Forest Hills Road, Rockford, IL 61111. Apochromatic refractors, Maksutov-Newtonian astrographs, equatorial mounts and accessories. Tel: (815) 282-1513.

Celestron International, 2835 Columbia Street, Torrance, CA 90503. Schmidt-Cassegrains, importer of Vixen telescopes and mounts such as Great Polaris German equatorial, plus extensive catalog of accessories. Tel: (310) 328-9560. Website: www.celestron.com

Ceravolo Optical Systems, 702 Pattersons Corners Road, Oxford Mills, Ontario, Canada K0G 1S0. Maksutov-Newtonian astrographs; astrocameras. Tel: (613) 258-4480. Website: www.cyanogen.on.ca/ceravolo

Meade Instruments Corporation, 16542 Millikan Avenue, Irvine, CA 92714. Schmidt-Cassegrains, Schmidt cameras, equatorial Newtonians, apochromatic refractors, complete mounts, plus extensive catalog of accessories. Tel: (714) 756-2291. Website: www.meade.com

Optical Guidance Systems, 2450 Huntingdon Pike, Huntingdon Valley, PA 19006. Newtonian and Ritchey-Chretien Cassegrain telescopes; premium mounts. Tel: (215) 947-5571. Website: www.nb.net/~ogs

Parks Optical, 270 Easy Street, Simi Valley, CA 93065. Equatorial Newtonian and Cassegrain reflectors; extensive catalog of accessories. Tel: (805) 522-6722.

Tele Vue Optics, Inc., 100 Route 59, Suffern, NY 10901. Apochromatic refractors and accessories. Tel: (914) 357-9522. Website: www.televue.com

Texas Nautical Repair, 3110 S. Shepherd, Houston, TX 77098. Importer of Takahashi Newtonian reflectors, astrographs, apochromatic refractors and mounts. Tel: (713) 529-3551. Website: www.Isstnr.com

Telescope Mounts, Drives and Trackers

Aeroquest Machining, HC02, Box 7334E, Palmer, AK 99645. Custom drive gears. Tel: (907) 745-1019.

Astro-Track Engineering, 9811 Brentwood Drive, Santa Ana, CA 92705. Premium mounts. Tel: (714) 289-0402.

Edward R. Byers Company, 29001 W. Hwy. 58, Barstow, CA 92311. Premium mounts and drive gears. Tel: (760) 256-2377.

Epoch Instruments, 2331 American Avenue, Hayward, CA 94545. Premium mounts. Tel: (415) 784-0391.

Hollywood General Machining Inc./Losmandy, 1033 N. Sycamore Avenue, Los Angeles, CA 90038. Premium mounts, with extensive system of mounting accessories and adapters. Tel: (213) 462-2855. Website: www.opamplabs.com

Optic-Craft Machining, 33918 Macomb, Farmington, MI 48024. Premium mounts. Tel: (313) 476-5893.

Parallax Instruments, 8318 Pineville-Matthews Road, Suite 708, Box 192, Charlotte, NC 28226. Premium mounts. Tel: (704) 542-4817.

Pocono Mountain Optics, RR 6, Box 6329, North Pocono Village Shopping Center, Moscow, PA 18444. Unique camera tracker mount. Tel: (717) 842-1500. Website: www.Astronomy-Mall.com

Software Bisque, 912 12th Street, Suite A, Golden, CO 80401. Computer-controlled robotic mount. Tel: (303) 278-4478. Website: www.bisque.com

Thomas Mathis Co., 830 Williams Street, San Leandro, CA 94577. Premium mounts and drive gears. Tel: (415) 483-3090.

Vista Instrument Co., 307 E. Tunnell Street, P.O. Box 1919, Santa Maria, CA 93454. Camera trackers and drive correctors. Tel: (805) 925-1240.

Astrophoto Cameras, Films and Accessories

Beattie Systems, Inc., P.O. Box 3142, Cleveland, TN 37311. Extra-bright camera-focusing screens for many 35mm SLR cameras.

Epoch Instruments, 1689 Abram Court, San Leandro, CA 94577. Exclusive dealer for Celestron Schmidt cameras. Tel: (510) 351-1288.

Jack Schmidling Productions, Inc., 18016 Church Road, Marengo, IL 60152. Limited-production 4 x 5 astrocamera. Tel: (815) 923-0031. Website: user.mc.net/arf

Jim Kendrick Studio, 2775 Dundas Street W., Toronto, Ontario, Canada M6P 1Y4. Anti-dew heater coils; focusing aids. Tel: (416) 762-7946. Website: www.Astronomy-Mall.com

Jim's Mobile Industries (JMI), 810 Quail Street, Unit E, Lakewood, CO 80215. Premium focusers; electric focus and declination motors; drive correctors. Tel: (303) 233-5353.

Lumicon, 2111 Research Drive, #5A, Livermore, CA 94550. Astrophoto adapters, filters, film-hypering kits and pre-hypered film. Tel: (510) 447-9570. Website: www.Astronomy-Mall.com/Lumicon

Northern Lites, 640 Cains Way, RR 1, Sooke, British Columbia, Canada V0S 1N0. Custom cold cameras. Tel: (604) 478-8065.

Orion Telescope Center, 2450 17th Avenue, P.O. Box 1815,

Santa Cruz, CA 95061. Extensive catalog of accessories. Tel: (408) 763-7030. Website: www.oriontel.com

Spectra Astro*Systems, 6631 Wilbur Avenue, Suite 30, Reseda, CA 91335. Guiders and focusing aids. Tel: (818) 343-1352. Website: www.rahul.net/resource/spectra

Taurus Technologies, P.O. Box 14, Woodstown, NJ 08098. Medium-format and 35mm Taurus astrocameras and accessories. Tel: (609) 769-4509.

Thousand Oaks Optical, Box 4813, Thousand Oaks, CA 91359. Mylar and glass solar filters. Tel: (805) 491-3642.

Van Slyke Engineering, 12815 Porcupine Land, Colorado Springs, CO 80908. Off-axis guiders and flip-mirror viewers. Tel: (719) 495-3828.

Vogel Enterprises, 38W150 Hickory Court, Batavia, IL 60510. Drive correctors. Tel: (708) 879-8725.

CCD Cameras and Accessories

Adirondack Video Astronomy, 35 Stephanie Lane, Queensbury, NY 12804. Starlight Express CCD cameras, CCD accessories and low-light video cameras. Tel: (518) 793-9484. Website: ourworld.CompuServe.com/homepages/AVAstro

Apogee Instruments Inc., 3340 N. Country Club Road, #103, Tucson, AZ 85716. Premium CCD cameras. Tel: (520) 326-3600. Website: www.apogee-ccd.com

Astrostock, 2195 Raleigh Avenue, Costa Mesa, CA 92627. Distributor of Pegasus CCD cameras. Tel: (714) 722-7900.

CCD Technology, 18092 Sky Park, South Unit E, Irvine, CA 92714. Low-cost CCD cameras. Tel: (714) 752-2442.

Celestron International, 2835 Columbia Street, Torrance, CA 90503. PixCel CCD cameras. Tel: (310) 328-9560. Website: www.celestron.com

CompuScope, 3463 State Street, Suite 431, Santa Barbara, CA 93105. CCD cameras; automated filter wheels. Tel: (805) 966-7179.

Electrim Corp., 356 Wall Street, Princeton, NJ 08540. Compact CCD cameras. Tel: (609) 683-5546.

Meade Instruments Corporation, 16542 Millikan Avenue, Irvine, CA 92714. Extensive line of Pictor CCD cameras and auto-guiders. Tel: (714) 756-2291. Website: www.meade.com

Micro Luminetics, Inc., 3447 Greenfield Avenue, Los Angeles, CA 90034-5301. Research-grade CCD cameras. Tel: (310) 559-2615. Website: www.cryocam.com

Murnaghan Instruments, 1781 Primrose Lane, W. Palm Beach, FL 33414. CCD cameras and accessories. Tel: (561) 795-2201. Website: www.murni.com

OPTEC, Inc., 199 Smith Street, Lowell, MI 49331. CCD accessory filter wheels, flip-mirror viewers and telecompressors. Tel: (616) 897-9351.

Photometrics Ltd., 3440 E. Britannia Drive, Tucson, AZ 85748. Research-grade CCD cameras. Tel: (602) 889-9933.

Photon Technology International, 1 Deerpark Drive, Suite F, Monmouth Junction, NJ 08852. Research-grade CCD cameras. Tel: (908) 329-0910. Website: www.pti-nj.com

RXDesign, 1753 Elmwood Drive, Rock Hill, SC 29730. Distributor of HiSIS22 CCD cameras. Tel: (803) 327-6024.

Saguaro Scientific Corp., 8215 N. Venus Court, Tucson, AZ 85704. Computer-controlled filter wheels. Tel: (602) 575-8524.

Santa Barbara Instrument Group, 1482 East Valley Road, #33, Santa Barbara, CA 93150. ST-4 auto-guider; extensive line of ST CCD cameras; imaging software. Tel: (805) 969-1851. Website: www.sbig.com

Schuler Astro-Imaging, P.O. Box 307, Sudbury, MA 01776. CCD-imaging filters. Tel: (508) 443-2037.

Sirius Instruments, 141 N. Charles Avenue, Villa Park, IL 60181. Stand-alone CCD cameras with integrated image-processing software. Tel: (708) 782-5819.

SpectraSource Instruments, 31324 Via Colinas, Suite 114, Westlake Village, CA 91362. CCD cameras. Tel: (818) 707-2655.

University Optics, Inc., 2122 E. Delhi Road, P.O. Box 1205, Ann Arbor, MI 48106. CCD camera kits. Tel: (313) 665-3575.

Astronomy Image-Processing Software and Services

Axiom Research Inc., 2450 E. Speedway, Suite 3, Tucson, AZ 85719. MIRA research-grade image-processing and data-reduction software. Tel: (520) 791-2864. Website: www.axres.com/axiom

CompuScope, 3463 State Street, Suite 431, Santa Barbara, CA 93105. Image-processing and telescope-control software. Tel: (805) 966-7179.

Cyanogen Productions Inc., 25 Conover Street, Nepean, Ontario, Canada K2G 4C3. MaxIm DL image-processing software. Tel: (613) 225-2732. Website: www.cyanogen.on.ca

Hallas Color Labs, 165 Alto Drive, Oakview, CA 93022. Custom printing and image-enhancement services by Tony and Daphne Hallas. Tel: (805) 649-1001. Website: www.west.net/~ahallas

Software Bisque, 912 12th Street, Suite A, Golden, CO 80401. CCDSoft image-processing and telescope-control software. Tel: (303) 278-4478. Website: www.bisque.com

The Saturn Nebula (NGC7009), top, and the Cocoon Nebula (IC5146), above. CCD images taken with a 16-inch Schmidt-Cassegrain by Jack Newton.

www.aa6g.org/astro.html Chuck Vaughn's site contains excellent advice on using the ST-4 auto-guider, among other techniques.

www.astropix.com Jerry Lodriguss presents useful tips, techniques and film recommendations.

www.frazmtn.com/~bwallis Brad Wallis's site contains a comprehensive set of links to the home pages and picture galleries of the world's best astrophotographers.

www.unicom.org/~dclapp/index.htm Among the highlights of Doug Clapp's site is a gallery of the best and the latest CCD images by Jack Newton.

pulsar.la.asu.edu/~chris Chris Schur presents a selection of helpful articles on his techniques.

ASTROPHOTOGRAPHY REFERENCE BOOKS

Astrophotography Guidebooks

The Art and Science of CCD Astronomy by David Ratledge, ed. (Springer-Verlag; New York; 1996). A dozen amateur astronomers and CCD experts present instructions for all types of CCD imaging, from lunar to deep-sky.

Astrophotography: An Introduction by H.J.P. Arnold (Sky Publishing; Cambridge, MA; 1996). Emphasizes simple techniques of camera-on-tripod and piggyback photography.

Astrophotography for the Amateur by Michael Covington (Cambridge University Press; New York; rev. ed., 1991). A good general introduction to the subject.

The Cambridge Eclipse Photography Guide by Jay M. Pasachoff and Michael A. Covington (Cambridge University Press; New York; 1993). Primarily reprints eclipse-shooting advice contained in Covington's earlier book, *Astrophotography for the Amateur*.

Choosing and Using a CCD Camera by Richard Berry (Willmann-Bell; Richmond, VA; 1992). A fine introduction to CCD cameras and their specifications.

The Handbook for Star Trackers by Jim Ballard (Sky Publishing; Cambridge, MA; 1988). This little book provides instructions for building several hand-cranked and motorized camera trackers. Unfortunately, all the commercially made trackers described are no longer available.

A Manual of Advanced Celestial Photography by Brad D. Wallis and Robert W. Provin (Cambridge University Press; New York; 1988). A new edition due in 1998 will update this comprehensive review of advanced techniques.

Saturn, September 9, 1997. CCD image with a 16-inch Schmidt-Cassegrain by Jack Newton.

General Books and Atlases of Interest to Astrophotographers

The Backyard Astronomer's Guide by Terence Dickinson and Alan Dyer (Firefly Books; Willowdale, Ontario; rev. ed., 1994). A general survey of amateur astronomy but with extensive chapters on basic astrophotography techniques.

Colours of the Galaxies by David Malin and Paul Murdin (Cambridge University Press; New York; 1984). The authors explain why various objects glow in the colors they do as well as professional techniques for capturing those colors on film.

Exploring the Southern Sky by S. Lausten, C. Madsen and R.M. West (Springer-Verlag; New York; 1987). A beautiful atlas of southern-sky wonders sure to inspire with its stunning images from the European Southern Observatory.

The Guide to Amateur Astronomy by Jack Newton and Philip Teece (Cambridge University Press; New York; rev. ed., 1995). A general survey of amateur astronomy but with detailed chapters on astrophotography and CCD imaging.

A Nature Company Guide: Advanced Skywatching by Robert Burnham et. al. (Time-Life/Weldon-Owen; Sydney, Australia; 1997). A colorful general guidebook with detailed sections on astrophotography and equipment selection.

The Photographic Atlas of the Stars by H.J.P. Arnold, Paul Doherty and Patrick Moore (Kalmbach Publishing; Waukesha, WI; 1997). Astrophotographers will find the color photos of the sky useful for planning wide-angle images of the Milky Way, nebulas and star fields.

A View of the Universe by David Malin (Sky Publishing and Cambridge University Press; Cambridge and New York; 1993). A stunning collection of the world's finest astronomical images taken by Malin on traditional film with some of the world's largest telescopes—a dying art and forgotten science.

MAGAZINES

Astronomy is a colorful monthly package of information on current sky events, discoveries, equipment reviews, and so on. Available on many newsstands. Kalmbach Publishing, Box 1612, Waukesha, WI 53187. Subscriptions: (800) 533-6644.

Sky & Telescope is a comprehensive monthly filled with useful articles and information for amateur astronomers. Almost every issue contains an article on astrophotography (film or CCD) as well as examples of celestial images taken by amateur astronomers. Available on many newsstands. Sky Publishing, Box 9111, Belmont, MA 02178. Subscriptions: (800) 253-0245.

SkyNews is a bimonthly Canadian astronomy magazine in full color published by the National Museum of Science and Technology. Examples of astrophotography in every issue. Available on selected larger newsstands. NMST Corp., Box 9724, Ottawa, Ontario, Canada K1G 5A3. Subscriptions: (800) 267-3999.

Useful Data for Astrophotographers

Frame Dimensions, Limiting Magnitude and Unguided Trailing Guidelines

Lens Focal Length	35mm Frame Size	Limiting Magnitude	Width of Moon on Film	Maximum Exposure Before Trailing Equatorial Region of Sky	Polar Region
20mm	82° x 55°	8.5		30	40
24mm	71° x 48°	9		25	35
28mm	63° x 44°	9.5		22	30
35mm	51° x 34°	10		17	26
50mm	38° x 26°	11	0.5mm	12	18
85mm	23° x 15°	12	0.8mm	7	11
135mm	14.5° x 9.5°	13	1.2mm	5	8
180mm	11° x 7°	13.5	1.6mm	3	6
300mm	6.5° x 4.4°	14	2.7mm	2	3
500mm	3.9° x 2.6°	14.5	4.6mm		
1,000mm	2.0° x 1.3°	16.5	9mm		

Deep-Sky Exposure Guidelines for Top-Rated* 400-to-1,000-Speed Print Films (Unhypered)

Conditions	f2.0	f2.8	f4.0	f5.6	f8
noticeable horizon glow	1-4 min.	3-6 min.	8-15 min.	20-40 min.	30-60 min.
deep rural with little horizon glow	3-6 min.	5-12 min.	12-30 min.	25-60 min.	as long as practical
exceptionally dark high-altitude site	4-10 min.	8-18 min.	20-40 min.	as long as practical	as long as practical

*As of late 1997, these films include: Kodak Pro 1000 PMZ, Fujicolor SG+ 800, Kodak Ektapress Multispeed PJM 640, Kodak Pro 400 PPF and Fujicolor SG+ 400.
Notes: Exposures can be cut by up to half if temperature is below 0 degrees C (32°F). Increase exposure times when using lenses shorter than 20mm focal length.

Deep-Sky Exposure Guidelines for Top-Rated* Slide Films (Unhypered)

Conditions	f2.0	f2.8	f4.0	f5.6
noticeable horizon glow	2-5 min.	5-12 min.	10-18 min.	20-40 min.
deep rural with little horizon glow	4-8 min.	10-20 min.	20-40 min.	as long as practical
exceptionally dark high-altitude site	5-12 min.	15-35 min.	25-60 min.	as long as practical

*As of late 1997, these films were Kodak Ektachrome P1600 and Kodak Ektachrome Elite II 100 (both films should be push-processed one or two stops).
Notes: Exposures can be cut by up to half if temperature is below 0 degrees C (32°F). Increase exposure times when using lenses shorter than 20mm focal length.

Useful Data for Astrophotographers

ISO Film Speed	Full Moon	Gibbous	First Quarter	Thick Crescent	Thin Crescent	Earthshine (at f8)
800	1/500	1/250	1/125	1/60	1/30	2-10 sec.
400	1/250	1/125	1/60	1/30	1/15	5-20 sec.
200	1/125	1/60	1/30	1/15	1/8	10-30 sec.
100	1/60	1/30	1/15	1/8	1/4	20-60 sec.
50	1/30	1/15	1/8	1/4	1/2	N/A
25	1/15	1/8	1/4	1/2	1	N/A

*Use one shutter speed faster around f11 and two faster around f8, and so on (Earthshine is adjusted to f8). As a general rule, though, always bracket exposures to account for atmospheric absorption and other vagaries. Use a lunar-rate drive for longer Earthshine photographs.

Lunar Photography: Image Size

Lens	Image Size on Film	Maximum Exposure to Avoid Trailing Undriven	Maximum Exposure to Avoid Trailing Driven at Sidereal Rate
50mm	0.45mm	12 sec.	4 min.
100mm	0.9mm	6 sec.	2 min.
200mm	1.8mm	3 sec.	1 min.
500mm	4.5mm	1 sec.	20 sec.
1,000mm	9mm	1/2 sec.	10 sec.
1,500mm	13.5mm	1/4 sec.	7 sec.
2,000mm	18mm	1/8 sec.	5 sec.
2,500mm	23mm	1/15 sec.	3 sec.

Conjunctions of Interest to Astrophotographers (1998-2009)

Date	Event
Mar. 26, 1998	Thin crescent Moon passes directly in front of Jupiter (called an occultation), 5-6 a.m., EST; visible only in eastern North America
Apr. 23, 1998	Venus less than 0.5° from Jupiter in morning sky
Feb. 23, 1999	Venus 0.3° from Jupiter in evening sky (spectacular)
Mar. 19, 1999	Venus 2° from Saturn, with crescent Moon; in evening
Feb. 2, 2000	Crescent Moon 1° from Venus in morning twilight
early Apr. 2000	Jupiter, Saturn and Mars cluster low in evening sky with crescent Moon joining them Apr. 6
Jul. 15, 2001	Venus and Saturn less than 1° apart in early-morning sky
Jul. 17, 2001	Crescent Moon, Venus and Saturn form a 3° triangle in morning twilight
Aug. 6, 2001	Venus 1.3° from Jupiter in early-morning sky
Nov. 6, 2001	Venus 0.8° from Mercury in morning twilight
Feb. 22, 2002	Gibbous Moon 0.3° from Jupiter around midnight
Apr. 22-May 13, 2002	For the first time in more than a generation (since May 1980), all five naked-eye planets are lined up above the western horizon at dusk; crescent Moon joins the group on May 13; best alignment will be late April, with planets in this order from horizon up: Mercury, Venus, Mars, Saturn and Jupiter; star Aldebaran near Saturn
May 14, 2002	Crescent Moon 1° from Venus low in west at dusk
Jun. 3, 2002	Venus and Jupiter 2° apart low in west at dusk
Jun. 14, 2002	Crescent Moon less than 2° from Venus (3° in western North America)
Nov. 5, 2004	Venus and Jupiter 0.6° apart in the east in morning twilight
Dec. 7, 2004	Crescent Moon passes directly in front of Jupiter from about 4-5 a.m., EST (not visible from western half of North America)
Jun. 25, 2005	Venus, Mercury and Saturn cluster within 1.5° of each other in west at dusk
Jun. 27, 2005	Venus just 0.1° from Mercury in west at dusk; closest encounter of these two planets visible from North America since 1965
Jun. 17, 2006	Saturn and Mars 0.5° apart and just 1° from Beehive star cluster in evening sky
May 19, 2007	Crescent Moon just 1° from Venus in evening sky; *very* impressive
Jul. 1, 2007	Venus 0.8° from Saturn low in west in evening twilight
Feb. 1, 2008	Venus and Jupiter 0.6° apart in east in morning twilight
Feb. 4, 2008	Venus, Jupiter and crescent Moon cluster in morning sky before dawn
Dec. 1, 2008	Venus, Jupiter and crescent Moon cluster in a 3° triangle at dusk
Dec. 31, 2008	Jupiter and Mercury 1.2° apart low in west at dusk
Feb. 27, 2009	Crescent Moon less than 2° from Venus in evening sky
Oct. 13, 2009	Venus and Saturn 0.5° apart in early-morning sky

AUTHORS

Terence Dickinson is the author of 14 astronomy books, including the best-selling guidebook *Night-Watch*. He is the editor of *SkyNews*, Canada's national popular-level astronomy magazine, and an astronomy columnist for *The Toronto Star* and the Canadian Discovery Channel. In the 1960s and 1970s, he was a staff astronomer at two major planetariums and, since 1976, has been a full-time astronomy writer and editor. He has received numerous national and international awards for his work, among them the New York Academy of Sciences book-of-the-year award and the Astronomical Society of the Pacific's Klumpke-Roberts Award for outstanding contributions in communicating astronomy to the public. Asteroid 5272 Dickinson is named after him. His lifelong interest in astronomy began at age 5, when he saw a brilliant meteor from the sidewalk in front of his house in suburban Toronto. He lives in rural eastern Ontario, where he enjoys dark night skies above his backyard roll-off-roof observatory crammed with telescopes and astrocameras.

Photo: Bernard Clark

Jack Newton lives on a mountaintop at the southern tip of Vancouver Island, where his home observatory is one of the best equipped in North America. He is internationally regarded as one of the world's foremost astrophotographers, and his portraits of celestial objects have appeared in every leading astronomy magazine as well as hundreds of other publications. By day, he is employed as a manager at a leading department store in Victoria, British Columbia. He is currently designing an observatory similar to the one at his home for installation in Florida that will be run remotely from a computer in his den, enabling him to be photographing the night sky on both sides of the continent at once. He is the coauthor of *The Guide to Amateur Astronomy*, published by Cambridge University Press (rev. ed. 1995). Jack's interest in astronomy was sparked at a very early age as he watched the stars from his childhood home in Winnipeg, Manitoba. Soon after he received a 50mm refractor telescope as a gift at age 12, he was rigging it up with a camera, and his fascination with astrophotography has never waned.

Photo: Jean-François Grant-Godin

To Susan, once again with thanks
—and love *—TD*

To my daughter Suzanne and son Rob —JN

INDEX